THE ARTHUR NEGUS GUIDE TO
BRITISH SILVER

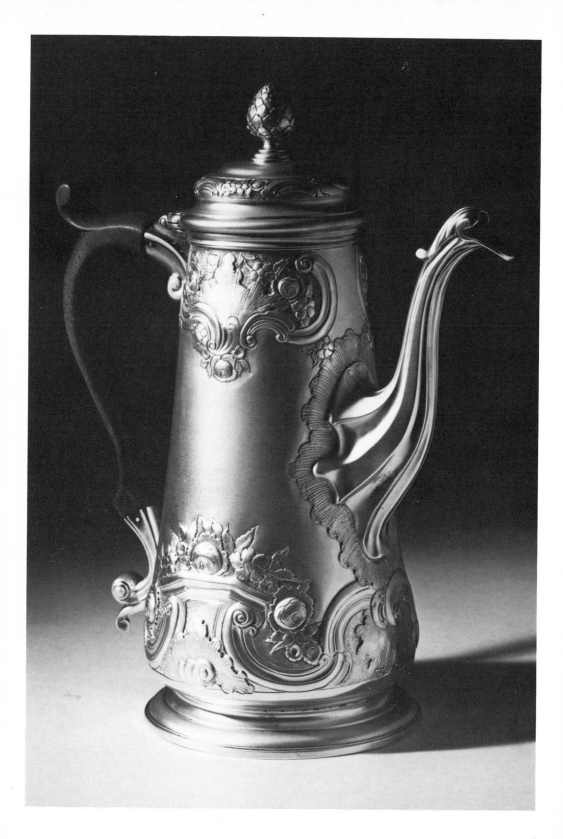

The Arthur Negus Guide to British

SILVER

BRAND INGLIS

Foreword by Arthur Negus

Consultant Editor: Arthur Negus

Hamlyn

London · New York · Sydney · Toronto

Published by
The Hamlyn Publishing Group Limited
London · New York · Sydney · Toronto
Astronaut House, Feltham, Middlesex,
England

First edition 1980

ISBN 0 600 33199 7

Filmset in England by
Photocomp Limited, Birmingham
Printed in Italy

Frontispiece:
George II coffee pot, c. 1749.

Acknowledgements

The photographs were all provided by the author with the exception
of the following:
James Charles London 64, 97, 103, 111, 148, 162; Christie Manson
and Woods, London 44, 88; Colonial Williamsburg Foundation,
Williamsburg, Virginia 2, 3, 4, 5, 6, 7, 8, 9; Worshipful Company of
Goldsmiths, London 26, 27, 28, 29, 30, 32, 33, 37, 42, 45, 47, 61, 66,
67, 73, 79, 90, 91, 118; Hamlyn Group Picture Library 41, 68, 92, 93,
115, 116, 117, 120; Los Angeles County Museum of Art, California
43; Thomas Lumley Ltd., London 57, 153, 154; Sotheby's Belgravia,
London 121, 123, 125, 141, 142, 146, 155; Sotheby Parke
Bernet,London page 155 top; C.J. Vander (Antiques) Ltd., London
156; Victoria and Albert Museum, London 124.
The author and publishers gratefully acknowledge The Hayward Art
Group who did the line drawings.

0077P

Contents

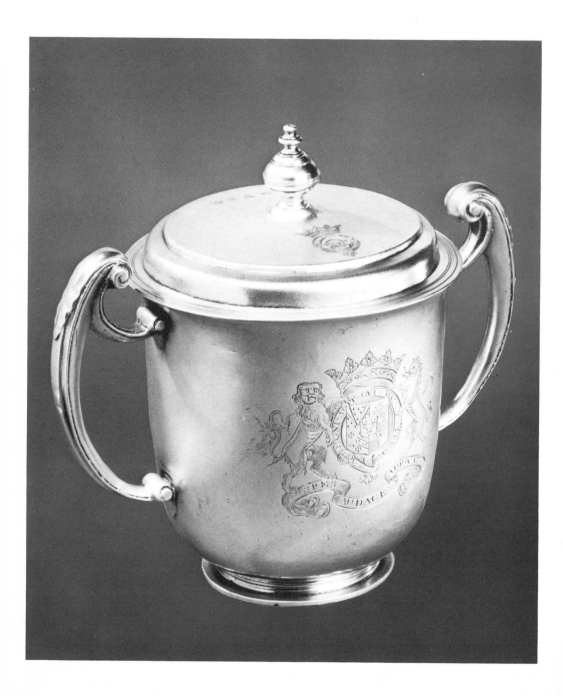

Foreword by Arthur Negus

One has only to visit the premises of Brand Inglis in Belgravia and see the lovely pieces displayed there to realise his great love and knowledge of silver, and we have been fortunate in persuading him to write a book on British silver giving us the benefit of that knowledge. The mysteries of the craft – the Goldsmiths Company and its ancient rules – have been explained, the method of producing silver articles described, all in language easy to understand, and the student of silver as well as the amateur collector will find much in this book to stimulate interest and linger in the memory.

Fashion has played a big part in the way the design of silver has changed, from the plain and austere style of the seventeenth century to the exuberant and fanciful patterns of the Victorian era, and a long chapter is devoted entirely to the description of articles that the collector may encounter. Brand Inglis has some very interesting thoughts on why people collect silver and, like me, he has little enthusiasm for the collection of silver as an investment. Surely, silver was made to be used and enjoyed by people – to buy pieces just because they are old and expensive, then put them in a bank until they can be sold at a profit, is not collecting. I commend this book to all lovers of silver and I am sure they will enjoy it as much as I have done. Readable as well as knowledgeable, it certainly earns a place in my reference library on the arts.

Arthur Negus

1 One of a fine pair of silver-gilt covered cups made by Nathaniel Underwood in 1699. They were made for John, 3rd Duke of Newcastle, K.G., and show his arms engraved within the Garter motto.

Chapter 1

The goldsmith's trade

The extraordinary qualities of silver, a metal which is at once beautiful to look at, easy to work, useful and hard-wearing, were recognised in prehistoric times. The ancient civilisations of the Near East used it (there are many references to silver in the Old Testament), Homer's heroes drank from silver goblets, and the Celts fashioned objects of mysterious splendour from silver. It is the most malleable of metals after gold and can be worked by skilful craftsmen into remarkably delicate forms, while its lustrous grey colour can be polished to a brilliant finish.

During the early Middle Ages silver virtually disappeared in Europe, probably because the local mines had been worked out. Around the end of the ninth century, large deposits of gold and silver were discovered in the Rhineland, and medieval European goldsmiths (a more common term than 'silversmith' which means the same, since no smith worked exclusively in gold) were supplied from this German source. However, not every article was made from new metal; on the contrary, silver articles which had become worn, broken or old-fashioned were frequently melted to be used for a new piece. In the sixteenth century, when German silver was becoming scarce, the Spanish empire builders in the New World discovered the immensely rich silver mines of Mexico, Peru and Bolivia. Much silver is still supplied by Mexico today, though larger quantities now come from North America and Australia.

Pure silver is too soft for normal use, and it must therefore be alloyed, i.e. combined with another metal, to make it harder. Though other base metals were used in the distant past, copper has long been established as the most useful for this purpose. In the sterling standard, to which for the most part all English silver has adhered for seven centuries or more, the proportions are 11 ounces 2 pennyweights of silver to 18 pennyweights of copper, which is equivalent to 925 parts per thousand pure silver.

The craft of the goldsmith is an ancient one which has changed remarkably little over the course of many centuries.

The tools and techniques used in a goldsmith's workshop in—
for example—the eighteenth century would be largely familiar
to a modern craftsman or a medieval one.

The typical goldsmith's shop was run by a master goldsmith,
a man who had served his seven-years apprenticeship in the
trade and been accepted as a freeman of the Goldsmiths'
Company. To assist him he usually had at least one journeyman
who received a regular wage. The journeyman was, like his
master, a qualified craftsman, but he chose to work for a
master, perhaps because he did not have the capital to set up
shop on his own. Very often his employer was the man under
whom he had served his apprenticeship. There were also one or
two apprentices, boys contracted to the trade at an early age
who learned the craft while assisting the goldsmith and lived as
members of his family. In spite of many stories of mistreatment,
apprentices were protected by their articles of apprenticeship,
and unless they had the bad luck to serve under a particularly
brutal or unpleasant man their existence was reasonably
comfortable by the standards of the time.

One way to understand the daily work of a goldsmith's shop
is to follow the progress of a single article—a coffee pot for
example—from start to finish.

The master goldsmith first makes a drawing of the coffee pot
he intends to fashion, which he discusses with his patron, for in
those days there was often a direct relationship between
craftsman and customer, and the manufacturer was, as a rule,
also the retailer. One important question to be discussed is the
amount of silver that will go into the article, as this will
obviously affect the price to be charged. The customer himself
may hand over some old, unwanted silver, which is weighed
and credited against the final bill.

The old silver is melted down together with sufficient new
metal to make up the total amount required. The silver ingot
that results is hammered into a thickish pancake shape by the
master and journeyman, using a heavy, two-handed sledge
hammer. With lighter hammers, the metal is gradually beaten
out into a thinner sheet, as evenly as the experienced eye of the
goldsmith can measure. The long and tiresome procedure of
turning a chunky ingot into a thin sheet was gradually taken
over by the rolling machine in the late eighteenth century.

When the metal has been hammered to the correct gauge, the
goldsmith marks a circle on it with a pair of heavy dividers, and
the metal beyond the circular outline is trimmed off with
shears. The next step is to 'sink' the body of the pot. The
circular sheet is held over a hollowed-out section of tree trunk,

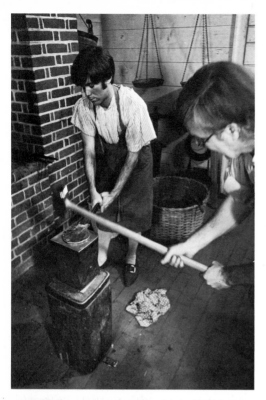

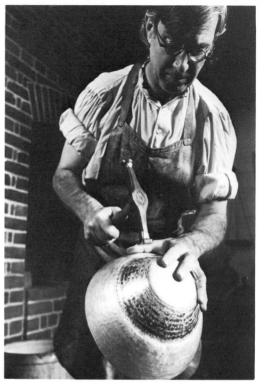

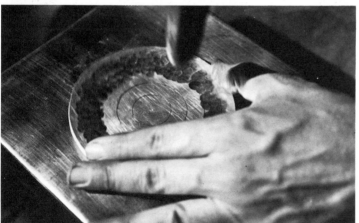

2 *Far left:* The apprentice holds the silver ingot as the goldsmith slowly hammers it into a flat sheet. These photographs are stills from an excellent film made at the James Geddy shop in Colonial Williamsburg, in the United States.

3 *Left:* A circular piece of silver is then cut out and the fashioning process begins.

4 *Above:* The circular disc has been sunk and the goldsmith begins to raise the body of the coffee pot on his raising stake.

and with a round-faced 'blocking' hammer, the flat sheet is slowly and patiently hammered into the hollow. The smith begins at the edge of the sheet, turning it fractionally after each blow and making a pattern of concentric circles of steadily diminishing diameter, until every part of the metal has been struck and the rows of concentric circles have reached the centre.

When the sheet is removed from the block, it has acquired a strongly dished shape. The practised eye of the goldsmith tells

him whether or not he has managed to sink it evenly all round.

The constant hammering and stretching of the metal distorts its crystal structure, making it brittle and liable to crack. To overcome this it must be annealed. In a dark corner of the workshop one of the apprentices has prepared a fire. The silver is placed in a pan called a 'hearth' and turned around in the heat until it glows a dull cherry red. This requires fine judgment and a practised eye; the dim light makes it easier to tell when the right stage has been reached, whereupon the silver is quenched in a tub of water standing nearby. The reheating or annealing process allows the crystal structure to adjust to the new shape of the metal, making it soft and workable again. It must be repeated many times in the course of working.

The 'sinking' of the circle of silver is followed by 'raising'. The dish-shaped circle is worked over a cast-iron anvil called a raising stake. Turning the silver all the time, the goldsmith begins hammering it, starting at the centre of the base and making a series of concentric circles of steadily increasing diameter, until the edge is reached. The edge, which will become the rim of the pot, is hammered down all round to thicken it. The silver is then annealed again and the process is repeated over a slightly narrower raising stake. With each working, the body of the pot advances further towards its final form, becoming elongated and vase-shaped. Finally the goldsmith lays down his raising hammers, judging that he has achieved the final shape of the pot. To aid his expert eye, he places it on a lathe, which reveals any slight deviations. Depending on the size and shape of the coffee pot, the process of raising the body takes about one working day.

Although the body of the pot is now in its final form, the raising hammers have left it in a comparatively rough state, a mass of circular hammer marks which must be painstakingly removed by planishing. The body is placed over a rounded stake and struck all over with a heavy, flat-faced hammer. It is here that the ability of a true master is most evident, as he carefully flattens out irregularities, gradually creating by eye and hammer alone a final texture smooth enough for polishing. At this exacting stage of the work, the young apprentices will be watching closely, while the hammer rises and falls and the silver is turned constantly on the stake so that no hammer blow falls in exactly the same spot as another.

While the master has been raising the body, the journeyman has been preparing the various other pieces which have to be cast and fixed to the pot—the spout, the handle sockets, the

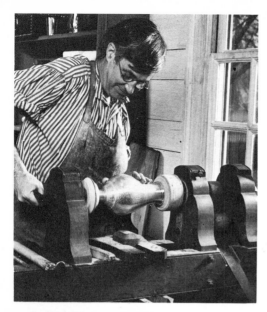

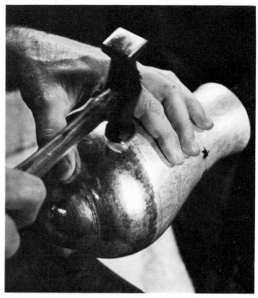

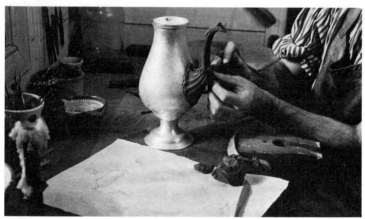

5 *Far left:* The body is turned on a lathe to check that it is absolutely true.

6 *Above:* The body is carefully planished until all the uneven areas are flattened out.

7 *Left:* The spout is first fashioned in modelling clay to make sure the proportions are correct.

8 The journeyman prepares the sand casting-blocks; the spout is cast in two halves.

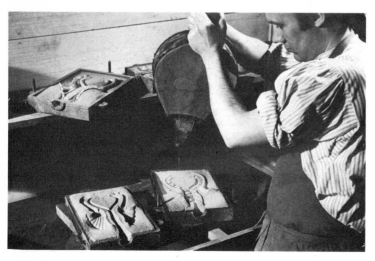

foot and the finial for the lid. The master may have casting patterns, but if not he must model the spout and other parts in wood, plaster or modelling wax. The spout is the most difficult, and while carving it, the master frequently holds it against the pot to ensure that the proportions are right. The model of the piece to be cast is pressed into a type of sand held in an iron box which is made in two parts. When the model has been pressed halfway into the sand in the lower half, the whole is dusted over with charcoal or some similar substance to ensure that the two halves of the sand-filled box will separate easily. The top half of the model is pressed into the sand in the upper part of the box. The two parts are pressed together, then separated and the model removed, leaving a perfect mould in the sand, which dries hard. The mould is then held firmly together while the molten silver is poured in and time is allowed for it to cool and set.

The cast pieces are finally fixed to the pot with solder, a tricky operation that demands meticulous neatness. Probably the foot is soldered first. It is clamped to the body with silver wire, then small pieces of silver alloyed with brass (nowadays zinc, which gives a harder solder) are placed around the join. The goldsmith takes a long thin pipe which he uses to blow a flame from a charcoal lamp directly at the solder, which melts and flows around the join. After it has cooled and hardened, the two parts of the pot should be firmly attached. Any superfluous pieces of solder beneath the foot are polished off on a lathe.

The spout is made in two halves which must first be soldered together. A hole is then cut in the body of the pot where the spout is to be soldered in place or, if a strainer is required, a

9 Soldering, with a charcoal brazier and blowpipe.

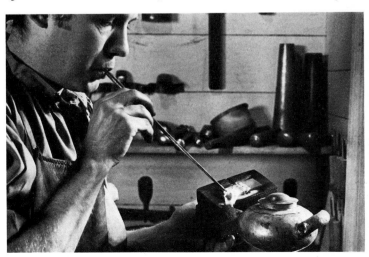

group of small holes are made with a bow drill. The lid will be attached to the body by a hinge, made from tubular silver, which is soldered on along with the sockets for the handle. The handle itself is not, of course, made of silver, which would be too hot to hold, but usually of wood. The goldsmith probably buys a ready-made fruitwood handle from a turner or a handle-maker. It is held in the sockets by two silver pins.

Assuming that the pot is a plain one, with no extra ornamental work to be done, it is now complete, though in a rough unpolished state, and ready to be assayed, or tested, to ensure that it is of sterling standard. The goldsmith first puts his maker's punch mark on it. The fineness of the silver content is strictly his responsibility, and he would place his mark on the piece even if it were some small item made entirely by his journeyman.

At the assay office, minute scrapings of silver are taken from each part of the pot, and analysed to ensure that the entire pot is made of sterling standard silver; there are several, comparatively simple ways of making a chemical test. If the silver comes up to standard, it is 'touched' with the hall marks of the assay office and returned to the goldsmith. All silver was and is supposed to be assayed but occasionally, perhaps for no more important reason than the customer's eagerness to have the article quickly, this legal obligation was neglected. The absence of hall marks does not necessarily mean that silver is not of sterling standard.

The coffee pot was sent to the assay office unpolished, and the finishing touches are made after its return to the workshop. Probably the apprentices undertake the job, as for the most part it does not demand special skill, unless, for instance, there is some chasing to be done on the spout, to smooth out possible irregularities in casting. There are three stages in polishing, using successively finer abrasives. To get rid of substantial scratches, file marks or 'firestains' (caused by oxidisation of the copper alloy during annealing) and to remove the marks of planishing, ground pumice mixed with oil is used, probably on a wheel. This first stage may be unnecessary if the planishing has been done very expertly, and in that case Tripoli powder or Trent sand, less abrasive than pumice, will be sufficient, followed by the third stage, jeweller's rouge rubbed in by hand (some goldsmiths use the inside of their forearm). The coffee pot is at last finished and ready to be delivered to the person who commissioned it.

There are other ways of making a vessel similar to that described above. Seaming, for example, is an easier and more

rapid way. In this method, a sheet of silver is bent around to form an open-ended cylinder, and the two edges are soldered together. The cylinder is then hammered into the required shape over the raising stake, and a disc of silver is soldered to the bottom end.

Another method quite common today, though it was also used in ancient Egypt, is spinning. A flat sheet of silver is rotated on a lathe and worked into shape on a pre-formed chuck made of hard wood. The spinner applies pressure with a steel-headed tool with a long handle which he steadies under his arm.

A very important tool in the goldsmith's shop is the wire drawer. This is a long wooden rack-like device to draw silver wire into various thicknesses, which has been in use in England since the sixteenth century at least. A rod of silver, tapered at one end so that it can be drawn more easily, is drawn through holes of diminishing size, making it progressively thinner. Silver wire can be drawn so fine that it can be manipulated like thread for decorative work and for strengthening the rims of vessels. The wire must be annealed several times in the course of the work as drawing, like hammering, makes the silver hard and brittle.

The process of making a coffee pot outlined above does not include any ornamental work. Some people prefer their silver plain, relying for its effect on shape and surface, but in most periods silver has received some form of decoration. There are a variety of different ways in which silver can be decorated, but basically they all fall into one of three groups: applied decoration, made separately; embossed decoration, in which the metal is hammered, punched or otherwise manipulated, and engraved decoration, in which it is cut or incised. The main types and techniques involved in the decoration of English silver are best described in an alphabetical list.

10 Acanthus

Acanthus A classical motif representing the prickly leaves of the acanthus plant, used in a formalised way in the capitals of Corinthian columns in Greek architecture, and common in silver, both embossed and applied.

Amorini Putti or cherubs, a common decorative motif in the Baroque period.

Anthemion A stylised classical motif based on the honeysuckle flower; found on silver of the Adam period usually as part of a decorative band. A single anthemion is sometimes to be seen under the spouts of jugs.

11 Anthemion

Applied Ornamental wire, mouldings or cast pieces which were made separately from the main body of the article and soldered on are said to be 'applied'. Applied ornament is sometimes purely decorative but may also serve to strengthen the body of the piece.

Arabesque Engraved ornament of intertwined foliage, found most frequently in the late sixteenth and early seventeenth centuries, and in pierced work of the eighteenth century.

Baluster An elongated pear shape of varying breadth, like a banister (baluster) in a staircase, sometimes incorporating an inverted acorn. Wine cups frequently had baluster stems in the late sixteenth century, and most eighteenth-century candlesticks are in one of many possible baluster forms. This type of stem was generally made by soldering two castings together, thus ensuring perfect symmetry. It is generally possible to see the solder line running along either side of the stem.

Beading A cast wire shaped like a string of small beads, usually found as a decorative addition on the borders of salvers, tea sets and sauceboats from about 1760 to about 1820, though also occurring in the late nineteenth century.

12 *Above:* Arabesque

13 *Left:* Beading

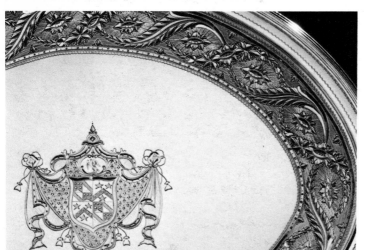

14 Bright-cut engraving

15 Chasing

Bombé A swelling, bulbous, kettle-like form in a vessel such as a soup tureen.

Bright-cut engraving A visually striking form of engraving used in the late eighteenth and early nineteenth centuries. Instead of incising lines in the silver, the engraving tool gouges out cleanly and flicks away tiny particles, leaving a jewel-like faceted line which catches the light brilliantly.

Burnishing Polishing with a hard smooth stone or, nowadays, steel.

Cartouche A device containing the owner's initials, coat of arms, etc., engraved, chased or cast; it often formed an important part of the overall design in the early eighteenth century, incorporating shells, masks and foliage.

Caryatid A female figure used as a column in classical architecture, sometimes adopted for the handles of porringers.

Castwork Decorative or functional elements made in a mould and soldered on to the vessel.

Chasing Decoration in relief made with a hammer and a multitude of punches of different shapes. The metal is raised or pushed in to form patterns of, chiefly, flowers, foliage or figures. Chasing has been done through the centuries, enjoying periods of great popularity and periods of almost complete disuse. The sixteenth and early seventeenth centuries used it extensively, but from about 1610 to 1640 or 1650 it was much less popular and though still done it was far less robust and exuberant. In the second half of the seventeenth century embossed chasing became again very fashionable, but from 1690 to 1740 it was scarcely used at all. In vogue during the Rococo period, it was used in a more limited way in the Adam style, though the Rococo revival of the nineteenth century adopted it once more. See also *Flat chasing.*

Chinoiserie Pseudo-Chinese designs, fashionable in flat-chased form in the 1680s, chased form in the mid-eighteenth century and applied form in the early nineteenth century.

Coats of arms Heraldic engraving on plate is a study of which anyone who is seriously interested in collecting English silver should have at least rudimentary knowledge. From the type of shield and the style of its surrounding cartouche, the date of an engraving can be determined to within a few years, which is a great help in dating a piece of silver that has no marks, or a maker's mark only, and a greater knowledge may reveal the

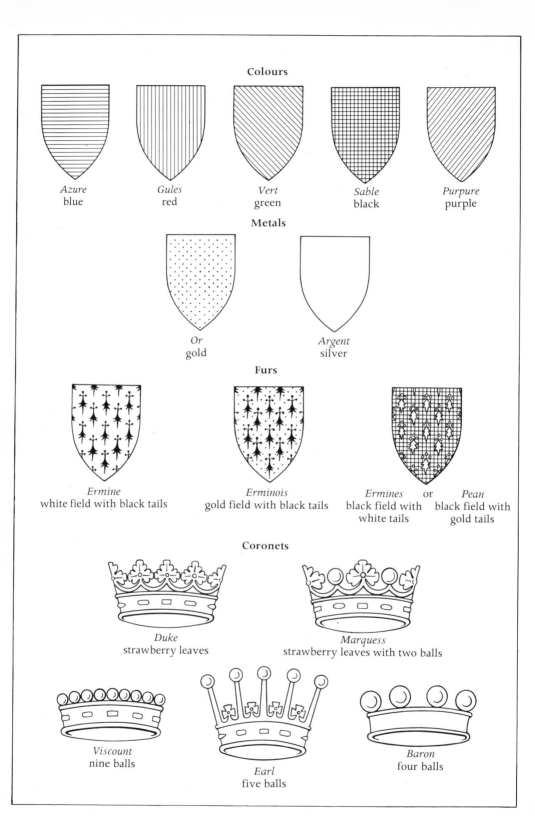

Colours

Azure blue

Gules red

Vert green

Sable black

Purpure purple

Metals

Or gold

Argent silver

Furs

Ermine white field with black tails

Erminois gold field with black tails

Ermines black field with white tails or *Pean* black field with gold tails

Coronets

Duke strawberry leaves

Marquess strawberry leaves with two balls

Viscount nine balls

Earl five balls

Baron four balls

16 Heraldry: *c.* 1680

17 Heraldry: *c.* 1730

18 Cut-card work

original owner of the piece. Altogether, a genuine interest in heraldry will be found to add a fascinating new dimension to the collecting of English silver. This is not the place to attempt even the briefest explanation of the highly complex subject of heraldry, which has a language all its own, but one common mistake should be pointed out. A coat or shield of arms is not the same as a family crest, in spite of the belief of numerous people to the contrary. The crest, originally worn on the helmet, can belong to many unrelated families. A coat of arms may do so also, but much less frequently, while a full achievement of arms – crest, coat, supporters, motto and so on – ought, in theory anyway, to be attributable to one family alone.

C-scroll A term chiefly applied to the handles of cups and other vessels formed roughly in the shape of a C.

Cut-card work A simple but very attractive form of applied decoration found in very basic form as early as 1640 but more characteristic of the period from 1660 to 1710. It consists of sheet silver cut in foliate, trefoil or fleur-de-lys designs and soldered on to the main body of the piece. It occurs most often as a calyx for a bowl or as a border. It was also used, mainly in the first decade of the eighteenth century, as a decorative feature around joints, such as the emerging handles of coffee pots, and in that position served the additional purpose of strengthening the joint.

Diaperwork Engraved or flat-chased patterns resembling a trellis or lozenge-shaped network.

Egg and dart Ornament used for mouldings, usually stamped, found in the sixteenth century. It consists of a series of ovolos (eggs) alternating with spear-like forms (darts).

Egg and tongue Similar to egg and dart, and found in the same period; the ovolos are interspersed with a small tongue-like motif.

Embossing Strictly speaking, the form of chasing in which the metal is hammered and worked from the inside surface, pushing it outward, but frequently used in a more general sense. See *Chasing*; *Repoussé*.

Engraving A form of decoration which consists of lines cut in the surface of the metal, in reality a whole art form in itself. The engraver of silver cuts into the surface and actually removes the metal with a graver, or burrin, in a series of lines, some deep

19 Flat chasing

20 Gadrooning

and some shallow to form shading and give a three-dimensional effect. Engraving was the method for inscribing names and coats of arms, but was also used for purely decorative work, particularly in the staggering pictorial engraving found on a small group of sixteenth-century silver and that done in the late seventeenth and early eighteenth centuries by Gribelin or Hogarth. Engraving is probably the most important aspect of silver which was not done by the goldsmith himself. It was a separate skill, and the work would be sent out to an artist-engraver. See also *Bright-cut engraving*; *Coats of arms.*

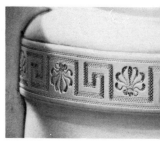
21 Greek key

Etching A technique similar to engraving except that the metal is bitten out by acid instead of being cut with a graver; very rare in English silver, though used occasionally in the sixteenth century.

Feather edge Chased slanting lines, as seen on the edges of some spoon handles.

22 Guilloche

Festoon A garland of fruit or flowers suspended at either end, which is found engraved or, more often, chased or stamped. It was used as a decorative device in the sixteenth century and the second half of the eighteenth century.

Flat chasing Decoration in low relief which, like chasing, *moves* the silver rather than *removing* it. When done extremely finely it can look like engraving. A quick test is to look at the back: if the imprint of the decoration is visible, the piece has been flat chased; if not, it is engraved.

Fluting A pattern of concave chased channels running parallel, adopted from the fluted column of classical architecture.

Gadrooning Similar to beading except the 'beads' are roughly oval in form rather than circular; frequently found after about 1690 on the borders of plates and dishes, salt cellars and sauceboats.

Greek key An ornamental band of geometric, repetitive pattern made up of a series of right angles, popular chiefly from about 1780 to 1810.

Guilloche Moulded border ornament of two interlacing bands enclosing a quatrefoil or rosette at tightly spaced intervals; found throughout the eighteenth century but perhaps more used by the Huguenots before about 1750.

Knop A bulb-shaped projection in the stem of a candlestick, goblet, etc.; also, the finial of a cup or spoon.

Matting A form of ornament made by striking the silver many times with a hollow tubular punch, to give a dull, rough surface; it was frequently used as a background for some ornamental motif, giving it more of a three-dimensional effect, but in the seventeenth century it was often used as a decorative element on its own.

Ogee An S-shaped curve made by alternate concave and convex surfaces.

Ovolo A convex oval or egg-shaped ornament, chiefly used repetitively in a border in the sixteenth century and occasionally in later periods.

Parcel-gilt Partly gilded.

Patera A circular ribbed motif usually encircling a flower head.

Piercing Fretwork decoration, the silver being cut out by saw (since the eighteenth century) or by chisel in a pattern of some kind. On the top of a caster it served a practical purpose; in a cake basket, for example, it is purely decorative. Pierced work is sometimes found as applied decoration.

Pricking Engraving made with a needle point, used mainly for inscriptions, coats of arms, etc.

Pouncing A stippled effect made by lightly pricking the metal, a decorative detail used mainly in the late seventeenth century.

Punched A term sometimes given to the rather primitive embossed decoration, usually of simple floral designs, on some seventeenth-century silver.

Reeding Engraved or moulded ornament usually found on the rims or edges of objects, consisting of parallel lines dividing convex forms.

Repoussé Decoration in high relief made by beating out the metal from the back, the richest form of ornament, especially fashionable in the mid-seventeenth century. It was often combined with surface chasing.

Ropework Ornamental borders or girdles suggesting a rope, frequently found both embossed and applied.

Scalework A pattern of fish scales, engraved or flat chased, found on silver between about 1735 and 1765.

Silver-gilt Silver with a thin surface coating of gold. The traditional method, most injurious to health, was to paint the surface with a gold-mercury amalgam, then apply heat to drive off the mercury and fuse the gold.

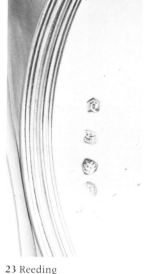

23 Reeding

Stamping or die stamping Relief ornament made by hammering the metal into an intaglio-cut die, used in the sixteenth century for borders and, very extensively, in Sheffield in the late eighteenth century for making candlesticks and other items. Die-struck candlesticks, if unworn, can look fine, though they sometimes have a stiff and mechanical appearance.

Strapwork A pattern of interlacing strap-like bands which, as used by the Huguenots in the early eighteenth century, was cast and applied; it occurred in earlier times engraved or repoussé.

Volute A scroll form as seen on an Ionic capital.

Wrigglework Engraved wavy lines.

24 Ropework

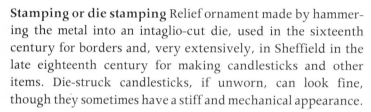

25 Wrigglework

Chapter 2

Hall marks

As a general rule, most silver and gold objects bear four small, punched symbols or marks. They are often called hall marks– though, strictly speaking, the maker's mark is not a 'hall' mark, the marks struck by the assay office which confirm where the silver was assayed. They include, besides the maker's mark made by the goldsmith before the ware was submitted to the assay office, a date letter, made by the assay office signifying the year in which the article was made and the sterling mark, the familiar lion passant. There are, naturally, various exceptions (some of the main ones are described below), and occasionally pieces of English silver may be found with no marks at all.

Hall marking in England was instituted by statute as long ago as 1300 and has continued to this day, a remarkable and invaluable record and not the least of the reasons why English silver is of such great interest to collectors worldwide. All gold and silver articles were to be assayed to ensure that people were not defrauded through buying metal of lower quality than the sterling standard, which was fixed at 11 ounces 2 pennyweights of silver to 18 pennyweights of alloy in Troy weight. The origin of the word sterling is a mystery, but the most likely explanation is that it derives from the 'Easterlings', German coin makers brought to England by Henry II (1154-89) to improve the quality of the coinage. At the same time as the sterling standard for silver, a standard for gold was introduced at $19\frac{1}{5}$ parts gold to $4\frac{4}{5}$ parts alloy. The 'parts' are usually expressed in carats: a carat, in reference to gold, is not a strict expression of weight as it is when referring to diamonds, but simply a unit representing one twenty-fourth of the whole. In 1477 the standard for gold was reduced to 18 carats (i.e. 18 parts gold to 6 parts alloy), but in 1575 it was raised to 22 carats. In 1798 two standards were permitted, 22 carats and 18 carats, and in 1854 three lower categories were added, 15 carats, 12 carats and 9 carats. Thus, when buying a gold ring for example, there will be a considerable difference in price between 9-carat gold and 22-carat gold.

The first hall mark to be used in England was a leopard's head, which became associated with London though it was used elsewhere as a standard mark. In the most unlikely event of finding a piece of silver made in England in the early fourteenth century, the leopard's head will be the only mark, but from 1363 the maker of the piece was required to stamp it with his own mark, which had to be first registered at Goldsmiths' Hall. A third mark was instituted in 1478, a letter of the alphabet which was changed annually and thus revealed the year in which the article was made. The purpose of the date letter was obviously not to make life easier for twentieth-century silver dealers and collectors. It was simply a means of checking on the identity of the assay master. Thus, if a piece of silver which had been correctly hall-marked was later found to be sub-standard, the warden of the Goldsmiths' Company would know by the date letter who had been assay master when it was assayed. The date letter was changed on St Dunstan's Day, 19 May, every year (St Dunstan is the patron saint of the Goldsmiths' Company). After 1660 the day was changed to 29 May, to commemorate Charles II's Restoration.

The fourth mark, the sterling mark of a lion passant, was added in 1544. There is some uncertainty over exactly why or even when the sterling mark was introduced, but the generally accepted explanation is that it was meant to reassure the public that, at a time when the coinage had been seriously debased in order to replenish the depleted treasury of Henry VIII, assayed silver still adhered to the sterling standard.

Coins nowadays are merely symbols, but in those days their value depended on the precious-metal content, and this fact had repercussions for the goldsmiths on more than one occasion. In the Civil War period, much silver was melted to be turned into bullion, or cash, and after the Restoration, when plate became so fashionable and the demand for silver far outstripped supply, the reverse process occurred. Coins were melted, or their edges were clipped, to be made into plate, with the result that they became desperately scarce. To combat the destruction of existing coins, the government in 1697 intro-duced a new, higher standard for plate of 11 ounces 10 pennyweights, or 958 parts per thousand. At the same time, a new system of marks was created.

The maker's mark had previously been some kind of symbol or device or, more recently, the initials of the goldsmith – the first letter of his first name and the first letter of his surname. The act of 1697 compelled him to make a new punch with the first two letters of his surname. For example, had there been a

goldsmith called Brand Inglis active at the time, his old mark would have been BI and his new mark IN.

A new cycle of date letters was begun in 1697, beginning with the letter A. It came into effect on 27 March, so the A mark lasted only about two months, being changed on 29 May to B, which ran for a year to be followed by C, and so on. Thus, for those who wish to memorise London date letters—different systems prevailed in provincial centres—the cycles of twenty letters (A to U omitting J) begin in '58, '78, etc. until 1678, and thereafter in '96, '16, etc., with the exception of the short-lived A of 1697. The complete series, until 1896-7, is illustrated in the tables at the end of this chapter.

The other two new-standard marks were a lion's head erased for the London mark and a figure of Britannia instead of the old sterling mark of a lion passant. The new standard is generally called the Britannia standard, after the Britannia mark.

In 1720 the obligatory use of Britannia-standard silver was abolished, though some articles continued to be made in the higher standard and still are today. Their marks remained the same, while sterling-standard silver, to which most goldsmiths returned with relief, reassumed the old marks of a leopard's head crowned (London) and a lion passant.

A great deal of antique silver is found with an additional mark—the head of the reigning sovereign at the time the piece was made, shown in profile. The purpose of the sovereign's-head mark was to show that the duty on silver had been paid. The duty was first imposed in 1719, though the sovereign's-head mark was not adopted until 1784. When the duty on silver was lifted in 1890, the sovereign's head disappeared, though it has occasionally been used since for special occasions such as the coronation of Elizabeth II.

Thanks to the records which have been kept safely by the Goldsmiths' Company—there are remarkably few gaps, all things considered—the history of hall marks in London is very well established. The situation is rather different in the provinces. Many towns had authorised assay offices at one time or another, some for a comparatively short period, and most of them used their own town marks. But some marks are found from towns which appear to have been unauthorised, and there is altogether more inconsistency and confusion outside the capital. Today, the only authorised assay offices outside London are Edinburgh, Birmingham and Sheffield; the latter two achieved their status as recently as 1773. The following tables, necessarily incomplete, should provide some guidance to provincial silver centres.

		TOWN MARK	STAN-DARD	DATE LETTER	DUTY HEAD	COMMENTS
London 20-letter cycle, A-U, exc. J	1558-9					
	1578-9	,,	,,			
	1598-9	,,	,,			
	1618-9	,,	,,			
	1638-9	,,	,,			
	1658-9	,,	,,			
	1678-9	,,	,,			cycle ends with T
	1697-8					lion head erased replaces crowned leopard Britannia standard replaces sterling
	1716-7	,,	,,			former town mark and sterling standard reinstated 1719-20
	1736-7					date-shield style alters for D onwards, although straightsided D also appears
	1756-7	,,	,,			
	1776-7	,,	,,			duty mark of George III introduced 1784-5 new duty mark of George III appears 1786-7
	1796-7	,,	,,		,,	
	1816-7	,,	,,			leopard uncrowned from 1821-2 duty mark of George IV appears 1820-1 duty mark William IV appears 1831-2
	1836-7		,,			duty mark of Victoria appears 1837-8
	1856-7	,,	,,		,,	
	1876-7	,,	,,		,,	data-shield style alters for B onwards duty mark dropped 1890-1
	1896-7	,,	,,			
York 24- or 25- letter cycle, exc. J and (1787-1837) U	1559-60					
	1583-4	,,				
	1607-8	,,				
	1631-2	,,				
	1655-6	,,				
	1679-80	,,				date-shield style varies assay office closed 1696
	1700-1					new town mark introduced on re-opening Britannia standard in operation date-shield and letter style varies office closed 1716
	1776-7					sterling standard in operation no date letter before D known duty mark of George III introduced 1784-5

		TOWN MARK	STANDARD	DATE LETTER	DUTY HEAD	COMMENTS
continued	1787-8			A		date-shield style varies new duty mark of George III appears 1787-8
	1812-3	,,	,,	A	,,	date-shield style varies
	1837-8	,,	,,	A		duty mark of Victoria appears 1840-1 office closed 1856
Norwich 20-letter cycle, A-V exc. J and U	1565-6			A		date-letter system breaks down c. 1574-5
	1624-5			A		
	1688	,, ,,		A		dissolution of provincial offices 1696-7
Exeter 24-letter cycle, exc. J and U, until 1797-8; thereafter 20-letter cycle, A-U, exc. J	1571-1698					various crowned X's in use several possible early attempts at date-letter system
	1701-2			A		Britannia standard in operation sterling standard reinstated 1721-2 date-shield style varies
	1725-6	,,		A		
	1749-50	,,	,,	A		
	1773-4	,,	,,	A		leopard head dropped 1788-9 I used for two years duty mark of George III introduced 1784-5 new duty mark of George III appears 1786-7
	1797-8	,,		A	,,	
	1817-8	,,	,,	A		duty mark of George IV appears 1822-3 duty mark of William IV appears 1834-5
	1837-8	,,	,,	A		duty mark of Victoria appears 1838-9
	1857-8	,,	,,	A	,,	
	1877-8	,,	,,	A	,,	office closed 1883
Newcastle 19-letter cycle, A-T, exc. J, until 1740-1; thereafter 24-letter cycle, exc. J and U	1658-1701					new town mark appears 1680 no standardised date-letter system
	1702-3			A		Britannia standard in operation irregular use of date-letter system
	1721-2	,,		A		shield of town mark alters 1722-3 sterling standard reinstated 1721-2
	1740-1		,,	A		date-shield style varies
	1759-60	,,	,,	A		B used for 8 years date-letter style alters 1773-4 duty mark of George III introduced 1784-5 new duty mark of George III appears 1786-7
	1791-2	,,	,,	A	,,	
	1815-6	,,	,,	A		duty mark of George IV appears 1820-1 duty mark of William IV appears 1832-3

		TOWN MARK	STAN-DARD	DATE LETTER	DUTY HEAD	COMMENTS
continued	1839-40	⛨	🦁👑	A	👤	25-letter cycle, J being excluded
	1864-5	,,	,,	a	,,	office closed 1884
Birmingham alternative 26- and 25-letter cycles, exc. J	1773-4	⚓	🦁	A	👤👤	duty mark of George III introduced 1784-5 new duty mark of George III appears 1786-7
	1798-9	,,	,,	a	,,	
	1824-5	,,	,,	A	👤	duty mark of Victoria appears 1838-9
	1849-50	,,	,,	A	S date-shield style alters for S onwards	
	1875-6	,,	,,	a	U date-shield style alters for U onwards duty mark dropped 1890-1	
Chester 25-letter cycle, exc. J, until 1751-2, thereafter 20- or 21-letter cycle, A-U/V, exc. J	1668-1700	🛡				occasional use of town mark some abortive attempts at date-letter system
	1701-2	🛡	🦁👑	A		🦁👑 sterling standard reinstated 1719-20
	1726-7	,,	🦁👑	A		
	1751-2	,,	,,	a		date-shield style varies
	1776-7	,,	,,	a	👤👤	new town mark 1779-80 duty mark of George III introduced 1784-5 🛡 new duty mark of George III appears 1786-7
	1797-8	🛡	,,	A	,,	
	1818-9	,,	,,	A	👤👤	duty mark of George IV appears 1823-4 duty mark of William IV appears 1835-6 leopard head dropped 1839-40
	1839-40	,,	🦁	A	👤	25-letter cycle, excluding J duty mark of Victoria appears 1839-40
	1864-5	,,	,,	A	,,	
	1884-5	,,	,,	A	,,	duty mark dropped 1890-1 cycle ends with R in 1900-1
Sheffield 25-letter cycle, exc. J	1773-4	👑	🦁		👤👤	date letters used in no regular order duty mark of George III introduced 1784-5 new duty mark of George III appears 1786-7
	1799-1800	,,	,,		,,	irregular order of date letters
	1824-5	,,	,,	a	👤👤👤	some date-letters accompanied by crown I, J, N, O, W, Y not used duty mark of George IV in operation duty mark of William IV appears 1831-2 duty mark of Victoria appears 1840-1
	1844-5	,,	,,	A	,,	
	1868-9	,,	,,	A	,,	duty mark dropped 1890-1
	1893-4	,,	,,	a		
Edinburgh 25-letter cycle, exc. J	1552-1613	🏰				appropriate deacon's mark also used

		TOWN MARK	STAN-DARD	DATE LETTER	DUTY HEAD	COMMENTS
continued	1617-77	🏰				appropriate deacon's mark also used
	1681-2	,,		𝖆		assay masters' marks appear after town mark date-shield style varies no U in cycle
	1705-6	,,		A		assay masters' marks date-shield style varies
	1730-1	,,		A		assay masters' marks
	1755-6	,,		A		thistle replaces assay master's mark 1759-60
	1780-1	,,	⬟	A		G used for two years date-shield style alters for I/J onwards duty mark of George III introduced 1784-5 new duty mark of George III appears 1786-7
	1806-7	,,	,,	a		26-letter cycle duty mark of George IV appears 1823-4
	1832-3	,,	,,	A		duty mark of William IV appears 1832-3 duty mark of Victoria appears 1841-2
	1857-8	,,	,,	A	,,	date-shield style alters for I onwards
	1882-3	,,	,,	𝖆	,,	duty mark dropped 1890-1
Glasgow 25-letter cycle, exc. J; 26-letter cycle from 1819-20	1706-1800	🦅	S O			town mark varies in detail, though generally within an oval S or O possibly represent 'sterling or 'old standard' date-letter system breaks down
	1819-20	🦁	🦁	A		town mark on rectangular shield duty mark of George III in operation duty mark of William IV appears 1832-3
	1845-6	,,	,,	A		duty mark of Victoria appears 1845-6
	1871-2	,,	,,	A	,,	duty mark dropped 1890-1
	1897-8	,,	,,	A		
Dublin 19- or 20-letter cycle, A-U, exc. I/I and J; from 1678-9, 24-letter cycle, exc. J and V; from 1821, 25-letter cycle, exc. I/J	1638-9	🛡		A		date-shield style varies
	1658-9	,,		a		
	1678-9	,,		R		certain letters used for 2-4 years
	1717-8	,,		B		date-shield style varies
	1720-1	,,		A		figure of Hibernia appears 1731-2 L used for 2 years
	1747	,,	🧍	A		
	1773	,,	,,	A		pellet at base of D to M
	1797	,,	,,	A		date-shield style alters from N onwards, although straight sided N also appears duty mark of George III introduced 1807
	1821	,,	,,	A		date-shield style varies duty mark of George IV appears 1822 duty mark of William IV appears 1831-2 duty mark of Victoria appears 1838-9
	1846-7	,,	,,	a	,,	date-shield style varies
	1871-2	,,	,,	A	,,	date-shield style alters from K onwards duty mark dropped 1890-1
	1896-7	,,	,,	A		

Chapter 3

Changing styles in British silver 1500-1900

Decorative art in the West has always tended to follow current styles in architecture and the fine arts, and style in silver therefore reflects the rules and conventions of the period in which a particular article was made. Other forces, economic pressures for example, may also have some influence in determining style. The present age is a good example, for the plain forms and straight lines of contemporary design probably owe something to the high cost of labour as well as to purely aesthetic ideas. However, styles change as surely as the seasons, and over the centuries style in the decorative arts appears to swing like a pendulum from the plain and austere on one hand to the rich and fanciful on the other. The simple and severe forms of the present have been with us for half a century, but sooner or later the pendulum will begin to swing back (if it has not already started), and designs more ornate or more fanciful will return.

Besides the changes in style which are more or less common to all the decorative arts, and the effects of economic circumstances, such as high labour costs in our period or a scarcity of raw material in an earlier one, social customs also have some effect. This is not so much a matter of style as of the *type* of object made in a particular period. One generation regards as unnecessary what a previous generation found utterly indispensable, while habits that are perfectly tolerable in one period appear vulgar and tasteless in another. In the early eighteenth century, for example, it was quite normal to keep a chamber pot in the dining room in case anyone wished to relieve himself during the meal, but by the end of the century such behaviour had ceased to be respectable and the chamber pot was banished. That is why silver chamber pots dating from the early eighteenth century are far from rare today although there is hardly a single example of one made later than about 1750. Similarly, the new custom of tea and coffee drinking dramatically increased the repertoire of the goldsmith in the eighteenth century, more than compensating for the earlier loss of the rosewater ewer and dish, a common item of plate in the

sixteenth century which all but disappeared when it ceased to be necessary to wash one's hands at frequent intervals during the course of a meal.

Historically, goldsmiths in general and English goldsmiths in particular have not been great innovators in design. As a rule they copied the creations of artists, most of whom were interested in design exclusively and never actually made any of the objects which they designed and published in books of engravings. Such designs were made for all manner of objects, besides silver and gold, and the pattern books were bought or borrowed by the craftsmen who executed the designs.

Tudor and Jacobean silver

English goldsmiths usually looked across the Channel for inspiration. During the sixteenth century they were almost totally under the influence of Germany, so much so that it is sometimes difficult to tell whether a particular piece was made in England or imported from Augsburg or Nuremberg and subsequently marked in London at Goldsmiths' Hall (so that it could be legally sold). A clue may sometimes be provided by the quality of the piece, for undeniably the goldsmith of the south German cities was a finer exponent of his craft than his English contemporary. The general standard of workmanship, especially repoussé work and flat chasing, was much higher in Germany, and although English engraving was frequently of the very finest quality, the English goldsmiths, unfortunately,

26 *Below:* Font cup and cover, made in London, 1503. A particularly fine and simple form of cup, it has a finial enamelled with the arms of John Cressener of Hinckford Hundred, in Essex. Height 6½ in. The Worshipful Company of Goldsmiths, London.

27 *Right:* Rosewater basin, made in London, 1556. Incorporating extremely delicate engraving as well as bold chased work, the piece is parcel-gilt and has very great strength. The raised central boss is enamelled with the arms of Legh of Lyme in Cheshire. Diameter 17½ in. The Worshipful Company of Goldsmiths, London.

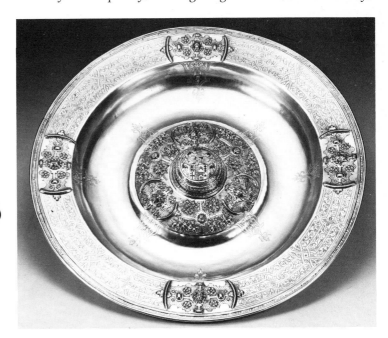

cannot take the credit, because what seems to have happened as a rule when engraving was required was that the unfinished article was given to an artist-engraver to complete. It is often difficult in any period to decide how much of a finely engraved silver object is actually the work of the goldsmith who fashioned it, and in the sixteenth century this problem is particularly acute.

The sixteenth century, as everyone knows, was a time of great upheaval and readjustment, both spiritual and temporal. The dissolution of the monasteries under Henry VIII had a catastrophic effect on goldsmiths because the monks had been among their greatest patrons, but the rising affluence of the gentry – due partly to their acquisition of monastic property – and to some extent of the merchant classes also, brought reasonably swift compensation. There is no point in being rich if one cannot demonstrate the fact, and affluence, especially when recently acquired, creates a natural desire for ostentation. In Tudor England it was expressed in fine houses and furnishings, in which the family plate figured large. For in spite of religious and political upheavals, the England of the sixteenth century was strong, bold (not to say brash) and assertive. Fortunes and reputations could be made in a generation or less, and there were no guilt-ridden protestations of egalitarianism to spoil the enjoyment of earthly riches. Renaissance optimism was reflected in architecture, from the brilliant and daring fan vaulting of Henry VII's chapel in Westminster Abbey at the beginning of the century to the proud magnificence of a country house like Hardwick Hall, in Derbyshire, at the end. On a smaller scale, the silver of the period equally proclaims the prosperity and ambition of its original owners. Some of it, judged by absolute standards, is perhaps not very distinguished either in general form or in its decoration, but that does not detract from its general vitality. Moreover, we should be wary of judging the whole output of the century by what happens to survive till today. A glance through an inventory of the jewels and plate of Queen Elizabeth I demonstrates with breathtaking impact how little we know at first hand of the true magnificence of the finest gold and silver of that time.

The Renaissance sprang largely from the reading and dissemination of the works of classical authors and, consequently, classical influences were predominant in art and design. English silver of the sixteenth century is to a large extent neo-classical in conception. Its frequent allusions to the classics and classical mythology, breaking away from the more

28 Standing salt and cover, silver-gilt, made in London, 1542. The cover is surmounted with a figure of the boy Hercules. Height 10 in. The Worshipful Company of Goldsmiths, London.

constraining hierarchical configuration of the Middle Ages, are another manifestation of contemporary feelings of prosperity and optimism.

Flatware – that is cutlery, spoons especially – is described in the following chapter. What else remains of the variety of objects made in silver in sixteenth-century England?

Perhaps the most distinctive articles of the period are the rosewater ewer and dish. These were essential adjuncts to the dining table in medieval and Tudor times to wash off the sticky traces of food that clung to the fingers. The fork was not unknown in Elizabethan England – the Queen herself was presented with some fine gold ones – but it was generally regarded as an article fit only for effete foreigners. In fact the prejudice against forks lasted a remarkably long time; not until the end of the seventeenth century did they become at all common. Attendants therefore circulated among the diners with a water jug, or ewer, a dish and a towel. The dish is invariably circular, the rim engraved with arabesques or flat chased with a formal pattern of interlacing strapwork enclosing paterae, sea creatures or classical heads. Surviving examples of these dishes of early date have comparatively plain bowls, with a central boss on which the ewer rested when not in use. As the century went on, there was a tendency towards more elaborate embossing of the bowl, frequently with a bravura design of tritons and sea monsters, or quasi-classical triumphant processions. In general ewers followed the same decorative pattern; early sixteenth-century examples are of a somewhat ill-formed beaker shape, while later ones take on a more elegant vase form. Decoration relies chiefly on flat chasing, embossing and engraving, and there is little use of cast ornament.

In the sixteenth century, the standing salt was still as important a piece of plate as it had been in the Middle Ages, and examples from the early years of the century remain distinctly Gothic in appearance. They are generally shaped like an hour glass and frequently display the spiral fluting that was so favoured a form of decoration in the late fifteenth century. There is usually a central band or girdle ornamented with applied crockets, a device taken directly from Gothic architecture. Indeed, the total effect of these early sixteenth-century salts is decidedly architectural.

In the Elizabethan salt, neo-classicism takes over. The repoussé ornament is of swags of fruit, lion masks, classical heads and sometimes whole scenes from classical mythology. There is an excellent example of a salt of this type which

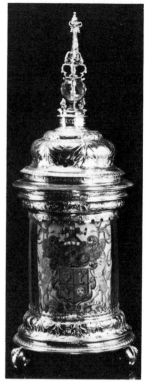

29 *Left:* The Gibbon Salt, 1576. Height 11¾ in. The Worshipful Company of Goldsmiths, London.

30 *Above:* The Rogers Salt, rock crystal mounted in silver-gilt, made in London, 1601. Inside the rock crystal is a vellum scroll painted with the arms of the Goldsmiths' Company. The Worshipful Company of Goldsmiths, London.

belongs to the Vintners' Company of London. It is square and straight-sided in outline and rests on four mask feet, with a typical guilloche border at the base. Each side is embossed in low relief with the cardinal virtues in neo-classical style, the virtues being personified by female figures in Roman dress with classical coiffure. The lid supports an urn with a finial in the form of a male warrior. The piece was made in 1569 and may be regarded as a typical salt of the period. Others are circular, rather than square, in section but otherwise similar.

One of the most beautiful Elizabethan salts is the Gibbon Salt which was presented to the Worshipful Company of Goldsmiths in 1632 and has remained in their possession to this day. This exquisite object stands almost twelve inches high and is architectural in concept, representing in perfect proportions a little classical temple, with four Ionic columns enclosing a figure encased in rock crystal. The lid supports a delicately proportioned classical urn finial. Made in London in 1576, the Gibbon Salt is highly unusual both in the advanced understanding of technique that it displays and in the flair and ingenuity of its original design (Plate 29).

A new type of salt appeared in the 1580s. Its general shape is not unlike a bell and such a piece is therefore called a bell salt. As there appears to be no continental equivalent, perhaps it can be claimed as a truly native, English design. Bell salts are usually flat chased with interlacing strapwork on a matt ground, but some are quite plain. They were made in three sections. The lid on top, in which a small caster is incorporated, removes to reveal a depression for salt, and this in turn acts as a lid covering a second, slightly larger depression below. Bell salts are seldom very beautiful; the craftsmanship is usually routine and the decoration coarse and repetitive. But the occasional example stands out because its maker devoted a little extra care and attention to his creation. Bell salts became less popular after the turn of the century and by 1620 the type was extinct.

A common drinking vessel in the sixteenth century was the tankard, and there are a fair number of them still to be seen today. One early example, made in 1556, is a pear-shaped vessel with a band of arabesque design engraved around the rim and simple bands on the lid and the handle, which is of plain S-scroll form. It bears the London maker's mark of a stag's head, by which it can be attributed to Robert Tallboys. A finer example, with more sophisticated engraving, is the tankard made in 1567 by Richard Danbe which is now in the possession of the Armourers' and Braziers' Company in London. This too

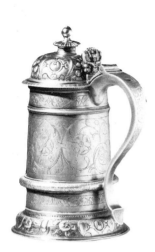

31 Silver-gilt tankard of typical Elizabethan design, made in London, 1591. As is often the case, the barrel is engraved but the foot and lid are chased. Height 7 in.

is pear-shaped, a form no doubt derived from stoneware and earthenware models which at this time was already being superceded by a straight-sided form. Elizabethan tankards are either engraved or embossed in much the same way as the salts of the period. One curious characteristic of the embossed decoration on the tankards is that it is always in noticeably lower relief on the barrel of the tankard than it is on the foot or the lid. On the whole, the tankards with engraved barrels are rather more attractive than those with the somewhat coarse flat chasing of the inevitable interlaced strapwork, paterae and lions' heads.

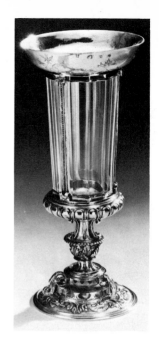

One of the most beautiful objects of the Elizabethan period is the wine cup, not to be confused with the communion cup or chalice which is usually accompanied by a paten forming a lid for the cup. Elizabethan wine cups occur with two basic shapes of bowl. The first, with a tulip-shaped bowl, is altogether taller than the second, shallow-bowled type. Some have bowls so shallow that it is doubtful if they were wine cups at all; more likely, they were used for holding sweetmeats of some kind. A cup of this type with a wide, shallow bowl is called a tazza, though it is arguable that this is a modern term only. To add further confusion, almost any shallow dish on a central foot is liable to be called a tazza nowadays.

While the taller type of wine cup was sometimes engraved, or left plain, the very shallow cups—the so-called *tazze*—were often quite highly embossed, with classical, mythological or sometimes biblical scenes (Plate 42). This tends to support the view that their purpose was different and that they were food servers rather than wine cups.

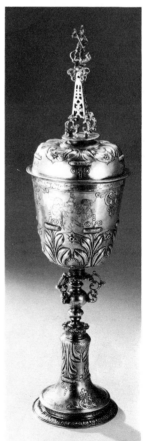

Towards the end of the century, a new type of wine cup appeared. This had a cover surmounted by a tall pyramidal steeple and is accordingly known as a steeple cup. For some reason steeple cups appear disproportionately tall even with the cover removed. Most of them have flat-chased and matted bowls, but a few of them are engraved. This type of wine cup remained popular up to the reign of Charles I.

During the sixteenth and early seventeenth centuries a wide variety of objects in various different materials were mounted in silver or, more frequently, silver gilt. Probably the best-known objects of this kind are the Rhenish stoneware jugs with foot rim, neckband and hinged lid of silver. They were made in Exeter, York, Norwich, Barnstaple and no doubt other places, as well as London, and judging from the number that have survived to the present they must have been made in their thousands. Some are very beautiful, although others are more

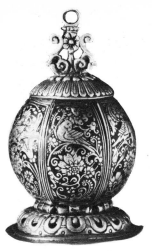

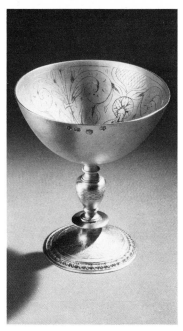

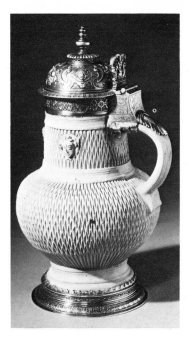

32 *Opposite, top:* Standing cup, silver-gilt and rock crystal, made in London, 1545. Height 11½ in. The Worshipful Company of Goldsmiths, London.

33 *Opposite, bottom:* Steeple cup, 1611. This is a peculiarly English form of cup and cover. The Company of Armourers and Brasiers, London.

34 *Above:* Pomander, particularly beautiful late Elizabethan piece, about 1600. The top unscrews and the six hinged segments fall outwards. Each segment would have contained different herbs and aromatics.

35 *Centre:* Late Elizabethan wine cup, parcel-gilt, made in London, 1592. This simple but beautiful cup illustrates the freedom of movement found in the engraving of this period. Height 5½ in.

36 *Far right:* Jug of white unglazed Rhenish pottery, silver-mounted, with die-stamped neck band, the lid chased with typical masks and strapwork, and beautifully engraved birds on the box hinge, made in London about 1585 (it bears the maker's mark only). Height 9 in.

perfunctory and slightly coarse in treatment. Chinese blue-and-white ware was also mounted in this way, and so were a great many more unlikely objects, such as coconuts, ostrich eggs and rhinoceros horns, as well as glass, turned wood and hard stones such as agate and onyx. The contrast of such disparate materials often results in a highly successful 'marriage' and the great majority of these items are strikingly attractive.

Styles do not change neatly at convenient dates such as the end of a century or the death of a sovereign, but at the end of the sixteenth century, or at the death of Elizabeth I soon afterwards, the beginnings of a basic change in fashion can be discerned. The queen's death brought not only a new monarch to the throne but also a new dynasty, and although fashion is not governed by monarchs or dynasties, general trends are, or were, often dictated by what is fashionable at court.

For a time there was no evident break, but what is apparent in the decorative arts of the reign of James I (1603-25) is, as so often when the pendulum of fashion is beginning to swing back, a loss of character and meaning, a symptom that the old fashion is dying and that it is time for new developments. There is a faintly lifeless look about the silver and other art objects of the early seventeenth century, a certain coarseness of form and decoration. Of course, to condemn outright all silver objects wrought between about 1600 and 1625 would be absurd, yet their general lack of spontaneity is undeniable.

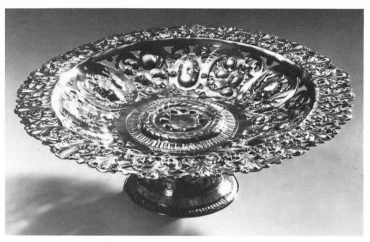

One new and notably attractive object of the period is a shallow pierced or openwork dish on a central foot. These dishes probably evolved from the sixteenth-century tazza, but they also owe something to Portuguese design; they usually have elaborately scalloped or crenellated borders. Tankards and ewers and dishes are not markedly different in design from earlier examples, and wine cups show little change either in form or ornament, although they seem to be on the whole rather taller than their sixteenth-century counterparts.

The seventeenth century

Insofar as it is possible to date a fundamental change in design, the change from the highly decorative, flamboyant era of the Elizabethans to the simpler, plainer style of the mid-seventeenth century occurred about the beginning of the second quarter of the century, or at the accession of Charles I.

The reasons behind the change to a simpler style have been often debated. It used to be said that it was all due to the influence of Puritanism, but this is an unsatisfactory explanation. Not everyone in England was a Puritan, and not all Puritans took a special interest in artistic affairs. Moreover, the simple, plain designs characteristic of England and of most other European countries never prevailed in Holland, where contemporary silver was highly elaborate. Yet Holland was the most rigorously Protestant country in Europe! The austere style common elsewhere was due in part to the inevitable though unpredictable swing of the pendulum of taste, but there is no doubt that it was also largely due to economic causes. 'The years around 1625', wrote Charles Oman, 'were in fact unfortunate for the goldsmiths in Western Europe – Germany was well launched into the Thirty Years' War, France had her

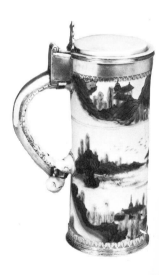

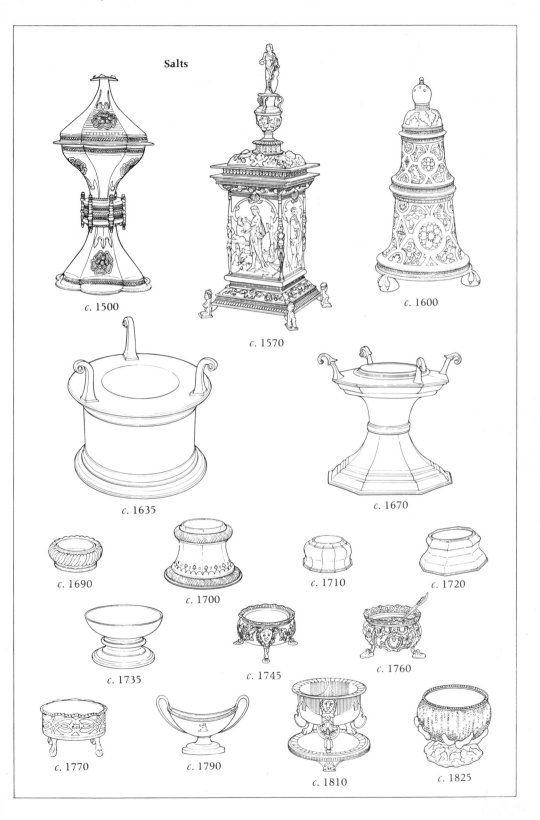

Salts

c. 1500

c. 1570

c. 1600

c. 1635

c. 1670

c. 1690

c. 1700

c. 1710

c. 1720

c. 1735

c. 1745

c. 1760

c. 1770

c. 1790

c. 1810

c. 1825

Huguenot troubles, whilst Spain was faced by the facts that the attempt to reduce the Duke [Olivares] had failed and that troubles were building up within the Peninsula. . . . The only part of Western Europe where there appeared to be no limit to the prosperity of the goldsmiths was Holland.' (*Caroline Silver*, Faber, 1970).

One obvious sign of the shift to plainer styles is the decline in silver gilt. By far the majority of pieces surviving from the sixteenth century and the first quarter of the seventeenth are gilt or parcel gilt (partly gilded), but in the reign of Charles I people turned away from the richness of gilding. In general, the preference was to leave surfaces entirely plain, but one comparatively new and extremely effective form of decoration became popular in this period. It is an effect called matting, produced by hitting the metal lightly with a small round-headed punch (Plate 39). On wine cups matting was usually made between two engraved lines around the bowl, leaving two small plain bands at the rim and the base of the cup. This very simple, almost naive form of decoration was to prove lastingly popular; it was still common well after the Restoration, when sober decoration was no longer in vogue.

A complete change in style is evident even in important pieces of ceremonial plate. The old rosewater dish and ewer with their heavily embossed strapwork, sea creatures and so on, their monster spouts and elaborately cast handles have gone. In the new version, the dish is a simple, circular plate with perhaps two or three bands of reeding at the rim and no other decoration apart from the occasional coat of arms engraved on the boss. The ewer is usually beaker-shaped, with straight sides and a slightly everted rim, a long beak-shaped spout and simple S-scroll handle; it stands on a plain trumpet-shaped foot.

The standing salt underwent a similarly dramatic change. By this time the salt was fast losing the social significance it had formerly commanded, when the importance of a guest at the dinner table could be gauged by whether he sat 'above' or 'below' the salt, and a less ostentatious design .was therefore natural. The salts of the 1630s are generally plain drum-shaped objects with three simple scrolls set vertically on top. The purpose of these scrolls is somewhat enigmatic: some writers have suggested that they were intended to support a dish, but it would have been a precarious perch and a more likely explanation is that a napkin was draped over them to protect the salt in the bowl beneath, taking the place of the fitted silver cover that was almost invariably provided with earlier salts.

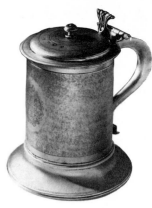

39 *Above:* Charles 1 tankard, made in London, 1639. An example of the prevalent use of matted ornament, it stands on a wide skirt foot – a very early use of this device. Height 7½ in. Boston Museum of Fine Arts, Mass..

40 *Below:* Silver wine cup of the reign of Charles 1 (the pricked initials and date were added in 1667), a fine example of this austere style. Height 6½ in.

41 *Opposite:* Rhodian jug, Isnik ware, with silver mounts, about 1580. Height 10¼ in. Victoria and Albert Museum, London.

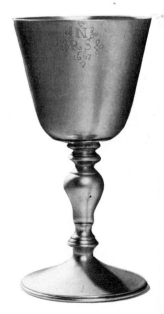

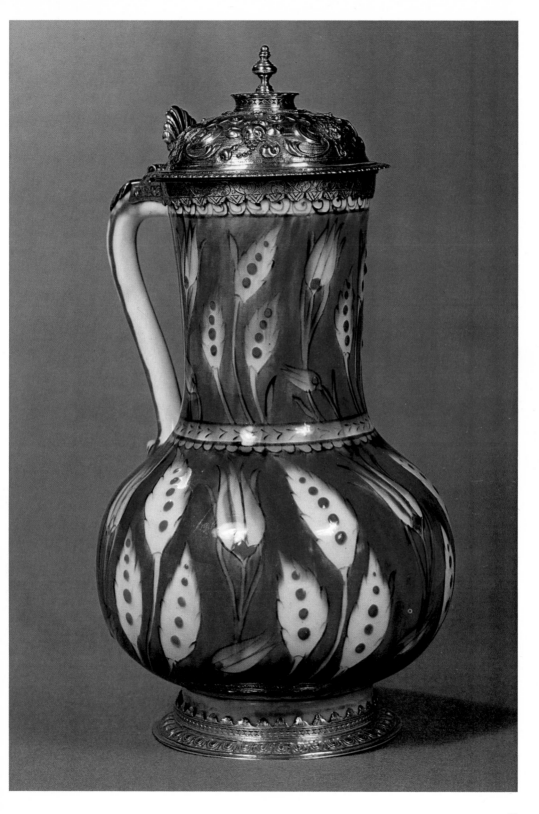

41

42 *Opposite:* Tazza and cover, silver gilt, maker's mark IG in a shield, 1584. Height 13½ in. Diameter 7⅛ in. The Worshipful Company of Goldsmiths, London.

43 *Left:* The Methuen Cup, silver gilt and rock crystal, maker's mark VH, made in Scotland, mid-sixteenth century. Height 7 in. Foreground, a perfume burner, maker's mark TI, 1628. Height 8¾ in. Both pieces are in the Los Angeles County Museum of Art, California. Gift of William Randolph Hearst.

44 *Below:* A magnificent pair of silver-gilt Elizabethan tankards, maker's mark IB, 1602. Height 8¼ in.

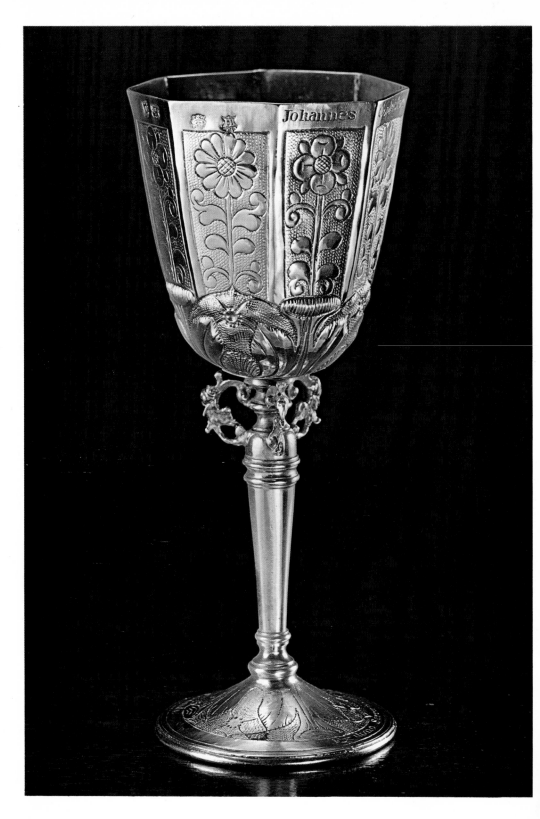

45 *Opposite:* Silver-gilt cup of the type known as a grace cup, maker's mark RP, 1616. Height 7½ in. The Worshipful Company of Goldsmiths, London.

46 *Above:* Bible, with finely fashioned silver-gilt mounts, about 1640. This beautiful piece was made for Colonel Sir George Strode, who was wounded at the Battle of Edgehill. Height 7 in.

47 *Far right:* Oval box with hinged lid, 1651. As is often the case, it is difficult to know what this very plain Cromwellian box was for – perhaps nothing in particular. From a modern collector's point of view it would be very exciting to own, but the actual quality of the work leaves much to be desired. The Worshipful Company of Goldsmiths, London.

Another type of standing salt, also with vertical scrolls, was made in plain capstan form. It seems to have superseded the drum-shaped variety and continued to be made throughout the century, until the standing salt ceased to exist as a standard item in the goldsmith's repertoire.

A single large standing salt was, anyway, rather inconvenient, and the reign of Charles I provided the first extant examples of the trencher salt (though some were certainly made as early as the sixteenth century). The trencher salt is a much smaller receptacle, which stood beside the diner's plate, or 'trencher' (from which we get the expression 'a good trencherman'). Usually round, sometimes triangular, and normally made in sets, the little trencher salt in silver was probably intended to provide a more refined alternative to the custom of placing a little pile of salt on the side of one's plate. (Many old wooden platters probably had a small circular depression in the rim for this purpose, and the same device can be seen in some English earthenware plates of the early eighteenth century.)

The tankard in the reign of Charles I was reduced virtually to the most elemental form possible. As a rule, the body was raised from a single sheet of metal. Straight-sided and tapering gently inwards towards the top, the typical Charles I tankard was not even provided with an applied rim foot. The lid is quite flat, with a simple rolled billet as a thumb-piece, and the handle is an unadorned S-scroll. It is hard to imagine a more striking contrast with the elaborately chased and engraved tankard of fifty years earlier.

When all, or almost all ornament is eschewed, shape and line become so much the more vital, and on the whole this challenge was met successfully by the goldsmiths of the period. Like

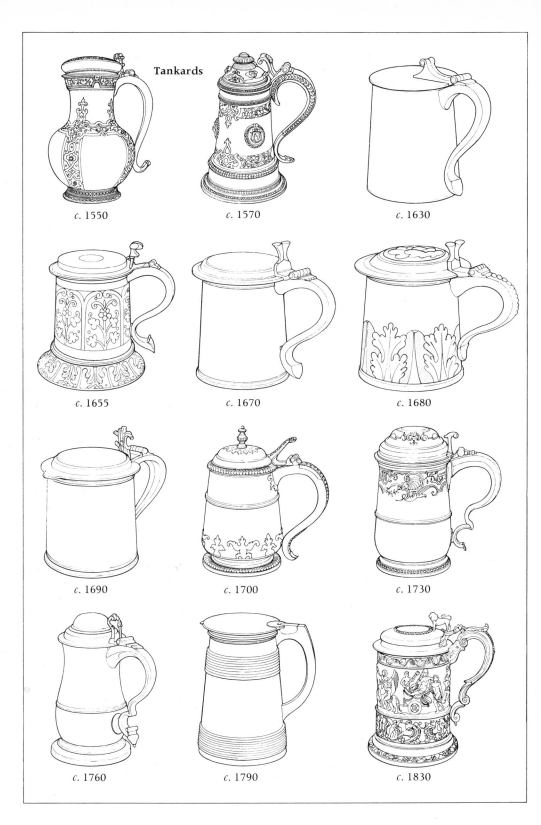

Tankards

c. 1550 c. 1570 c. 1630

c. 1655 c. 1670 c. 1680

c. 1690 c. 1700 c. 1730

c. 1760 c. 1790 c. 1830

tankards, wine cups are beautifully proportioned, with V-shaped bowls on cast baluster stems, a type which had first appeared towards the end of the sixteenth century. Signs of the general aversion to ostentation are the scarcity of large standing cups with covers, the relative profusion of pleasant, simple goblets, and the appearance of plain beakers, an ancient form of drinking vessel certainly, but uncommon before this period. Beakers are usually straight-sided, with everted rim and turned, reeded rim base. Sometimes they have arabesque ornament engraved below the rim in a style that was slightly archaic.

During the reign of Charles I, an object which in a multitude of guises was to retain its popularity to the present day made an embryonic appearance. This was the two-handled cup. They are of simple pear-shaped outline with strikingly small circular ring handles at opposite sides just below the rim. They represent, in fact, the basic form of the porringer and cover, of which there are innumerable examples from the middle of the century onwards. This early form, of which the first known example is dated 1616, is generally called an ox-eye cup, for reasons that become obvious when it is viewed from the side with the handles at right angles to the line of vision. Another name for it is college cup, which presumably derives from the coincidental fact that a large proportion of extant examples are owned by the colleges of Oxford and Cambridge.

The question of nomenclature in silver, as in other decorative arts, is often a vexed one. It is worth repeating that the names used to describe objects of a certain type today are not necessarily the names used at the time, and many of the names that *were* used are either unknown or obscure to us today. It is

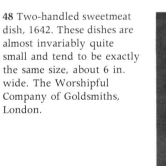

48 Two-handled sweetmeat dish, 1642. These dishes are almost invariably quite small and tend to be exactly the same size, about 6 in. wide. The Worshipful Company of Goldsmiths, London.

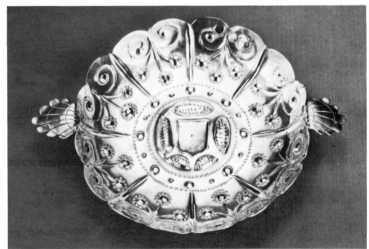

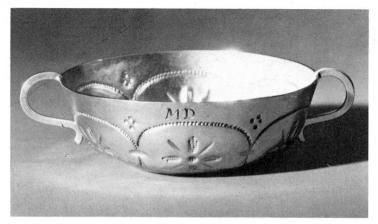

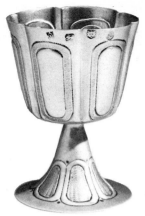

not clear, for example, what distinction was implied in the seventeenth century between 'bowls' and 'cups', or even if there was any distinction at all. What we call a tankard seems to have been generally known as a 'pot', while the name 'porringer' is nowadays likely to be applied to almost any cup or bowl with two handles, with or without cover. Another much-argued term is 'strawberry dish'. This is the name given to a type of shallow fluted dish with two shell handles which was very popular in the seventeenth century (Plate 48) and plain, fluted shallow bowls without handles of the early eighteenth century. There seems to be no contemporary evidence that these dishes were intended for strawberries, and it has been pointed out that, owing to their great variety in size, you would have received either a gigantic portion or a rather mean one, as some 'strawberry' dishes are considerably smaller than the average saucer—hardly generous even for red currants. At about the same time there appeared another type of small, shallow dish, about three inches in diameter, with two plain scroll handles (Plate 49). These dishes, which retained popularity in a form almost unchanged well into the 1680s, are today often known as wine tasters, but it is extremely unlikely that this description is correct. There are a few somewhat similar vessels surviving which are definitely known to be wine tasters—they often have a raised dome in the bowl to show off the colour of the wine. The authenticated wine tasters are normally engraved with the name of a vintner, but in no single case that I know does a vintner's name appear on the former variety. Moreover, these exist in such quantity today that, if they were wine tasters, then every vintner in England must have owned dozens of them. It seems odd, to say the least, that none carries a name, and odd too that the Worshipful Company of Vintners does not possess a single one. Surely some member

49 *Far left:* A small dish of the sort usually known as a wine taster, made in London, 1641. More likely, these little dishes were for spices or condiments. The pattern continued unchanged almost to the end of the seventeenth century. Diameter 4 in. including handles.

50 *Above:* Wine cup of the type sometimes called a dram cup, made in London, 1650. This type is usually associated with the Cromwellian period. Height generally $3\frac{1}{2}$ to 4 in.

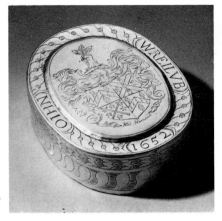

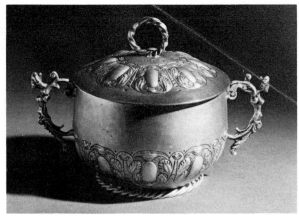

51 *Above:* Tobacco box of the Commonwealth period, made in London, about 1652. It is engraved with the arms of John Burwell of Woodbridge in Suffolk and his name appears as an anagram. Length 5 in.

52 *Far right:* A Cromwellian porringer and cover made in London, 1656. Though a remarkably fine example of its type, it is made in a rather slap-dash manner, typical of its period. Height about 5 in.

would have presented his favourite wine taster to his company? The exact purpose of these doubtful 'wine tasters' must remain uncertain, but probably they were for small sweetmeats; alternatively, they were 'saucers' in the original meaning of the term – containers for sauce.

The Restoration of the monarchy in 1660 represents an important milestone in the history of English silver in that the surviving pieces from about 1660 onwards are far more numerous and more diverse than those of any earlier period. Before this time, a man's plate was his capital – he had no stocks and shares nor bank account – and in time of need the family silver was melted down to be turned into ready cash. The hard times of the 1630s, followed by the Civil War, placed a heavy call on this form of capital. The needs of King and Parliament to pay their soldiers caused the reduction of plate to bullion on a massive scale, larger even than the melting down of monastic plate during the Dissolution of the Monasteries a century before. It is therefore not surprising that English silver surviving from a period earlier than the mid-seventeenth century is rare, and often not found outside museums and institutions. Moreover, the survivals, however beautiful, rare or interesting they may appear to us, tend on the whole to be the smaller, less important pieces. Owners who had to raise money by sacrificing their plate would naturally select the large, ceremonial pieces first, hoping to retain the smaller and more personal articles, which were probably more useful in the house and were anyway less valuable in terms of weight.

Since the Restoration, there have been no more great assaults on silver. With the rising prosperity of the late seventeenth century and the growing use of banks both for storing capital and for business speculation, silver became more of a luxury item and less of a capital investment. After 1660, far fewer

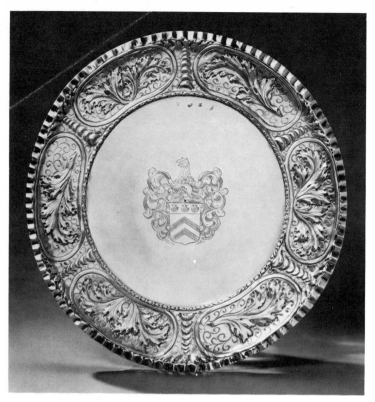

53 Salver on a foot, engraved with the arms of Fettiplace, 1677. It makes a striking contrast with the salver of 1672 in Plate 54. The chased decoration and pie-crust edge strengthen the middle, allowing a much thinner gauge of silver to be used. This salver, though considerably larger than the silver-gilt example, is noticeably lighter in weight. Diameter 14 in.

pieces were melted merely for cash, and the main threat to survival became nothing more formidable than natural wastage—wear and tear, theft, or occasionally the desire of an owner to have a piece melted and reworked into something more fashionable. At the same time, production increased dramatically. The destruction of silver in the Civil War period still had to be made good, which, combined with the general increase in consumer spending, especially on luxuries, meant that the goldsmiths were busier than ever before. No one had greater reason than they for cheering King Charles II when he rode into London in 1660.

The Restoration of the monarchy, the renewal of a spirit of expansive optimism, and the general increase in prosperity combined to revive a delight in luxury. The decorative arts became more obviously 'decorative', and silver more ornamental.

Of course, this did not happen suddenly in 1660. As mentioned earlier, during the period of Carolean austerity in English silver, the Dutch silversmiths were producing plate in designs of almost riotous splendour, extravagantly chased with scenes from domestic life, allegorical and mythological subjects, classical motifs, sea monsters and other grotesques.

England was not entirely cut off from this influence. During the 1630s Christian van Vianen, a member of a famous family of silversmiths, came from his native Utrecht to work for Charles I, a great patron of artists and craftsmen. His major commission was a service of plate for St George's Chapel, Windsor, but unfortunately it was looted in 1642 and never seen again – no doubt it was melted down for its value as bullion. Nevertheless, several pieces in the voluptuous, perhaps over-ripe Dutch decorative style (known as the auricular style), which were made by van Vianen in England, have survived.

It was this style, though seldom exercised by craftsmen as talented as van Vianen, which dominated English silver in the period from 1660 to 1680. The first signs of it were evident earlier, under the Commonwealth, with objects such as dishes, porringers and wine cups given more ornament than they would have received ten or twenty years before.

In the Restoration period the porringer, both with and without a cover, became a standard piece of plate. Some collectors make a distinction between the 'porringer' and the 'caudle cup', on the basis of the shape of the bowl or some other subtlety, but contemporaries were probably less pedantic. It is unlikely that a 'porringer' was exclusively for porridge or a 'caudle cup' for caudle (gruel spiked with wine or beer).

Commonwealth and Restoration porringers are usually pear-shaped, with the lower part heavily embossed with flowers and foliage, sometimes interspersed with a lion and unicorn, a hound and stag, or, on one rather eccentric example, an elephant. Handles were often in the form of caryatids (female half-figures) and for the most part they are poorly cast and finished. The covered porringer of the last quarter of the seventeenth century is more often straight-sided than pear-shaped, and the decoration on the lower part is a more formal design of vertical acanthus leaves; the caryatid handles are often replaced by simpler S-scrolls.

54 Silver-gilt salver on a central trumpet foot, made in London, 1672, and engraved with the arms of the Duchess of Richmond and Gordon, 'La Belle Stewart'. Diameter 11 in.

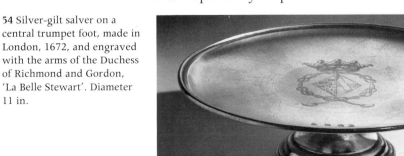

Two-handled cups

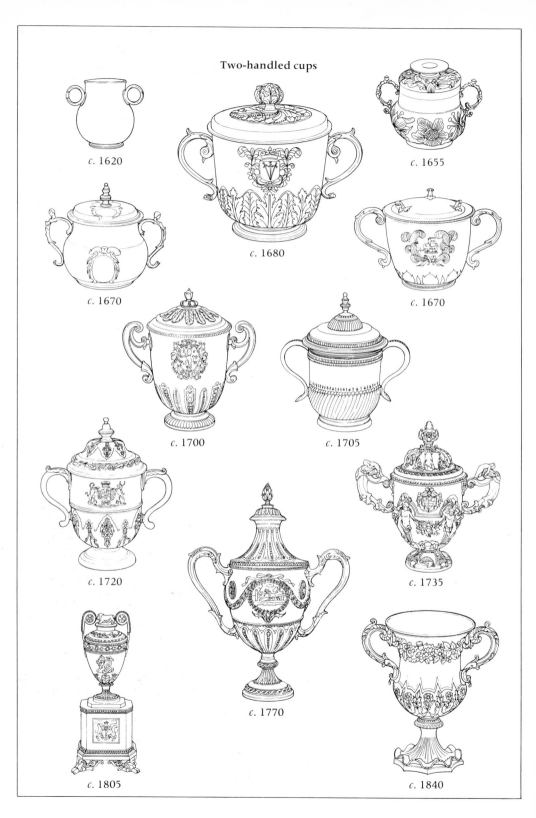

c. 1620

c. 1655

c. 1680

c. 1670

c. 1670

c. 1700

c. 1705

c. 1720

c. 1735

c. 1770

c. 1805

c. 1840

One innovation dating roughly from the Restoration was 'a newe fashioned peece of plate, broad and flat, with foot underneath ... used in giving beer, or other liquid thing to save the Carpit or Cloathes from drops'. This useful piece, described by Thomas Blount in his *Glossographia* (1661), was the salver. First made, as Blount says, as a tray for a porringer or other container for liquids, it soon gained an independent existence. Early salvers generally have a broad, highly embossed rim, with the shallow central depression left plain, to be engraved, if desired, with a coat of arms; they stand on a central, trumpet-shaped foot. As the century drew to a close, the broad rim disappeared, leaving a flat surface with a reeded or 'rope-edge' rim, and the salver, apart from its central foot, took on more of the appearance of the typical eighteenth-century piece.

During the second half of the seventeenth century the English goldsmiths' main sources of design were the Netherlands and, in the later years especially, France. Both these foreign influences encouraged extensive ornament on silver,

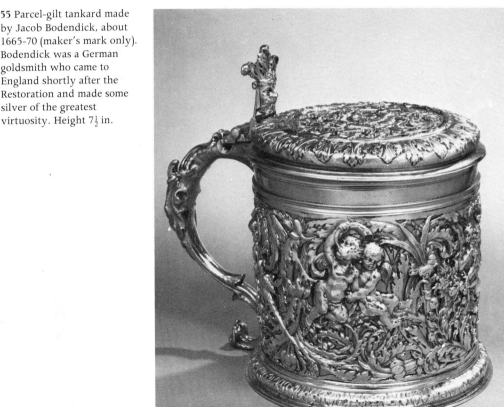

55 Parcel-gilt tankard made by Jacob Bodendick, about 1665-70 (maker's mark only). Bodendick was a German goldsmith who came to England shortly after the Restoration and made some silver of the greatest virtuosity. Height $7\frac{1}{2}$ in.

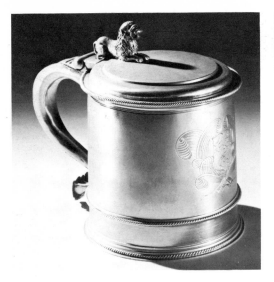 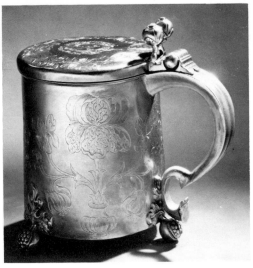

but some articles nevertheless remained comparatively plain. Perhaps the most notable example is the tankard. Apart from a group of tankards dating mainly from the 1680s which have a broad band of stiff, vertical acanthus leaves around the base (like the decoration on some porringers of the same period), the general pattern was plain and straight-sided. A spreading 'skirt' foot which was popular for a time in the 1640s and 1650s was soon abandoned in favour of a low, moulded rim foot; handles are of plain S-scroll form while the hinged lid, no longer completely flat, is stepped – a single step on earlier examples, two steps later. It should be emphasised that this is the general pattern only; there are numerous examples which do not exactly fit this description.

Among the exceptions is a notable group of tankards from York and, to a smaller extent, Newcastle, which were derived from Scandinavian design. The barrel rests on three pomegranate feet, and the rimless, rounded cover has a double-pomegranate thumb-piece. Many of them have two other features in common: a handle in double C-scroll form rather than the plain flowing S-scroll of London-made examples, and a 'bullet' hinge – much more common in Europe than in England. The barrel is sometimes plain or engraved with a coat of arms, but some are embossed with flowers and foliage all around. Perhaps the most beautiful – arguably the most beautiful of all English tankards – are those made in York from the late 1650s to the early 1670s by John Plummer (Plate 57). They are engraved with flowers and foliage, from which spring half-figures or monsters. The quality of the engraving is exceptional, and it is a great pity that the name of the engraver

56 *Far left:* Tankard, made in London by Thomas Jenkins, 1675. Compared with the Bodendick example, this tankard appears superbly austere, relying on simplicity of line and decorated only with a bold lion thumbpiece and beautiful plumed mantling around the coat of arms – typical of the period. Jenkins was one of the finest English goldsmiths of the latter half of the seventeenth century. Height $5\frac{1}{2}$ in.

57 *Above:* Tankard, made in York by John Plummer, 1662. A beautiful example of Plummer's work, it is engraved with flowers and rests on pomegranate feet. Huntingdon Library and Art Gallery, San Marino, Calif..

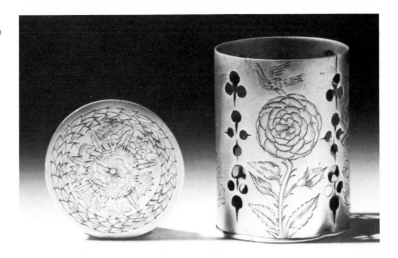

58 Counter box, probably made in London, about 1680 (it has no marks). Counter boxes are not usually the most exciting objects, but this is a charming example, engraved with roses and thistles and containing thirty-six gaming counters. Height 2 in.

is unknown. Of course it may have been John Plummer himself, though the only evidence for that conclusion is that nearly all the tankards bearing this superb engraving were made by him.

An interesting example of the diversity of surviving silver is the candlestick. Both wall sconces and hanging chandeliers were made in considerable quantity, sconces especially. These things were certainly made in the previous century, but we have little idea of what they looked like at any time before about the middle of the seventeenth century because not one has survived from the earlier period.

A mark of the demand for luxury in the home was the greater use made, certainly by the aristocracy, of plate in the bed chambers and dressing rooms. Typically, the mantelpiece

59 A Charles II pin cushion, unmarked, about 1675, originally no doubt part of a toilet service. It is extremely well chased but its main distinction is the form of its four extraordinary little feet, apparently demi-phoenix rising from flames. Length 7 in.

60 Bellows, silver-mounted wood, about 1680. This pair is in fact probably Dutch but is a good example of the kind of objects being made in silver in the extravagant age of Charles II. The silver mounts against the richness of the turned wood are rich and satisfying, and the bellows are still in working order. Length 18 in.

supported a pair of silver ginger jars with covers, tall and embossed flower vases and silver mirrors. There was even a vogue for silver furniture. A silver bed was made for Nell Gwyn in 1674 and another of the royal mistresses, the Duchess of Portsmouth, had tables and fireplaces made in silver. But few people could afford to indulge in such expensive tastes, and it is difficult to know how far the fashion spread. (Today, a remarkable display of silver furniture can be seen in the throne room of Rosenborg Castle, Copenhagen.)

The silver or silver-gilt toilet service became the traditional wedding present from husband to wife. John Evelyn described it in verse:

A New Scene to us next presents
The Dressing Room and Implements
Of Toilet Plate Gilt, and Embossed
And several other things of Cost,
The Table Mirror, one Glue Pot,
One for Pomatum, and what not?
Of Washes, Unguents and Cosmeticks,
A pair of Silver Candlesticks,
Snuffers and Snuff Dish, Boxes more
For Powders, Patches, Waters Store,
In silver Flasks or Bottles, Cups
Covered or open to wash chaps.

These services were frequently as large and elaborate as Evelyn's description suggests, consisting generally of a mirror, a pair of candlesticks, a large oblong box, two medium-sized boxes and two small ones, a pair of scent flasks, a pair of covered two-handled bowls, a pin cushion, sometimes a

snuffer and tray, and various brushes, combs and whisks. Altogether they present an impressive array (Plate 68), but unfortunately many have been broken up recently and the items sold individually. However, something of the feeling of exciting, perhaps slightly cloying, opulence of this era can be seen in the state bedroom at Knole, or at Ham House near Richmond.

It is possible to see this whole period as one of gentle evolution, with gradual change but no dramatic breaks, with the single important exception of an extraordinary style of decoration, more notable in silver than in the other decorative arts, known as Chinoiserie. The interest of Europeans travelling to the Far East was primarily economic, but inevitably they brought back travellers' tales, wrote accounts of the sights they had seen, and published drawings of the Chinese style in architecture or dress. For a short time, roughly between 1675 and 1690, these were copied, in a naive way, in flat chasing on silver articles ranging from whole toilet services to individual tankards, bowls and other small everyday items.

The designs, fantastic in conception but realistic in execution, are of such marked similarity on all surviving examples that it is tempting to assume that one workshop was responsible for almost the entire output – the various goldsmiths all sending their work there to be chased in this new fashion. It was almost entirely confined to London, though there is one

61 Porringer and cover, 1680. This example is decorated with flat chasing in the Chinoiserie manner with birds, trees and a fountain and, unlike many porringers of this period, relatively well constructed. Height 7 in. The Worshipful Company of Goldsmiths, London.

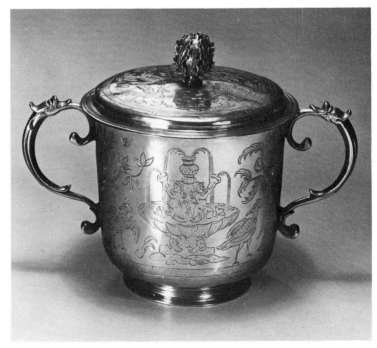

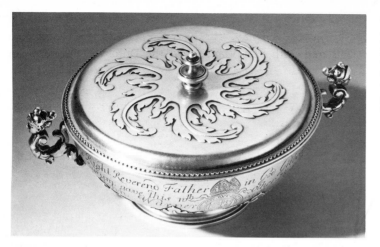

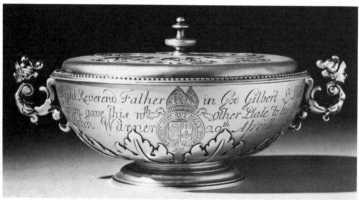

62, 63 Silver-gilt bowl and cover, made by Pierre Harache, about 1695 (it bears his maker's mark only). This superbly made small bowl was given by the Bishop of Salisbury to his godson, John Warner, in 1697. Length 5½ in.

striking exception, which is a small group of pieces made in Newcastle around 1690 in which the decoration, though similar, lacks the versatility of London and is altogether so dissimilar that it can be confidently classed as local work. There are also some Chinoiserie pieces bearing Dublin hall marks, but the decoration is so like that of London as to suggest that they were sent to London to be chased and finished. The only other exception of which I am aware is a pair of bulbous mugs made in Barnstaple about 1685, in which the design is similar but executed with such crude naiveté that it seems safe to conclude that it was done locally. The mugs were probably made to the order of a local patron who had a London-made example for the Barnstaple craftsman to copy, a task he completed with indifferent success.

It is dangerous to generalise about silver in the latter half of the seventeenth century, but very broadly, and with a number of striking exceptions, it could be said that it looks rather better from a distance than it does when examined closely. The English goldsmith seems to have been less concerned with the

finest quality and detail and more concerned with making a grand general display. The heavy repoussé style which had originated with van Vianen and the Dutch in the Carolean period had become so diluted as to be almost unrecognisable, while the French taste had as yet made comparatively little impact, probably because it required exceptional ability in the goldsmith which, with one or two exceptions, was simply not available. By about 1690 the pendulum of style had once more swung to its limit, and the time was ripe for a new style and new techniques. The impetus for change was partly provided by emigré craftsmen from France.

Queen Anne and early Georgian silver

In 1685 Louis XIV revoked the Edict of Nantes, which had given a measure of toleration to the minority of French Protestants, or Huguenots. Already, some Huguenots had come to England, and the revocation of the Edict of Nantes forced

64 A cup and cover, made by Matthew Lofthouse, 1695. This is a typical English piece of the period. Note how weak the handles look compared with the remarkable cut-card cup and cover of the unknown Huguenot goldsmith in Plate 65. Height about 7 in.

them to leave France in much greater numbers. Though more went to the Netherlands or to North America, some came to England, especially after the Glorious Revolution of 1688 had rid the country of the Catholic, pro-French James II and introduced the solidly Protestant William III. A quite extraordinary proportion of the Huguenot emigrés proved to be craftsmen – including goldsmiths – of exceptional talent. William III appointed as his own court architect and designer a Huguenot named Daniel Marot, whose designs helped to cause a swift and dramatic change in England.

The grand, Baroque style of Louis XIV's France demanded higher technical skill, particularly in the use of cast ornament, than the average late seventeenth-century English goldsmith possessed, and it was perhaps this fact that enabled the Huguenots to achieve such prominence in the craft. They arrived as oppressed emigrés, and although their presence was eventually to prove an inestimable boon to the English silver trade, it did not seem so at the time. Many attempts were made to prevent the 'strangers' practising their craft. It was necessary for a goldsmith to have his wares assayed before he could legally sell them, but he could only get them assayed if he were a freeman of the Goldsmiths' Company. The Company refused to admit the Huguenots unless they first served the full seven-years apprenticeship, an absurd provision since most of them had already completed a far more rigorous apprenticeship

66 The Seymour Salt, silver gilt, unmarked, about 1662. Height 10½ in. Diameter 9¼ in. The Worshipful Company of Goldsmiths, London.

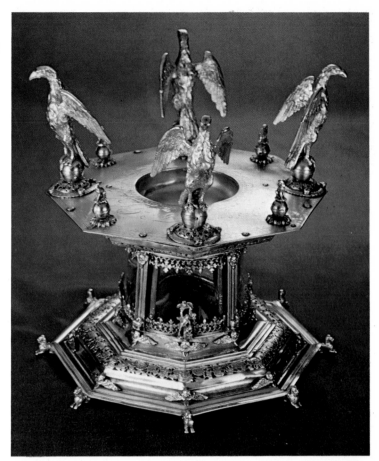

67 Silver porringer and cover, maker's mark GS with two dots above and a crozier between in a shaped shield, 1658. Height 4 in. Diameter 4½ in. The Worshipful Company of Goldsmiths, London.

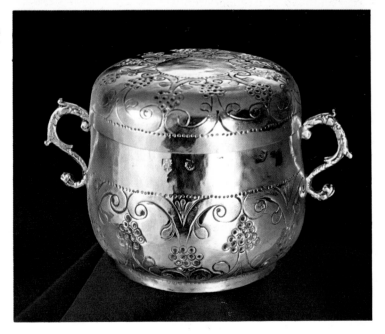

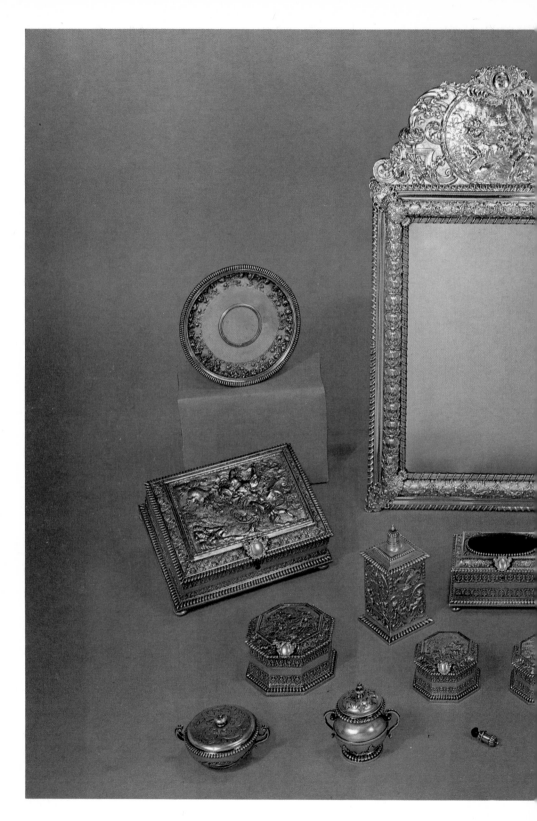

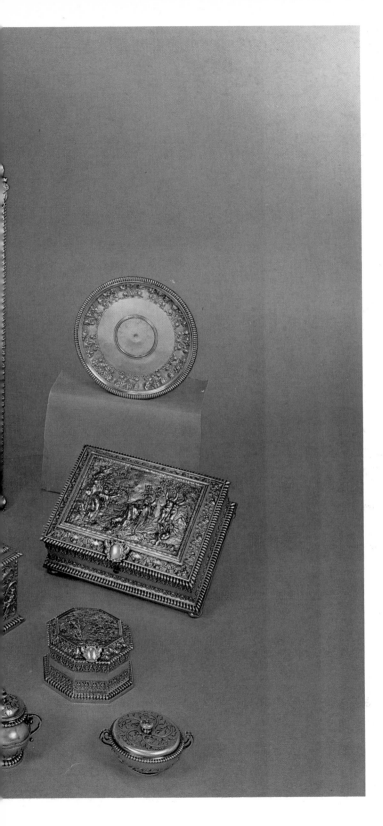

68 Toilet service of seventeen silver-gilt pieces, made by Daniel Garnier, about 1680 (maker's mark only). Height of mirror $31\frac{1}{4}$ in. Birmingham City Museums and Art Gallery.

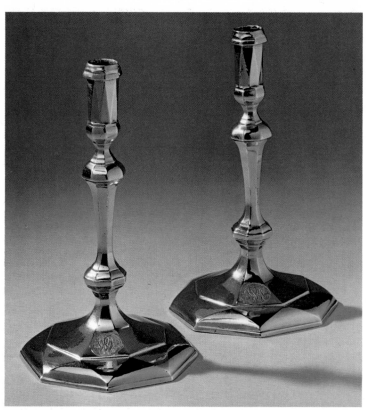

69 *Left:* A pair of Queen Anne silver-gilt tapersticks, made by Thomas Merry, London, 1713. Height 5 in.

70 *Below:* Silver oval dish, with the initials of Catherine wife of the 6th Earl of Thanet, maker's mark IC conjoined, made in London, 1683. Length 19 in.

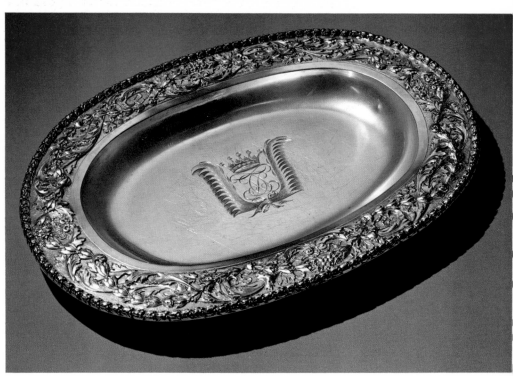

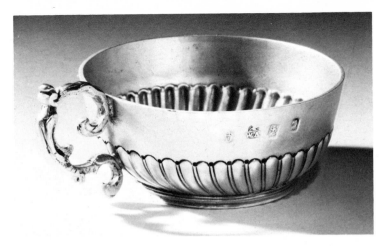

71 A small single-handled wine taster (I think this really *is* a wine taster), made in London by Samuel Wastell, 1701. It is an unusual, rather French-looking object, though made by an Englishman.

in France. Meanwhile, many gifted French goldsmiths were compelled to work as employees of established English freemen of the Company. However, thanks largely to English patrons who appreciated their worth, the barriers were soon broken down, and by the end of the century a substantial sprinkling of French names appears in the records of the Goldsmiths' Company. Simultaneously, those English goldsmiths who would not or could not cope with the new demands upon their competence gradually disappeared, leaving only those who could compete on equal terms with the 'strangers', frequently by learning from them.

From about 1700 it is possible to distinguish two emergent styles, different but complementary. On one hand there is the true French, Baroque style with its bold use of cast forms, a heavy style of restraining grandeur, displaying the utmost finesse in technique and design and relying mainly for decorative effects on bold, applied strapwork (in the cut-card technique), heavy cast handles and tightly drawn cast gadrooning (Plate 74). Embossing was rejected, and a heavier gauge metal helps to impart the effect of magnificence. On the other hand, from the new generation of English goldsmiths, there is a simple purity of form, relying more on elegant lines than ornamental technique to achieve a satisfying balance (Plate 76). But it would be wrong to imply that these two groups are mutually exclusive. On the contrary, many coffee pots, teapots and salvers in remarkably austere style were made by Huguenots, and equally, English goldsmiths turned out many a two-handled cup and cover adorned with rich strapwork mouldings. Both styles relied on simplicity of form, though their marked difference in ornament signifies their origin in different camps.

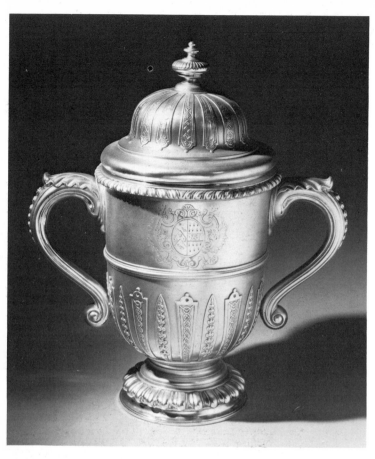

72 *Left:* An extremely large cup and cover, an excellent example of the monumental form of Huguenot silver, made in London by David Willaume, 1712. This is, in fact, the largest Queen Anne cup and cover of which I am aware; the bold strapwork designs are clearly visible. Height 16½ in.

73 *Opposite, top left:* A George I mug, silver at its most simple, beautifully made and relying solely on form and finish for its aesthetic appeal, made in London, 1720. Height 4 in.

74 *Below:* A fine William III sugar caster in the Huguenot manner, made by Pierre Harache, 1699. Notice the finely engraved lid and the cut-card work radiating from the finial. Height about 10½ in. The Worshipful Company of Goldsmiths, London.

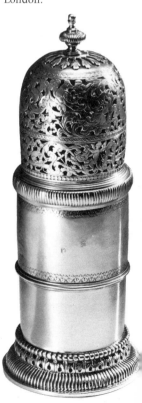

The two-handled cup, which had evolved from its simple origin in the ox-eye cup through the porringer, now began to be made in more massive proportions. The basic outline is bell-shaped; it stands on a shortish, spreading, turned foot, and is topped by a stepped-dome lid with a bold baluster or acorn finial. In earlier examples the handles are harp-shaped, but from about 1700 they generally have S-scroll handles with an acanthus leaf overlaid at the top. The strapwork calyx around the lower part of the cup is usually of simple lobate forms around the turn of the century, but after about 1715 it is much more elaborate, frequently pierced and incorporating classical heads, and often alternately matted and plain.

In tankards it is possible, if not perhaps wise, to distinguish between an 'English' form – straight-sided with a moulded girdle and domed lid – and a 'Huguenot' variety – slightly bellied with cut-card work around the base and possibly a baluster finial to the lid. Pear-shaped jugs with covers for wine or beer made their appearance, while other, once-common vessels declined – the old ewer and dish had become a rarity

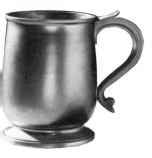

75 *Right:* A Queen Anne chocolate pot, perfectly plain and simple, made by Gabriel Sleath in London, 1709. The second hinged lid, which was used for stirring the chocolate, can be clearly seen. Height 10 in.

76 *Below:* George I octagonal sugar caster, 1719. Though extremely competent and very pretty, it does show the difference between the simple lines of the English goldsmith and the luxuriant genius of the Huguenot craftsman.

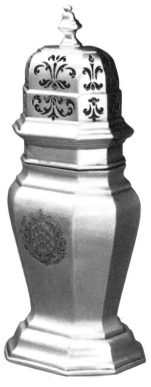

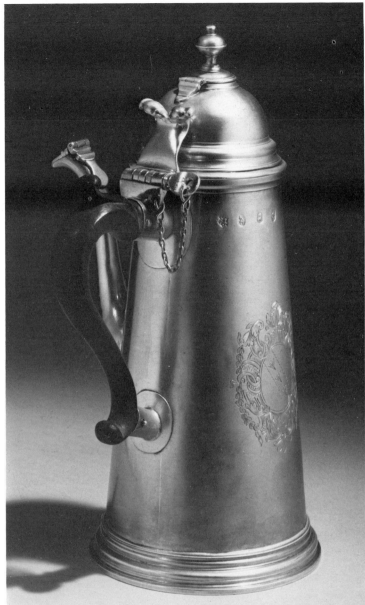

and silver wine cups had been largely displaced by glass since the improvements in making flint glass associated with the name of George Ravenscroft (1618-81).

While the English had more or less ceased to drink their wine from a silver cup, they had adopted new drinking habits which offered greater scope to goldsmiths. The drinking of tea, coffee and hot chocolate became customary in the late seventeenth century and grew increasingly popular in the eighteenth. Silver provided the most suitable containers for

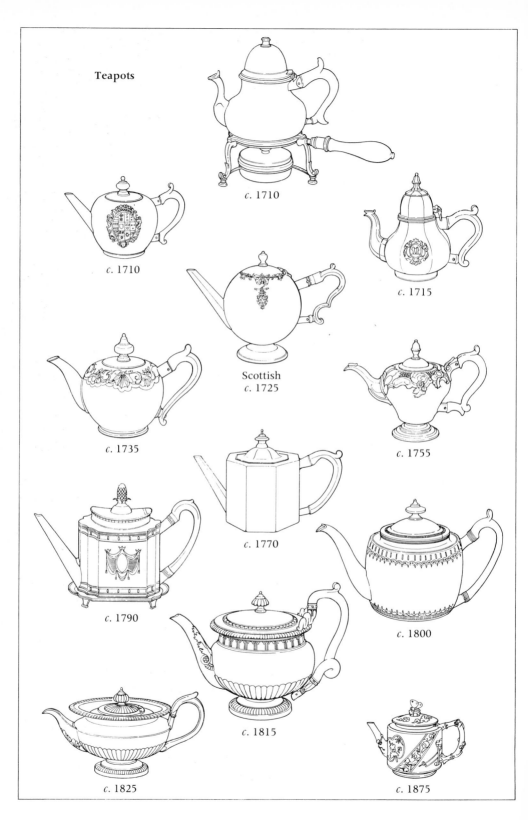

Teapots

c. 1710

c. 1710

c. 1715

Scottish
c. 1725

c. 1735

c. 1755

c. 1770

c. 1790

c. 1800

c. 1815

c. 1825

c. 1875

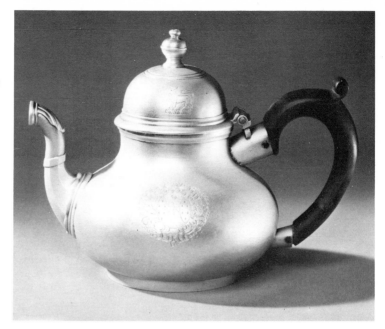

77 Queen Anne pear-shaped teapot, made by John Fawdery, 1713. The shape is particularly attractive and this is a favourite teapot of mine. Some tend to be a little elongated and therefore not quite so pretty. Height 5 in.

these very expensive beverages. The first coffee pots and teapots were made as individual items; the idea of a matching set was not taken up until later. Coffee and chocolate pots are generally tall and straight-sided, with either a swan-necked or straight – sometimes faceted – spout. Lids are tall and domed up to about 1720, thereafter lower and more rounded. The handle, of wood or other material, is mounted either in the conventional position opposite the spout or at right angles to it; the latter form is always less common in England and tends to disappear after 1720. Probably, the same pot was used interchangeably for coffee or chocolate, but some pots were made especially for chocolate. Unlike coffee, chocolate does not actually flavour the water; what one tastes is the particles of chocolate suspended in water. To ensure that the first cup is not pale and flavourless and the last strong and sludgy, it is best to stir it briskly before pouring. For this reason, chocolate pots were provided with a small, extra lid, set into the normal cover, through which a rod could be lowered to whisk up the chocolate without too much heat being lost (Plate 75).

A different form was adopted for teapots. Tea came from China, and the shape of the English teapot was also adapted from the Chinese (though the vessel concerned was actually used in China for wine rather than tea). Up to about 1715 teapots tend to be pear-shaped, after that a slightly squashed sphere. In Scotland the globular or bullet-shaped teapot was popular longer than in the south; it tends to be more nearly

spherical and stands on a somewhat higher foot. It would be hard to find a 'bullet' teapot made in London much later than 1740, but Scottish examples can be found as late as 1760.

Other accoutrements of the tea table were sugar bowls, almost exact copies of the Chinese covered tea bowls of the period, more or less hemispherical and standing on a low rim foot, with a shallow cover. Cream jugs are usually pear-shaped, with simple S-scroll handles. Kettles conform in outline to the teapot, but are obviously considerably larger. They stood on a four-legged stand which supported a spirit burner. The purpose of the burner was to keep the water hot, not to boil it. The truth of this I once proved to my own satisfaction when trying to make a cup of tea during a power cut: the eventual result was not a success.

The tea- or coffee pot sometimes sat on a tray which, at this period, is either square or rectangular with in-curving corners, or occasionally octagonal. The number of trays that have survived, however, is small compared with the number of teapots and coffee pots, which suggests that many people did without a tray. Last but not least, the tea itself was kept in a tea caddy, rectangular or square and taller than its length. They often have cut corners. The tea was poured through a smallish aperture with a removable domed cover. This was less convenient when it came to filling the caddy, which was therefore made with a sliding base or top.

Between about 1710 and 1725 a delightful new pattern was popular, in tea equipage especially, in which the circular form was modified into an octagonal, occasionally hexagonal outline (Plate 78). This attractive variation is also evident in the candlesticks which were made during the period.

78 A pair of Queen Anne tea caddies made by Louis Cuny, 1709, over-struck by Pierre Platel. The arms, Aylmer impaling Ellis, are those of a famous admiral, Lord Aylmer. Commander-in-Chief of the Fleet, 1709-11 and 1714-20. One caddy has a letter B and the other a letter G engraved above the arms and on the lid; these stand for Bothea and Green, two kinds of tea.

79 *Right:* A set of coffee pot, teapot and kettle by Joseph Ward, 1719, a truly superb example of the octagonal form. The Worshipful Company of Goldsmiths, London.

80 *Below:* George I octagonal sugar caster with heavy lobate straps, made by David Tanqueray in London, about 1720. It is engraved with the arms and cypher of George I and once belonged to Sir Robert Walpole. Height 7½ in.

81 *Below right:* Silver-gilt toilet box, originally from a large toilet service, made by John Edwards, 1725. The arms, which are superbly engraved, are those of Joseph Gascoigne Nightingale and his wife Elizabeth, eldest daughter of the 2nd Earl Ferrers. Length 9¾ in.

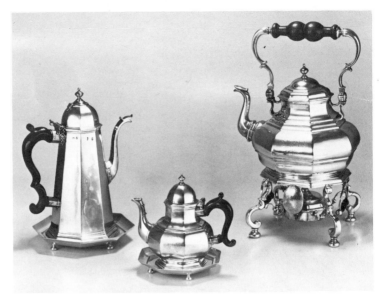

There is a startling difference between the candlesticks of the Restoration period, up to about 1685 or 1690, and those made subsequently. In the earlier period they are almost invariably fashioned from thin sheet silver, the earliest ones with a plain trumpet outline roughly bisected by a large drip pan. Then there are various forms of the cluster column. Most of these are of rather poor quality, but some really exceptional examples were made by Jacob Bodendick, a German immigrant goldsmith of astonishing ability and versatility; there is a magnificent pair of candlesticks by him belonging to Harthill Church in Yorkshire. The early Huguenot candlesticks are invariably cast and are fairly plain, with either a circular or, more commonly, a square base with cut corners, and a baluster

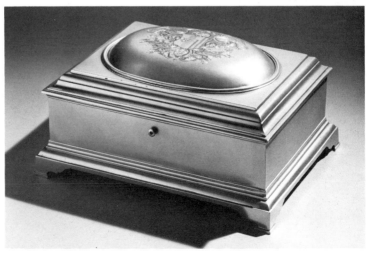

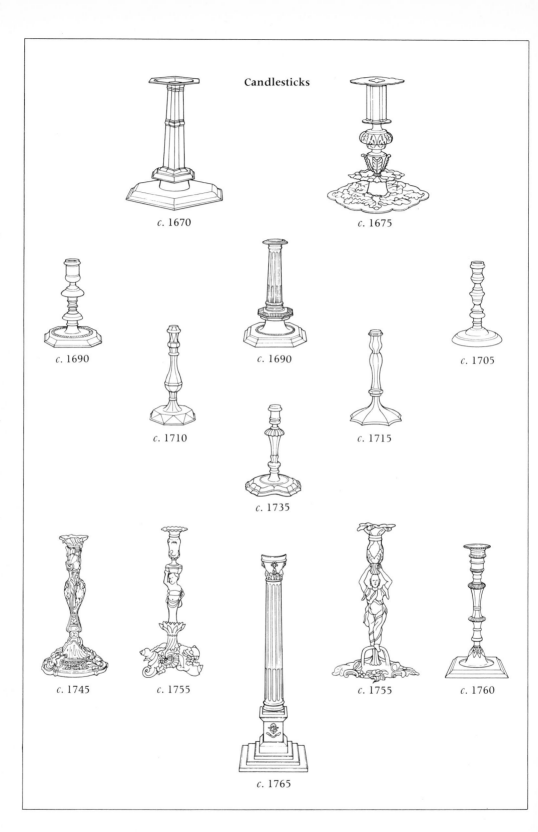

Candlesticks

c. 1670

c. 1675

c. 1690

c. 1690

c. 1705

c. 1710

c. 1715

c. 1735

c. 1745

c. 1755

c. 1755

c. 1760

c. 1765

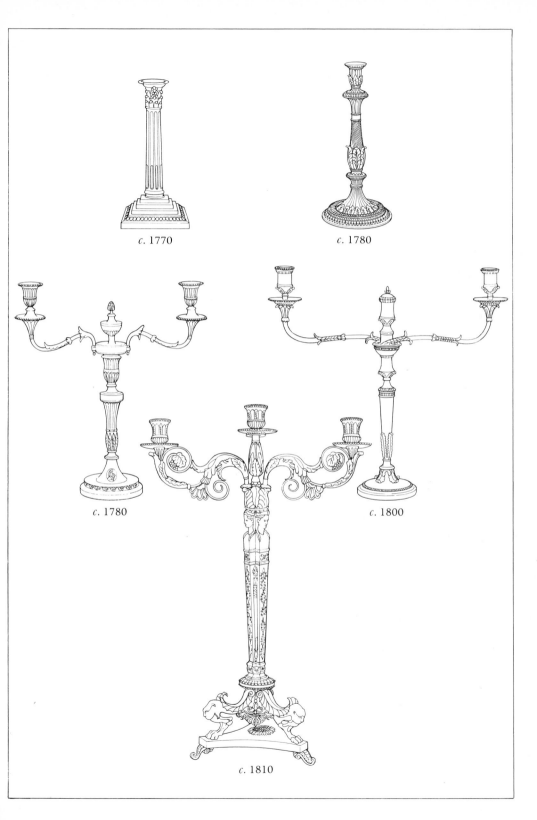

c. 1770

c. 1780

c. 1780

c. 1800

c. 1810

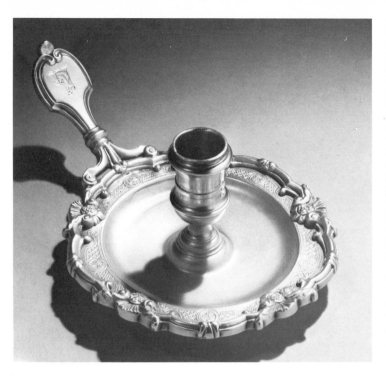

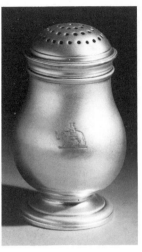

stem incorporating an inverted acorn motif. They are much superior to the general run of rather inferior Restoration candlesticks, but in this instance the Huguenot goldsmiths did not dominate the trade because the English goldsmiths changed over to the new cast type almost overnight. Possibly the finest candlestick maker of the first two decades of the eighteenth century was Thomas Merry, who appears to have specialised solely in candlesticks and snuffer stands.

Up to about 1730 the square base with cut corners remained popular, though octagonal and hexagonal examples were also made in large quantities. There is also a rare form with a base like an open umbrella. Virtually every known form of candlestick in this period was also made in miniature, and these are known as taper sticks. Their purpose is not known for certain, but the usual explanation is that they were used at a desk for melting the sealing wax necessary for sealing letters. The fact that taper sticks are nearly always found as single articles, rather than pairs (like candlesticks), is evidence in support of this explanation.

Apart from the majestic Baroque style of France, the Huguenots also brought to England towards the end of the seventeenth century a number of new objects. The soup tureen, the sauceboat and the hand candlestick all seem likely to have had a French rather than an English origin, and so does

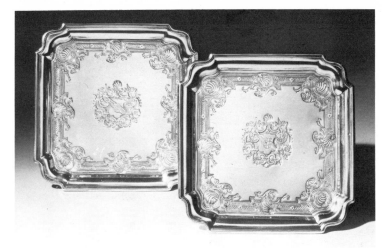

84 A pair of small salvers by Paul de Lamerie, 1732. They are decorated with beautifully drawn engraving which, notably on the border, shows his first awakening to Rococo. Width 6 in.

that long-popular article, the helmet-shaped jug. Other comparatively new objects, such as those associated with tea and coffee, of course developed from changing social customs rather than the background or imagination of silversmiths, while the greater use of cut-card work, for example, was partly the result of the invention of a metal-rolling machine, which greatly reduced the time and effort needed to convert an ingot into a thin sheet.

Like most small foreign communities, the Huguenot craftsmen tended to stick together, often marrying among their own people and, judging by the large number of objects which have one maker's mark overstruck by another, often helping each other in fulfilling a large order. They also remained in closer touch with developments in their native France than did their English contemporaries. By 1726 the French goldsmith Just Aurèle Meissonnier had been appointed court designer to Louis XV, and he was experimenting with a new style which came to be known as Rococo.

Rococo

The Rococo style is easy to recognise visually though not simple to describe in words. It was in part a reaction against the calm monumentality of Baroque, abandoning strict symmetry in favour of flamboyant and whimsical forms and vigorous, even frantic movement. The architectural element in Baroque was totally abandoned and line disappeared under lavish ornament, with decorative motifs drawn from naturalistic forms—the assymetry of rocks (the original meaning of 'rococo' was 'rockwork'), sea creatures and shells. Ornament was cast, chased and engraved with riotous abandon, so that

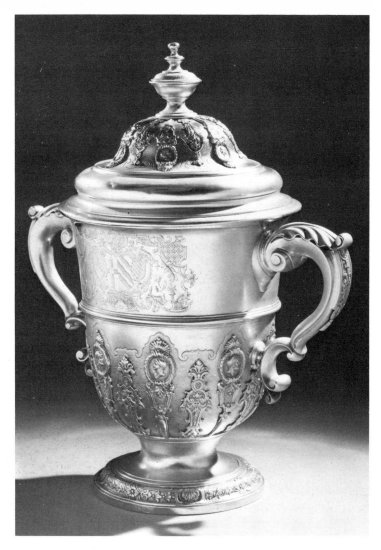

85 George II cup and cover of astonishing brilliance, made by Peter Archambo, about 1732-5. The applied strapwork is of fantastic intricacy and the engraved cartouche is no less remarkable. The arms are those of Brooke of Norton Priory, in the county of Chester, impaling Wilbraham of Nantwich, for Sir Thomas Brooke, 3rd Baronet. Height 13 in. Colonial Williamsburg Foundation, Williamsburg, Va..

the eye finds no place to rest and even something as solid as a piece of silver seems to be in constant writhing movement.

In England the Huguenots were the leaders in the new style. Paul de Lamerie (1688-1751), arguably England's greatest goldsmith in this period, was beginning to break away from the conventional production of his time, and in certain of his pieces in the late 1720s and early 1730s the awakening of Rococo can be detected (Plate 84). In England, however, Rococo never reached quite the heights of extravagance it achieved in France, even in the hands of the Huguenot craftsmen who led the way. There are probably two main reasons for this. It is possible that even the finest English goldsmiths, de Lamerie, Paul Crespin, Nicholas Sprimont and others, were not quite capable of fully realising the Meissonnier designs, which began

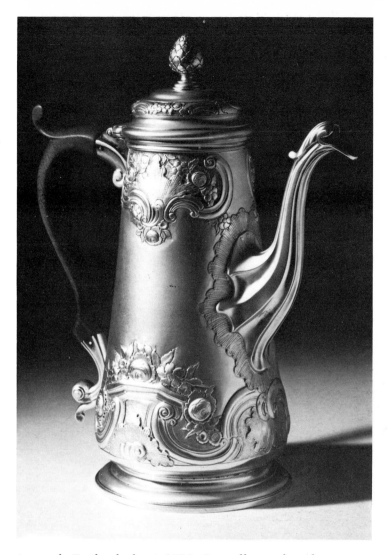

to reach England about 1736. Secondly, and perhaps more significantly, it was not the goldsmith but his customer who had the last word on the object being made. English taste has often tended to be more restrained than French, and the Rococo at its most lavish never had quite the same popular appeal on the English side of the Channel. Even when the style was at its height, large numbers of objects were being made which are essentially plain and simple, perhaps paying faint-hearted lip service to the Rococo in an assymmetrical cartouche for a coat of arms or some other inconsequential feature.

It was not only the customer's taste which decided whether his plate should be plain and simple or elaborately ornamental. The depth of his purse was an equally important factor. The goldsmith charged his customer so much an ounce for the silver

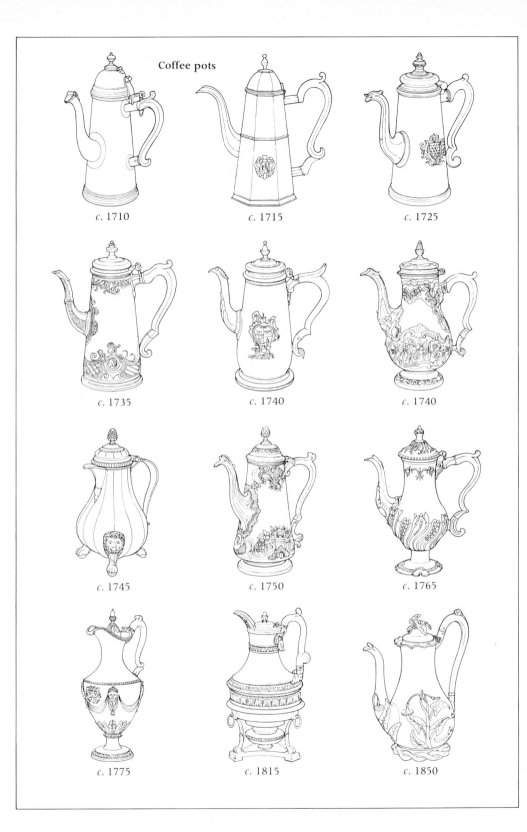

Coffee pots

c. 1710

c. 1715

c. 1725

c. 1735

c. 1740

c. 1740

c. 1745

c. 1750

c. 1765

c. 1775

c. 1815

c. 1850

he used and so much an ounce for the actual fashioning. Obviously, the latter sum depended on the amount of work the goldsmith put into the piece, and possibly the comparative paucity of decoration on many pieces of English silver in the Rococo period was the result of necessary economy rather than a distaste for the current high-flown style.

The two-handled cup and cover, which had come to form such an important part of the goldsmith's oeuvre, retains the bell-shaped outline that was characteristic of it in the early years of the century. The decorative strapwork, however, becomes increasingly naturalistic: gone are the baluster-shaped straps enclosing classical busts; instead, the strapwork bands are formed of shells and flowers winding around the lower half of the body. Handles become more elaborate, consisting of double S-scrolls overlaid with shells and acanthus leaves, while the lids rise to grotesque leaf and rock finials. One unusual series of covered cups, made by Paul de Lamerie, has a snake writhing in and out of the bowl to form the handles, which are richly decorated all over with scalework and grotesque masks.

By and large, teapots and coffee pots escaped the more extreme forms of the new style, especially in the early years of Rococo. However, the plain, straight-sided shape which had characterised the coffee pot for such a long time was gradually abandoned in favour of a taller, baluster form on a moulded foot. In the 1760s they were sometimes given exotic decoration in the Chinese manner. This second period of Chinoiserie is more evident in tea- and coffee pots and their accompanying pieces than in other types of plate. It seems to have been largely inspired by the paintings of Boucher and his school, who were fascinated by the vision of 'Cathay' (China), though of course they knew little of its reality.

Of all the pieces of plate associated with the drinking of tea and coffee, the kettle was most attractive to the Rococo goldsmith, offering plenty of scope for him to exercise his imagination and talent. Some astonishingly elaborate and exquisitely made examples have survived. The tea tray and the salver also offered a generous surface for ingenious and extravagant engraving, though cast work, for obvious practical reasons, was confined to the borders. There are some remarkable Rococo salvers with fine cast openwork borders, but in general it is the engraving that is most striking.

A new piece of plate appeared in the centre of the dining table, the épergne. Essentially, it was a stand for sweetmeats or fruit, consisting of one large basket and a group of smaller ones

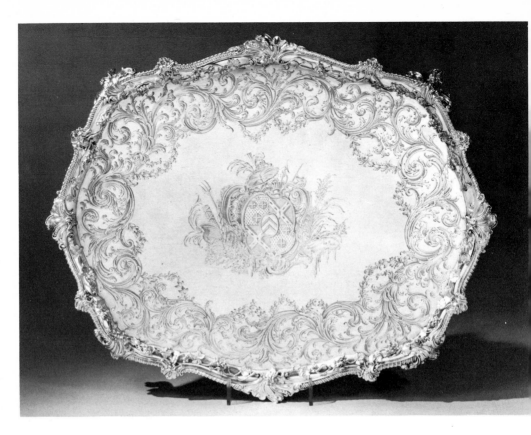

hanging from or fitted to the ends of scrolling branches. It was ideally adapted to the lush ornament of the period, and to Rococo goldsmiths like de Lamerie it offered an opportunity to indulge in thrilling flights of fancy.

Candlesticks wrought in the ornate style of high Rococo are not very common, and those that exist were almost all made by Huguenot goldsmiths (though by this time, of course, the majority of 'Huguenots' were English-born). The most common candlesticks of the period were made by specialist candlestick makers like the Goulds, the Cafes and Ebenezer Coker. They are taller–about ten inches from the 1740s onward compared with an average height of six or seven inches in the first twenty years of the century. The basic pattern is a shaped square base with a shell at each corner, rising to a baluster stem, with a drip pan at the top in the same style as the base. Among other contemporary patterns are hexafoil bases and square, gadrooned bases, often with a swirling lower stem. There are many others.

The branches of candelabra are usually of plain double S-scroll form, the nozzles and drip pans following the form of the candlestick itself. The general run are less than inspired; they

87 *Above:* Silver tray, a real tour-de-force of engraving with its bold border of intertwining foliate scrolls and swags and a brilliant piece of design work for the central cartouche. Length 30 in. Weight approximately 266 ounces. Colonial Williamsburg Foundation, Williamsburg, Va..

88 *Opposite, top:* A George II soup tureen with dolphin handles, shell feet and a crab finial (for fish soup, clearly), made by John Edwards, 1737. Width 16¼ in.

89 *Opposite, bottom:* Three early eighteenth-century snuff boxes, illustrating the very fine quality of engraving prevalent at this period, about 1720.

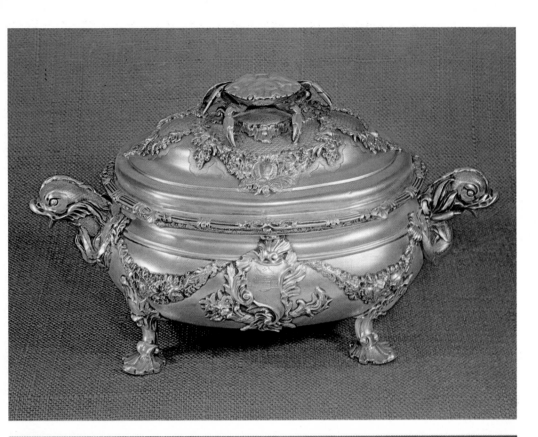

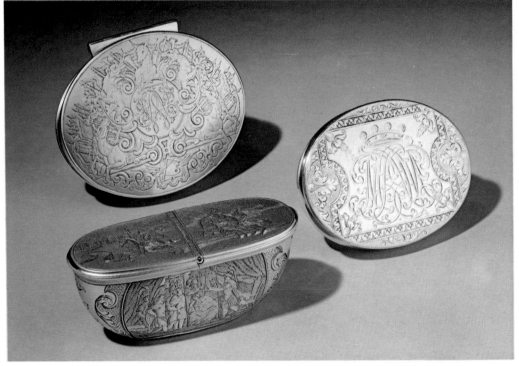

90 *Right:* A George II silver-gilt cup and cover, by William Kidney, London, 1740. Height 14¼ in. The Worshipful Company of Goldsmiths, London.

91 *Below:* 'The Tea Party', an oil painting by an unknown artist, about 1720. The Worshipful Company of Goldsmiths, London.

92 *Opposite, top:* Silver-gilt inkstand and bell, the former by Paul de Lamerie, 1741. It was ordered by the Goldsmiths' Company to accommodate the bell, which has a maker's mark WW and is dated 1666.

93 *Opposite, bottom:* Gilt cup and cover, or tea caddy, in the Adam style by J. Arnell, 1772, with a black basalt ware vase and cover made by Josiah Wedgwood. Victoria and Albert Museum, London.

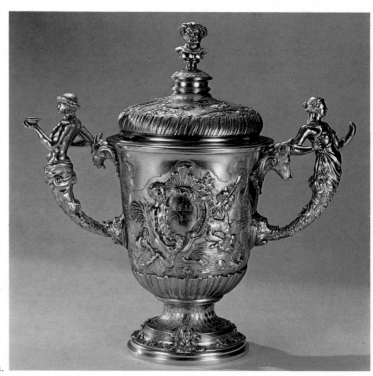

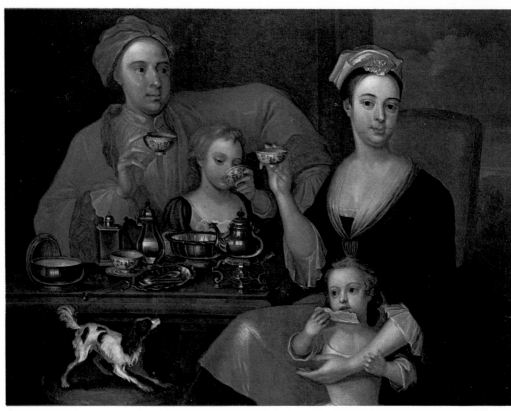

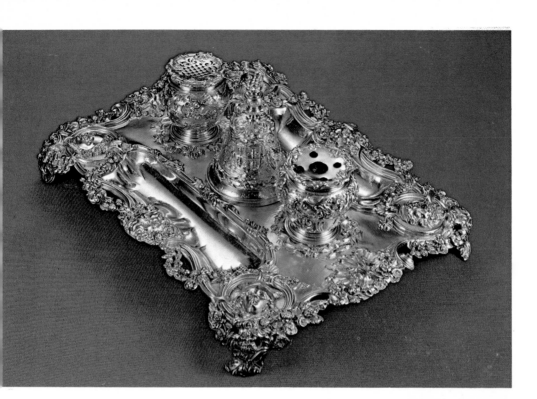

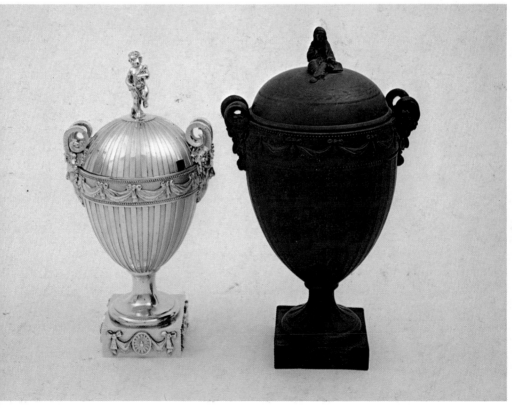

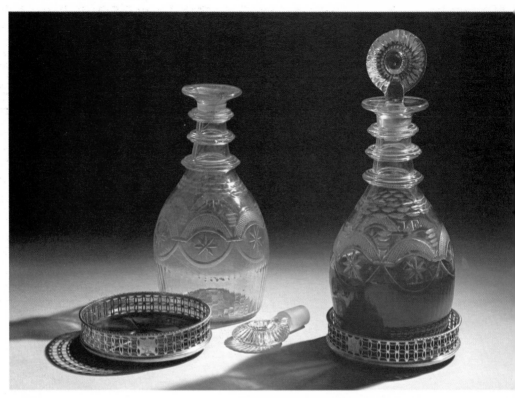

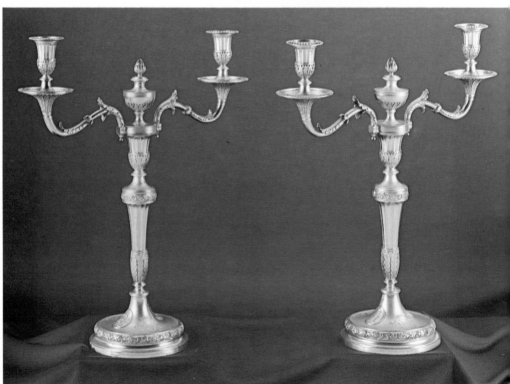

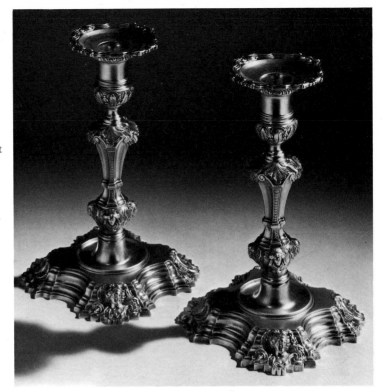

94 *Opposite, top:* A pair of George III bottle coasters by William Plummer, London, 1773.

95 *Opposite, bottom:* A pair of George III silver-gilt candelabra, made by John Scofield, London, 1783. Height 16½ in.

96 *Right:* A pair of the highest quality candlesticks in the best early Rococo taste, with applied masks, shells and foliage, made by Peter Archambo, 1738. Height 8 in.

must have been turned out in thousands for everyday use in the home, although there are some fine flights of fancy by Huguenot makers. Since the late seventeenth century at least, candlesticks had occasionally been made with a human figure forming the stem, and under the influence of the renewed taste for Chinoiserie, some makers, including Aymé Videau and – rather unexpectedly – John Cafe, produced the slightly zany conceit of a Chinese male figure standing on a boldly Rococo, triangular base and holding the actual candleholder and drip pan with both hands above his head.

Like kettles, tea urns, punch bowls and soup tureens were large enough for the goldsmith to display the full exuberance of the Rococo style. An outstandingly elaborate tureen was made by Paul Crespin. It is covered with a cascade of fruit and the bowl is supported by two reclining goats – altogether an ingenious and exceptional piece. Another, by John Edwards, has dolphin handles and swags of crustacea and seaweed, while the finial is a most alarmingly realistic crab. No doubt this was intended for fish soup (Plate 88).

Sauceboats underwent a transformation of form as well as decoration. As we have seen, the early sauceboats are oval, with a lip at either end. By about 1725, they have a lip at one

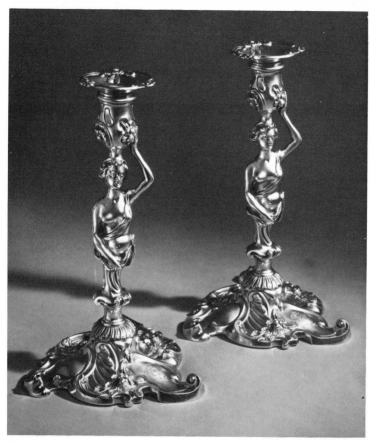

97 A pair of candlesticks, made by John le Sage, one of the Goldsmiths in Ordinary to the King, 1759. The amusing conceit of caryatid candlesticks was quite popular in the late 1740s and 1750s. These examples are engraved with the arms of George II and are considerably better made than most similar candlesticks. Height 11½ in.

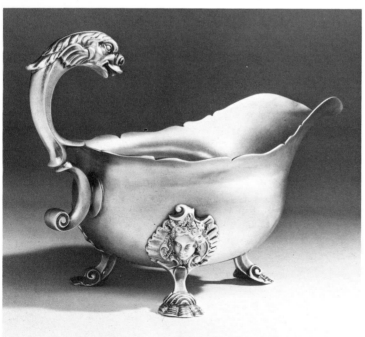

98 Sauceboat, made by William Woodward in London, 1744. The plain body of this fine piece is augmented by a bold Rococo handle, though in general the Rococo feeling is restrained. Length 7 in.

end only, with a single scroll handle at the other, though the oval form, with an oval collet lip, remains. In general these early Georgian sauceboats were left plain or engraved with a band of trelliswork. A more elaborate form began to appear in the 1730s, standing on four lion-mask feet and sometimes with heavy cast festoons, and by 1740 the true shell form of boat had evolved. The sheer exuberance of some of these Rococo sauceboats—a mass of swags and shellfish with handles made as herons or eagles—is a joy. In a particularly beautiful set in the royal collection at Windsor, the shell bodies of the boats rest on dolphins among shells and rocks, while the handles are fashioned as young tritons, scantily clad, seated on the rim. They were made in 1743 by Nicholas Sprimont, who had recently come to England from Liège. He worked as a silversmith for only about seven years before taking charge of the Chelsea porcelain factory in 1748, and as a result his work is unfortunately rare today. What there is of it confirms his astonishing inventiveness and technical virtuosity.

Salt cellars evolved similarly to sauceboats. The salt cellar of the 1720s and early 1730s is usually circular and stands on a collet foot which, as in the sauceboat, eventually gives way to three or four lion-mask feet interspersed with foliage, while a slightly undulating gadrooned rim becomes common. Casters adopt a more pronounced baluster shape. The more expensive ones received extensive applied decoration of swags, masks,

9 A salt, in strong Rococo form, made in 1749. To acquire a superb example of something, it is not always necessary to buy pairs or sets of four. This little single salt probably belonged to a set of four.

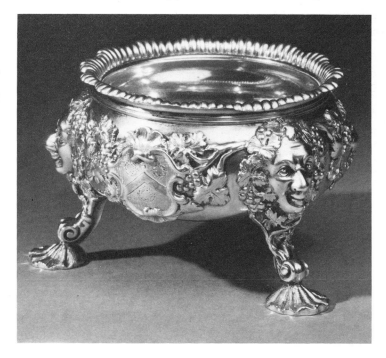

shells and scrolls, while those made for the cheaper end of the
market are naturally much plainer, with the piercing of the lid
alone reflecting the Rococo. Casters were frequently made in
sets of three, one larger than the others. The larger one was for
sugar, the others for pepper and mustard (which was then
taken dry) or other spice. The mustard caster is often engraved
in the same pattern as the other two but not actually pierced.
Occasionally, the three casters are found in a stand or frame
together with two glass bottles for oil and vinegar.

That very delightful object, the silver basket, though made
in the sixteenth century, did not become a common article until
the 1730s. They are generally oval, and some of the early ones
are fashioned in rough imitation of actual basketwork. More
typically, the sides are pierced in an elaborate pattern of
scrolls, with a wavy or scalloped edge and a central swing
handle. There is often an engraved coat of arms on the base,

100 A George II oil and
vinegar set, made in London
by George Wickes, 1742. The
sides are pierced in elaborate
intertwined scrolls and
foliage.

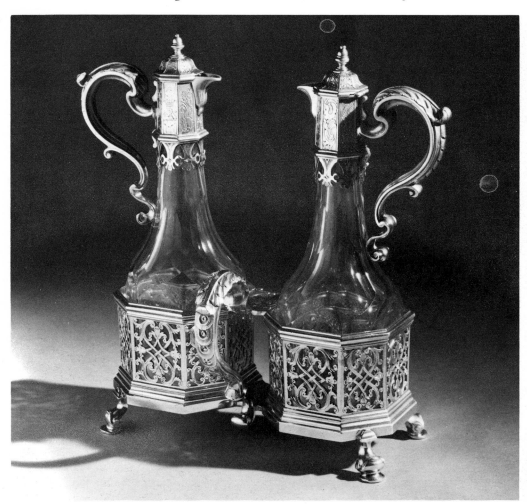

with a border of shells and trelliswork, sometimes flat chased, sometimes engraved. After about 1750 they are lighter in weight and the decoration tends to be less rich, with the luxuriant Rococo ornament giving way to Chinese fretwork and simpler borders, sometimes incorporating a wheat-ear motif. Although these objects are usually called cake baskets, their exact use is not certain. Probably they held cake, bread, fruit, or anything else their owners chose to put in them.

The great quantity of plate produced during the Rococo period without much sign of Rococo ornament should not be forgotten. Plates are a good example. A great many, probably the majority, are relatively plain. At the beginning of the century they were given a simple moulded rim, but later the edges were shaped, with a gadrooned wire border. With some exceptions, they have continued to be made in more or less the same way until the present. Mugs (generally smaller than

101 Silver basket by Paul de Lamerie, 1739. It has cast and applied work, engraving and flat chasing, and is altogether a beautifully composed piece. The detail of the inside of the basket shows how it is still possible today to find silver of this period in mint condition.

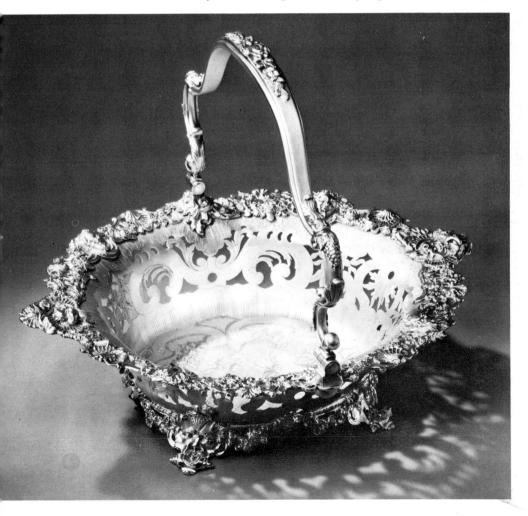

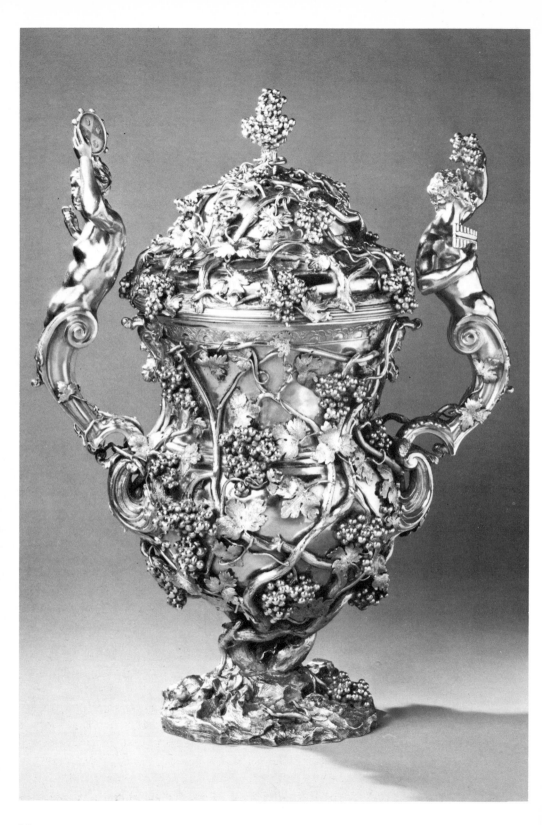

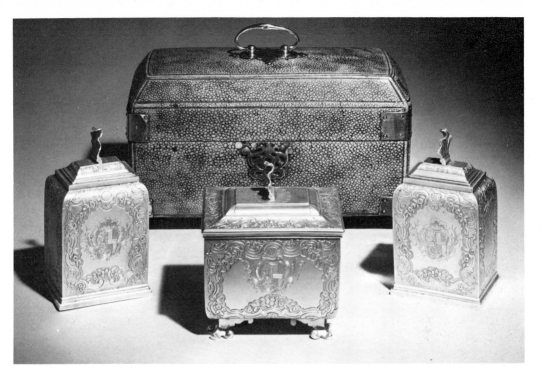

102 *Opposite:* Silver-gilt cup and cover, showing the quite extraordinary elaborations that the High Rococo goldsmiths employed, unmarked but almost certainly made by Thomas Hemming, about 1745-50. The tambourine held aloft is engraved with the arms of Tatton. Height 14 in.

103 *Above:* A pair of tea caddies and a sugar box, displaying good Rococo flat chasing, made by Elizabeth Godfrey in London, 1742. They fit into a sharkskin case.

tankards, and lidless) and tankards were similarly little influenced by the Rococo. The tapering straight-sided form current at the beginning of the century gave way about 1730 to a baluster form, but there is little sign of Baroque grandeur or, later, of Rococo extravagance. Of course there are exceptions. Some very splendid ornamental tankards were fashioned for very wealthy patrons, but most people made do with tankards in a much-diluted version of the prevailing fashion.

The Adam style

Every style eventually provokes a reaction against itself: the pendulum can swing only so far before it reverses direction, and the end of the Rococo came rather swiftly. In little more than the single decade of the 1760s, the pendulum swung sharply away from the whirling extravagance of Rococo: in 1760 the style was still in full bloom, but ten years later it was virtually dead. Hardly a single Rococo object was made after 1770.

The new style was a relatively austere and refined neo-classicism. It is usually known as the 'Adam' style because of the overwhelming influence of the Adam family, especially the great Robert Adam (1728-92). But while Robert Adam did make many designs for silver, they were only a small and insignific-ant part of his total influence, which embraced everything

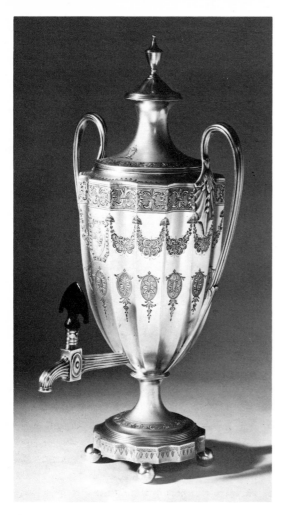
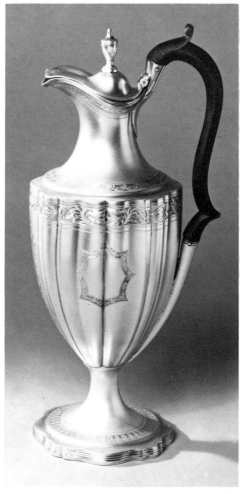

from the architecture of a house, the colour of the ceilings, walls, carpets and curtains, down to the smallest details of interior decoration, even including the view from the windows. Hundreds of his designs are kept today in the Sir John Soane Museum in London, and to see them is a fascinating and rewarding experience.

By the middle of the eighteenth century the Grand Tour was an essential part of an English gentleman's education, and thus many people (Robert Adam among them) went to Italy and other parts where they could see—and sometimes purchase—for themselves the works of the ancient Greeks and Romans, especially the extraordinary discoveries of classical antiquities that had been made recently at Pompeii and Herculaneum. Public interest in antiquity was further stimulated by the writings of art historians like J. J. Winckelmann. With remarkable speed—and remarkable thoroughness—popular taste em-

104 *Far right:* Adam-style tea urn, typical of the extreme elegance of the period. Bright-cut engraving looks beautiful when in mint condition (this tea urn seems to be almost unused) but loses its appeal when worn.

105 *Above:* Hot-water or coffee jug, 1796. The urn-shaped outline typifies the Adam period. Height about 13 in.

braced the classical. Customers demanded only 'the most refined Grecian articles', although in fact many of the patterns adopted were Roman rather than Greek, and many were not strictly either. The use that Adam and others made of the classical was essentially adaptative rather than slavishly imitative. The Adam style has never really gone completely out of fashion, and it is therefore familiar to most people at least through later copies. Much of the decoration is in relief, usually applied on grander pieces, but engraving was also revived, often in the new form of 'bright-cut' engraving – clean and sparkling lines made with a special graver. The forms of silver vessels are frequently based on the urn or the vase, and classical decorative motifs – paterae, ram's heads, anthemion scrolls, laurel festoons and acanthus leaves – are everywhere.

The sauceboats on Georgian dining tables were joined by sauce tureens. These generally look like miniature soup tureens, the favourite shape being oval. They have two elegant C-scroll handles and domed lids with baluster finials. Salt cellars were made to match, with the same elegant handles but no lids. It was now, too, that full tea or coffee services came into fashion. Tea urns are large and gracious (Plate 104); they frequently come in matching pairs of two sizes. Jugs for hot water or coffee follow a similar urn shape, while the teapot and the sugar basin are usually oval, with straight sides and perhaps shaped corners. The milk jug, tall and helmet-shaped, stands on a square or circular collet foot with an elongated C-scroll handle. The commonest form of decoration for the tea and coffee services is bright-cut engraving which, on pieces that

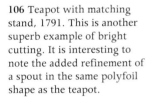

106 Teapot with matching stand, 1791. This is another superb example of bright cutting. It is interesting to note the added refinement of a spout in the same polyfoil shape as the teapot.

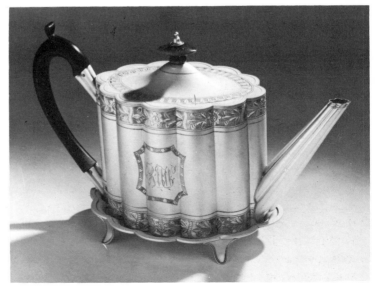

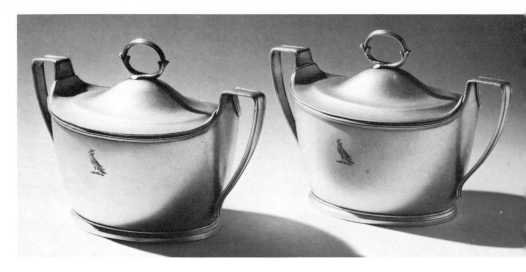

have been protected from much wear, creates a beautiful and sparkling effect. Unfortunately, however, much old silver is not in pristine condition, and this form of decoration loses its original diamond sharpness rather easily.

The appearance of the Adam style roughly coincided with the introduction of new, industrial methods of production. The long-established predominance of London in the silver trade was threatened by the rise of Sheffield and Birmingham, where factory production made silver articles much more easily available. Birmingham goldsmiths had always been regarded as trinket makers and little more, but Matthew Boulton and others employed the methods which the Industrial Revolution spawned to create a genuine art industry in the city. The die-stamping process allowed candlesticks, baskets and similar items to be turned out in thousands. Mass production, plus the thin gauge of metal used (the hollow candlestick was filled with pitch and the base weighted), made them inexpensive. The best work was still done in London, but the cheap filled candle-sticks that poured out of Birmingham must have taken some of the trade away from London, although they also found a new market among people who were not able to afford traditionally hand-wrought silver. Birmingham production, moreover, should not be dismissed as worthless. Some very beautiful candlesticks were made there and in Sheffield, and the rising new middle class, while they required inexpensive articles, also had an eye for general quality and workmanship.

Another development which had enormous effect on the silver trade was the production of what is known as 'Sheffield plate'. Strictly, 'plate' is the term for all silver and gold articles, but it is commonly used for plated silver, i.e. a layer of silver on

107 A pair of old Sheffield-plate sauce tureens, unmarked (as is usually the case with old Sheffield plate), made about 1790. Though fairly simple, they would be both useful and decorative on any table.

base metal. The process of fusing a thin layer of silver on to a copper core had been discovered more or less by chance by Thomas Boulsover in 1742, though it was not employed on a commercial scale until the 1760s. A copper ingot is married to a sheet of silver about one-eighth of an inch thick, hammered firmly and placed in a furnace. Heating fuses the two inseparably together, and after cooling the ingot can be rolled into a workable sheet, then hammered or punched in the same way as solid silver without separating the silver coating from the copper. Any object which can be made in silver can be made in fused plate, and it is obviously much cheaper because of the small quantity of silver used.

During the 1770s and 1780s the commonest object made in Sheffield plate was the candlestick, though some coffee pots and tea urns were also made. From about 1785 a huge variety of objects—épergnes, baskets, teapots, wine coolers, even such small things as wine labels and coasters—were produced in Sheffield. During the last twenty years or so of the eighteenth century Sheffield plate was at its height, and the care lavished on its finishing was equal to that of solid silver. About 1830 a decline is evident. The industry was no longer engaged in making fine objects in the latest manner, and its general

108 A striking pair of silver candelabra made in London, 1807, and presented to Admiral Sir John Duckworth by the Island of Jamaica after he had defeated the French fleet off Santo Domingo. They are of massive proportions and an interesting feature is Duckworth's crest fashioned as a finial in the centre of the three branches. Height 24 in.

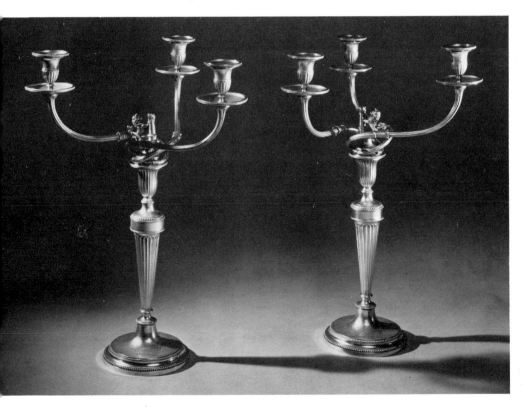

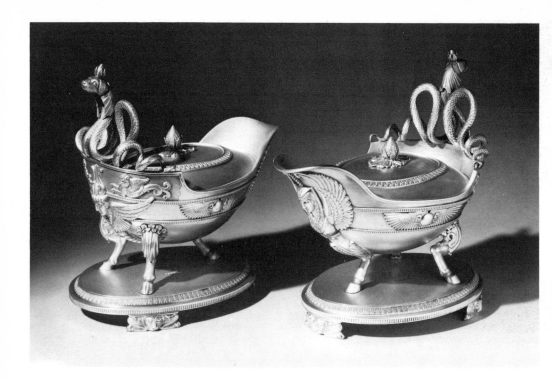

production became old-fashioned and rather dull. Finally, the successful commercial exploitation of electrolytic techniques made Sheffield plate obsolete. Today, however, as long as the piece has not been over-cleaned so that large areas of copper show through, Sheffield plate forms a delightful and highly collectable part of the silver of the Adam period.

Before the end of the eighteenth century the light and pure classical elegance of the 1770s and 1780s was being dissipated, and a tendency towards a grander style, more Roman than Greek, was appearing. It is generally in this new movement towards more massive styles, which remained characteristic of the early nineteenth century also, that high-quality work is most obvious. At the lower end of the scale, mass production resulted inevitably in dilution of the Adam style, and the vitality of the early years diminished. As the end of the century drew near, writes John Culme, 'the charm of the Adam style became less apparent, until even the King complained that the Adam brothers had "introduced too much of neatness and prettiness . . ." ' (*Nineteenth-Century Silver*, Country Life, 1977).

About 1800-10, the neo-classical was briefly and partially diverted to themes inspired by Ancient Egypt. Sphinx-like feet and masks made a brief appearance, though the Egyptian style never had as much influence on silver as it did on, for instance,

109 A pair of George III sauceboats, covers and stands, made in the Egyptian taste by Digby Scott and Benjamin Smith, London, 1806.

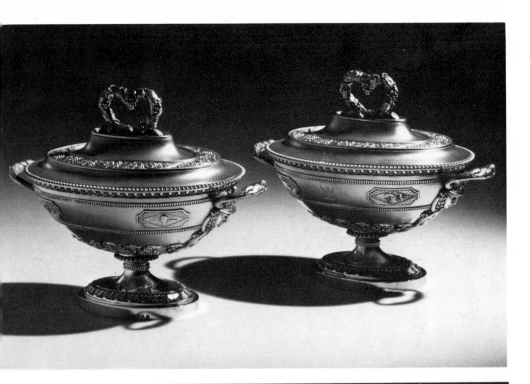

10 *Above:* A pair of outstanding sauce tureens, by Digby Scott and Benjamin Smith, 1803, good examples of the new fashion for massiveness. They have certain characteristics that could almost make them French. Length about 8 in. each.

11 *Right:* A silver-gilt cast bottle-label for sherry, 1830. Many bottle-labels are dreary, but others were made with great care and effort: this example is unusually well made.

furniture. One characteristic of the late Rococo period had been the increasing diversity of styles (even Gothic enjoyed a brief vogue), and the later years of the Adam period show a similar tendency. This time, however, there was to be no sudden and overwhelming changeover in fashion. What is here discernible is the beginnings of nineteenth-century eclecticism.

Nineteenth-century silver

For a number of reasons it is very difficult to describe the silver of the nineteenth century briefly without creating some misleading impressions. One problem is the vast amount of silver made, the prevalence of several different styles, and the mingling of disparate styles in individual pieces. At the same time there was much mere copying, not only of eighteenth-century designs but also of Renaissance or 'Neo-Renaissance' designs. Then there is the enormous quantity of silver of no particular form or merit which was manufactured by the ever-increasing use of mechanised processes. All this creates a good deal of confusion – and distrust – in discussions of nineteenth-century work.

At the beginning of the nineteenth century, the most influential firm of retail jewellers and goldsmiths was the remarkable house of Rundell and Bridge. It began in 1772 when Philip Rundell went into partnership with William Pickett. In 1785 he bought Pickett out and took on John Bridge as a partner. They were men of very different but complementary temperaments, and it was their successful working partnership that raised the firm to the top of the trade. In the earlier period, however, although Rundell and Bridge were already employing the foremost goldsmiths of the time, their silver was not, in general, outstanding. The ambitious and lavish plate for which the firm became famous was mostly made after the time when Rundell's nephew joined it, in 1805 (thereafter it became Rundell, Bridge and Rundell).

The goldsmiths who worked for Rundell and Bridge and dominated English silver for the first thirty years of the nineteenth century included Digby Scott and Benjamin Smith, a partnership which produced some of the most splendid and massive silver ever made, as well as Paul Storr, probably the most famous silversmith of the nineteenth century though arguably no greater than Scott and Smith. The mixture of styles and themes which in the hands of less gifted craftsmen often led to rather curious-looking objects was carried out by these men with striking success. There is, for instance, a dinner service by Paul Storr which combines elements of the classical

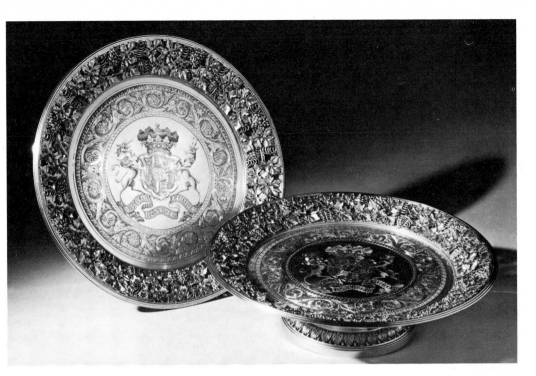

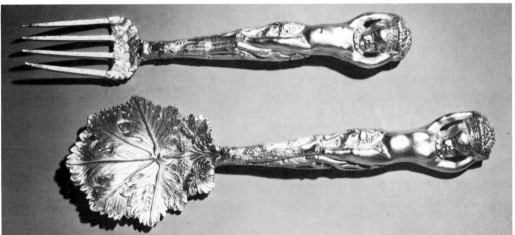

112 *Top:* A pair of typical Regency silver-gilt salvers or dessert stands on a central foot, superbly made and engraved with the arms of the Duke of Richmond and Gordon, 1807. Diameter 12 in.

113 *Above:* A delightful pair of silver-gilt fruit servers of outstanding quality, made by Edward Farrell, 1816.

with Egyptian and Rococo motifs—a very surprising mixture which nevertheless 'works'. The extravagant naturalism that marked the Rococo was not lost but modified by Romanticism. Edward Farrell produced a wide range of pieces employing flower forms in the most naturalistic way, combined with cast cherubs and foliage. Edward Barnard and Sons, another eminent firm which is still in business today, made many articles of similar feeling. One example is a perfect pair of salts in the form of an idealised peasant boy and girl each holding a basket for the salt receptacle. However, a tendency towards

the sentimental is often evident, as it is in a pair of silver-gilt candelabra in the form of flower sellers standing on a grassy knoll with a tree whose branches support the candle holders (Plate 114). Designs of this kind, while possessing less appeal for modern eyes than they did for contemporaries, nevertheless represent some of the loveliest Victorian silver.

Not so long ago, writers often dismissed the last seventy years of the nineteenth century as unworthy of serious consideration. There is certainly much to criticise, both in design and workmanship, but it would be easy to find many examples of faulty design and poor craftsmanship in any other period. Even the most devoted collector should be prepared to admit this fact. Age is not necessarily synonymous with good quality.

The liking for naturalistic decoration gave rise to a rather unfortunate habit among the Victorians which is perhaps largely responsible for posterity's accusations of poor taste and philistinism. A large quantity of eighteenth-century silver was sent by its Victorian owners to be ornamentally embossed. To

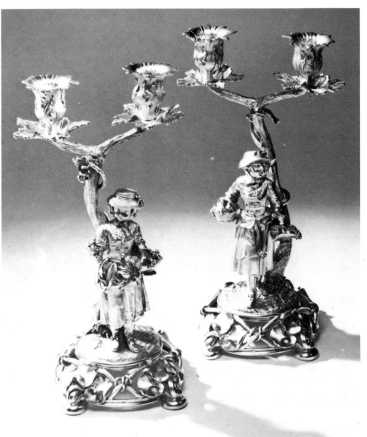

114 *Left:* A pair of silver-gilt Victorian candelabra, 1861. These beautiful examples of Victorian goldsmithing take the form of fruit and flower sellers leaning against a tree, each of which branches into a two-light candelabrum.

115 *Opposite, top:* Silver-gilt inkstand, by Digby Scott and Benjamin Smith, London, 1803. This piece was given by George III to one of his godchildren. The Worshipful Company of Goldsmiths, London.

116 *Opposite, bottom:* Silver-gilt cup, based on a cup found at Herculaneum, by Edward Barnard and Sons, London, 1840. The same design can be found in Minton stoneware.

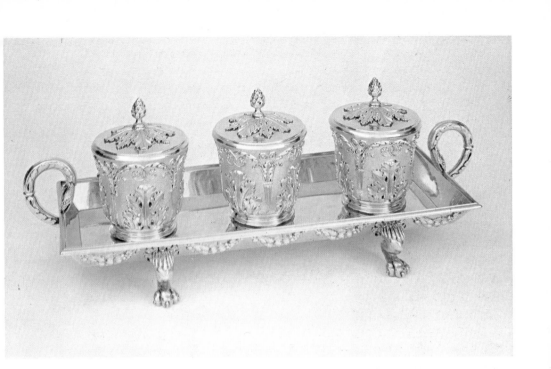

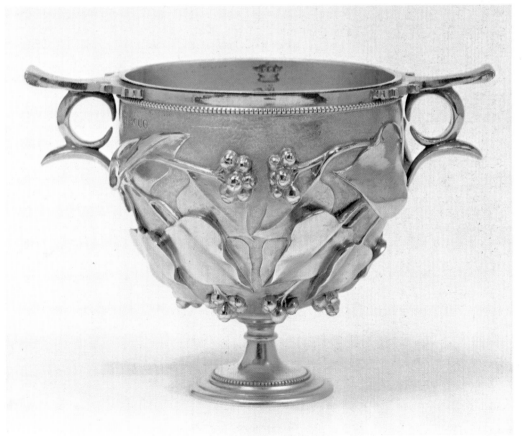

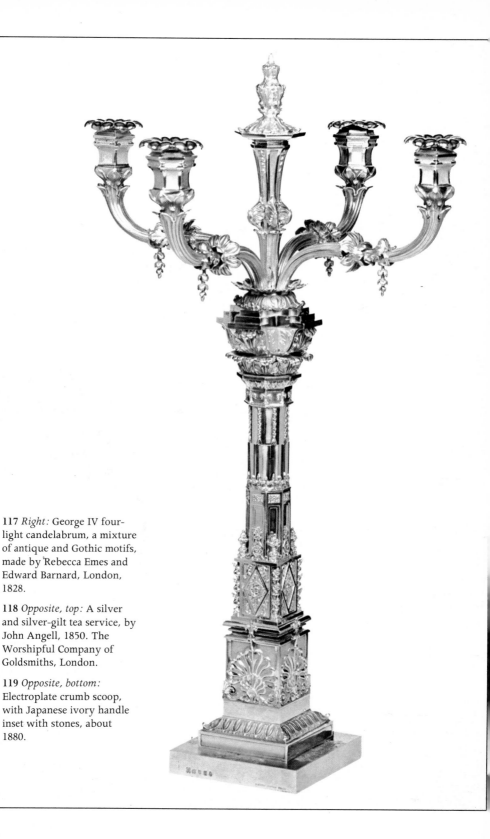

117 *Right:* George IV four-light candelabrum, a mixture of antique and Gothic motifs, made by Rebecca Emes and Edward Barnard, London, 1828.

118 *Opposite, top:* A silver and silver-gilt tea service, by John Angell, 1850. The Worshipful Company of Goldsmiths, London.

119 *Opposite, bottom:* Electroplate crumb scoop, with Japanese ivory handle inset with stones, about 1880.

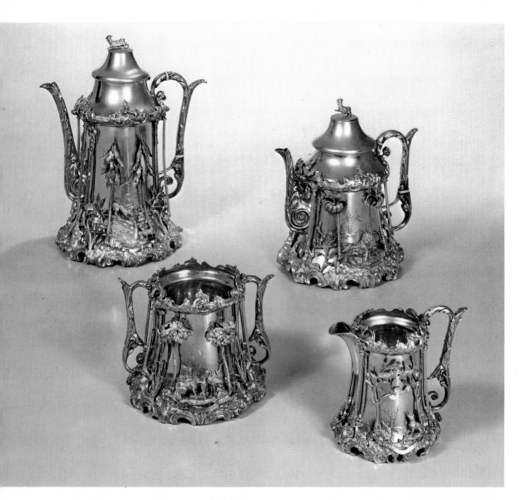

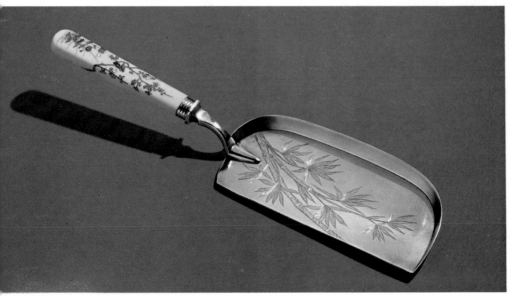

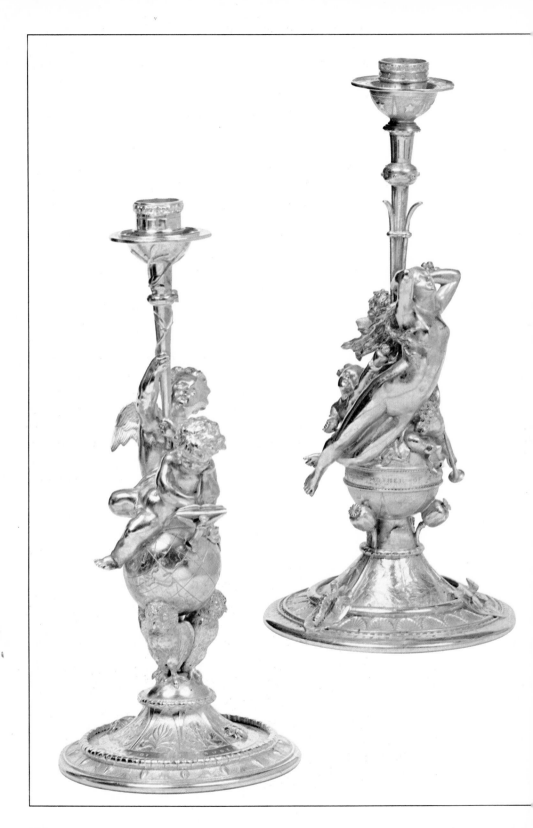

Georgian bowls and cups they added scrolls and foliage, hunting scenes or industrial scenes, or sometimes simply a foliate cartouche in which the name and accomplishments of some civic worthy might be engraved. Much as we may deplore this habit, it should be looked at rationally. Old silver is not necessarily sacred, and for the Victorians Georgian silver was no older than Victorian silver is today. Conservation of old things was not—and, to be fair to the Victorians, did not have to be—so much a matter for concern. Moreover, Victorian design was not always bad. An objective judge would have to say that many 'doctored' articles were at least not spoiled by Victorian additions.

Such an extraordinary multiplicity of designs, such ingenious new methods of manufacture, such creative inventiveness on a scale unrivalled in any other century is displayed by the silver of the Victorian period that it would be absurd for us to treat its aspirations and achievements with scorn or indifference. Not many years ago some of the best work of Victorian goldsmiths used to be melted down without compunction. Let us hope that the work of our best goldsmiths today is treated with greater vision by our descendants a hundred years hence.

In the area of design, there is only space here to pick out some of the main developments. In the Victorian period there was, as everyone knows, a great revival of the Gothic, much more wide-ranging and more authentic than the brief and less serious 'Gothick' revival of the eighteenth century. Silver designed in this Gothic style was, in my opinion, generally

20 *Opposite:* Two Victorian candlesticks, from a set of four designed by G.A. Carter for Hunt and Roskell, London, about 1880.

21 *Below:* An inkwell in the form of a lily, made by Walter Jordan, 1834. This is an early example of the charming nineteenth-century naturalistic form.

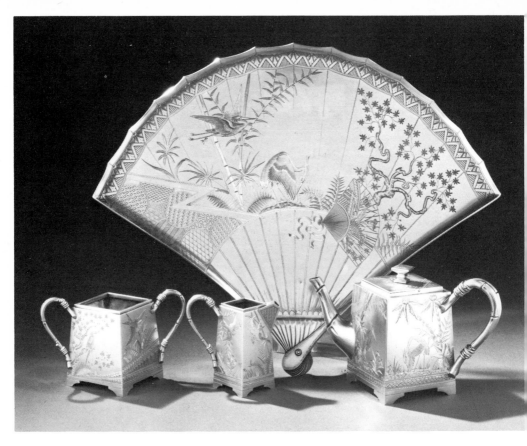

rather unsuccessful. True, some very remarkable pieces were made, and some church plate in particular is thoroughly satisfactory. Secular objects, however, have to my eyes rather an uneasy feeling.

During the latter part of the century there was enormous interest in a style in art and decoration that could hardly have been more of a contrast – the style of Japan. Some of the most delightful examples are the tea sets of about 1870-90, which have parcel-gilt decoration of engraved birds, flowers and butterflies, with handles looking like bamboo and fan-shaped trays (Plate 122). Highly imaginative card cases were also made in the delicate Japanese style, and altogether this is a delightful and (except by a few discerning people) little-known area of Victorian silver. A firm like Elkington and Company made great use not only of Japanese designs but also Japanese techniques, for instance in their employment of cloisonné enamelling on silver or, more often, electrotype wares.

Elkington's of Birmingham achieved their prominence largely as a result of their virtual monopoly of electroplate. Experiments in gilding by electrolysis had begun very soon

122 *Above:* Parcel-gilt tea set and tray in the Japanese taste, by Edward Charles Brown, 1879. Scarcely recognised as something worth considering by collectors until quite recently, the work and craftsmanship of this set is, in fact, simply marvellous.

123 *Opposite:* Wine or water ewer made in Sheffield by James Dixon, 1884. Though known as the 'Cellini pattern', this is not a pure copy of a Renaissance ewer and it should certainly not be dismissed as merely derivative. Height $12\frac{1}{4}$ in.

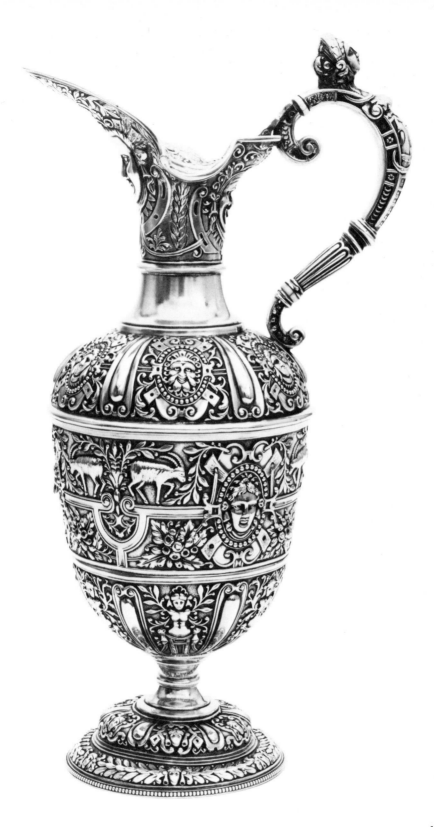

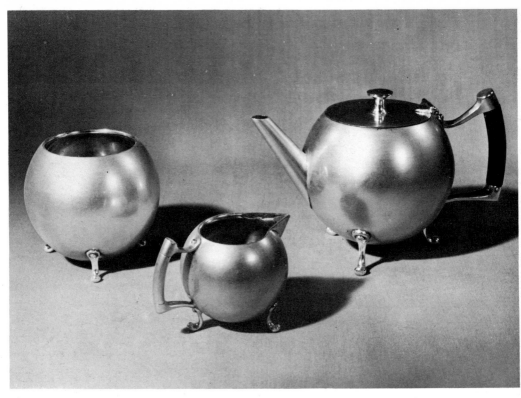

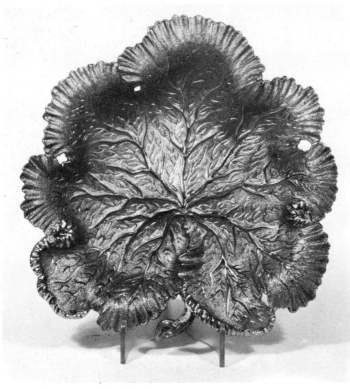

124 *Above:* An electroplated tea service, by Christopher Dresser, 1880. Even today, this tea service seems reasonably contemporary and it is a striking example of the power of Dresser as a pioneer of modern design. Victoria and Albert Museum, London.

125 *Left:* One of a pair of electrogilt (gilding on base metal) dishes, made about 1855. Although beautifully made and to my mind extremely attractive, Victorian electroplate like this would have been thrown out a few years ago.

126 *Opposite:* Glass wine jug overlaid with silver, made by Elkington and Company, 1897. An example of the 'aesthetic' taste of the 1890s, the glass is the colour of crushed blackberries. Height about 14 in. Boston Museum of Fine Arts, Mass..

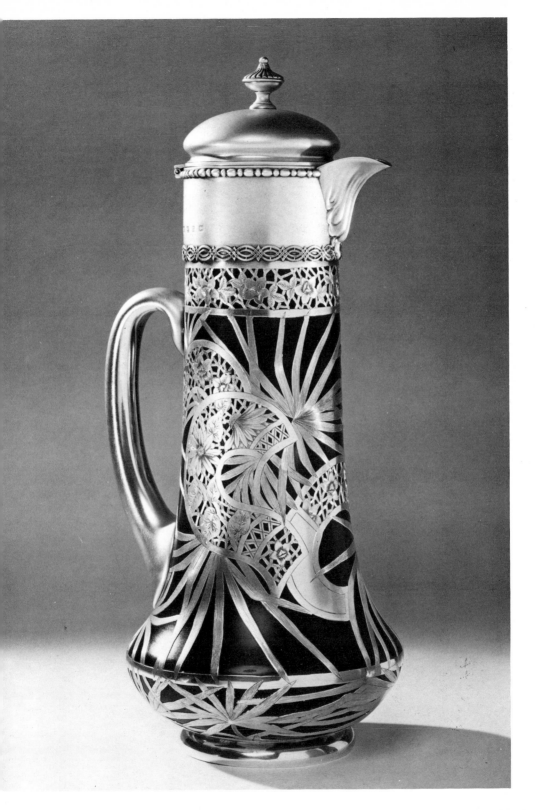

after the invention of the electric battery, and in 1814 Paul Storr had made his famous electrogilded 'Galvanic Goblet' from a design by John Flaxman. The method used then was not practical, but improvements followed, while Elkington's, with great foresight, managed to secure patents for all the most commercially useful techniques. By about 1855 electroplate had driven Sheffield plate into oblivion. Elkington's also produced electrotypes, precise copies of objects (usually in copper) made by electrodeposition, which were then electroplated in silver. Any object could be faithfully reproduced by this method, including natural objects like flowers or sentimental objects like a baby's outgrown shoe. At the same time new alloys like Britannia metal and nickel silver were employed in mass production, using steam-driven machinery. Art schools were established to encourage design, though the new ability to reproduce exactly the articles of earlier times inhibited the development of style.

At the very end of the century, however, a revolution in taste occurred with the flowering of Art Nouveau, a genuinely new and universal style (arguably the last example of such a phenomenon), though it did not supercede all other styles. Owing a good deal to the 'Japanese taste', Art Nouveau's sinuous lines might seem, superficially, not ideally suited to metalwork. The contrary proved true, and some of the most beautiful of all Art Nouveau objects were made in silver. Less than twenty years ago, Art Nouveau silver could be purchased in the most unpretentious antique shop for a song, but since then the style has been engulfed by a wave of renewed popular enthusiasm and prices have risen to what may perhaps turn out to be a somewhat over-inflated level.

127 Carving knife and fork rests in the form of a soldier and sailor having a tug of war, made in electroplate, about 1880. They are characteristic examples of Victorian inventiveness. Length about 3 in.

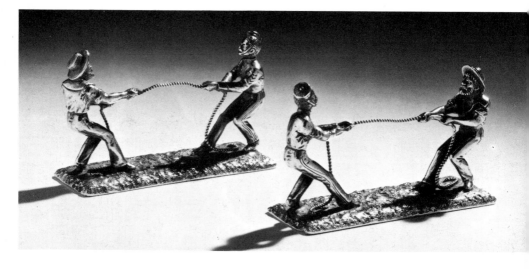

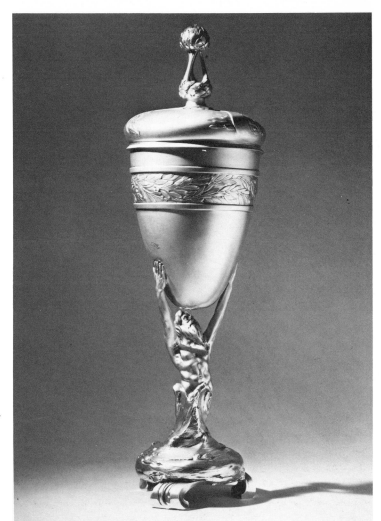

128 *Right:* A dramatic Art
Nouveau cup and cover
depicting a triton rising from
swirling waves and grasping
a cup in his outstretched
hands, made by Aldwinkle
and Slater, 1902. Height 14 in.

129 *Below:* A charming little
butter spade engraved with
flowers and a butterfly,
made towards the end of the
nineteenth century. This is a
perfect little piece for a
discerning collector without
too much money.

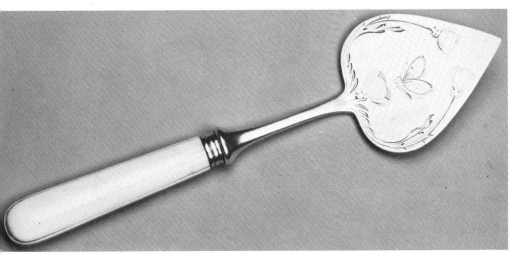

Chapter 4

Cutlery 1500-1900

Cutlery or 'flatware'—the rather curious term used by gold-
smiths for sets of cutlery—requires a chapter to itself. Apart
from the engraving or other ornamental details, it can best be
categorised by features of design that are often not directly
connected with the changing fashions in silver generally.
Moreover cutlery, or spoons at least, provides the best
opportunity for a collector today who is interested in early
English silver—made before about 1600. Larger pieces of silver
from the Tudor period do occasionally come up for sale, but
being so rare they are naturally very expensive. No one can
reasonably contemplate making a collection of English silver
earlier than the eighteenth century unless he or she is either
very rich or is prepared to confine his or her interest to that
fascinating subject, the silver spoon.

Early spoons

The sheer variety—and to some extent perhaps the survival
rate—of early spoons owes something to the fact they were often
given as presents on special occasions such as christenings.
Apart from the many different patterns, the early spoon also
offers the collector a greater chance to investigate provincial
silver—objects made outside London which sometimes manage
to escape the powerful influence of the capital on the silver
trade throughout the centuries. It is only quite recently that
collectors have become aware of the vast number of goldsmiths
who were at work, before 1700, in places as far apart as
Inverness and Falmouth, or Carlisle and Beccles (Suffolk). It is
not always possible even now to ascribe every provincially
made spoon to a particular maker or even to a particular town,
but research goes on continuously and new discoveries are
constantly made—often by spoon collectors—so that our
knowledge of the craftsmen of the past is expanding all the
time.

Most early spoons are hall-marked, and can therefore be
dated accurately, but provincially made examples may well
have no marks associated with the town of manufacture.

London-made spoons up to 1660 are marked with a leopard's head in the bowl with the maker's mark, date letter and hall mark at the base of the stem. (The only exceptions to this rule are early spoons without a finial, such as 'slip-end' spoons, on which the date letter is placed at the top of the stem.) Provincial spoons tend to follow the London practice inasmuch as they have the maker's mark on the base of the stem and something in the nature of a town mark in the bowl. However, in the smaller centres the marking was rather slap-dash: there is sometimes only a single mark, either in the bowl or at the base of the stem, and it is frequently impossible to say whether it is a town mark or a maker's mark.

Such spoons cannot be dated accurately by their marks, and it is therefore necessary to adopt other means. One clue may be provided by the finial or 'knope', as medieval goldsmiths called it, at the end of the handle, which was usually cast and soldered on to the spoon. Some of the main types of early spoon finial are shown in the drawing, with a rough indication of the period in which they were made, but these dates must be treated with caution as the finial is a far from foolproof indication of date. A sounder guide, at least to the approximate date, is the shape of the bowl, which gradually changed over the period from about 1400 to 1650. There are three general rules, which were described in the definitive work on this subject by G. E. P. and J. P. How, *English and Scottish Silver Spoons* (3 vols, 1952). These are the points to watch: (1) the later the spoon, the greater the angle made by the sides of the bowl as they leave the stem; (2) the later the spoon, the smaller the angle of the drop between the stem and the base of the bowl; (3) the curve of the bowl away from the stem, viewed from above, is a concave curve in early examples and changes gradually into a convex curve in later ones.

The great majority of early spoons have an ornamental finial of some kind. As a rule, the finial was cast and then soldered on to the handle. There were two methods of doing this, one characteristic of London and the other of provincial goldsmiths. The London goldsmith or spoon-maker (there were some specialists), having fashioned his spoon, cut a V-shaped notch from front to back in the stem and fitted the finial into the notch before soldering. The provincial spoon-maker preferred a lap joint. This difference continued as long as spoons were made with separate finials. No one has ever explained why, and it seems very remarkable that, over so long a period, all London goldsmiths should use the one method and all provincial goldsmiths the other. But the fact remains that

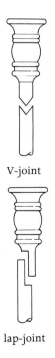

V-joint

lap-joint

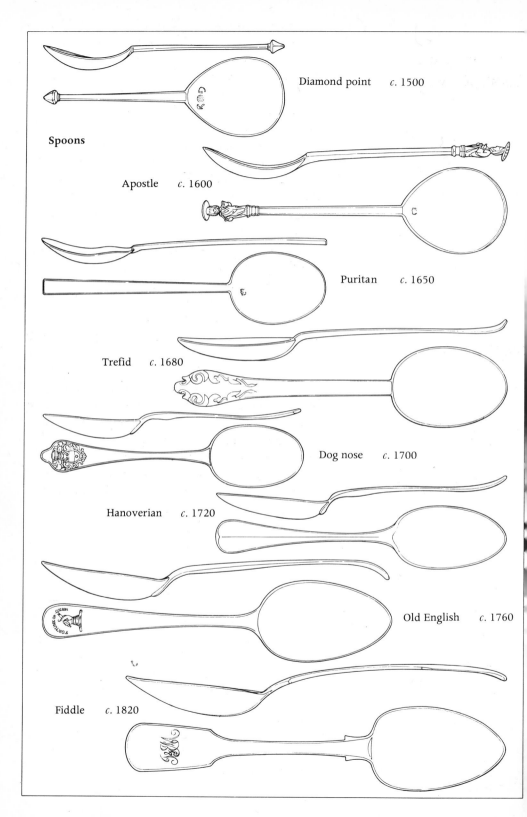

Diamond point *c.* 1500

Spoons

Apostle *c.* 1600

Puritan *c.* 1650

Trefid *c.* 1680

Dog nose *c.* 1700

Hanoverian *c.* 1720

Old English *c.* 1760

Fiddle *c.* 1820

lap-jointed London spoons are extremely rare, while V-jointed provincial spoons are practically non-existent (I have seen just one example). Of course, goldsmiths, like all craftsmen, tend to be professionally conservative, but that is hardly sufficient explanation.

The spoon was hammered from a single small ingot. First, the stem was roughly fashioned, then the chunk of metal left at one end – the future bowl of the spoon – was hammered out into a rough, flat oval. The bowl shape was obtained by hammering it into a lead die, and the whole spoon was filed and planished, ready for the finial to be soldered on. The stem was hexagonal, but as time went on the top and bottom facets became steadily broader, possibly to make more room for the marks, and eventually the two facets at each side of the stem disappeared altogether, making a rounded, more 'modern' shape. By the end of the seventeenth century a strengthening rib or 'rat tail' was made from the junction of bowl and stem, extending about half-way along the underside of the bowl.

In these early spoons, the finial was invariably gilt, though the spoon itself was usually left white, i.e. ungilded. All-gilt spoons do exist, but they are comparatively rare, especially if the gilding is original. The inexperienced collector should try to make himself familiar with the appearance of genuine old gilding, which to the practised eye is not difficult to spot; a dealer who specialises in spoons will probably be the best person to guide him in the detection of the small but important variations in gilding. Then he can at least be sure that the gilding on a spoon is old, even if it is difficult to tell whether it is as old as the spoon.

Apart from the gradual changes in the shape of the bowl and stem, early English spoons are categorised by their finials. Some types which the collector is most likely to come across are listed below.

Acorn knop

Diamond point

Acorn knop A small finial in the form of an acorn appears to have been popular in the Middle Ages. The majority of those surviving were made before 1500, and therefore hardly belong in this chapter. The acorn is usually little wider than the stem, and with one or two exceptions it was fashioned from the same piece of metal as the rest of the spoon.

Diamond point This is also a rare early type, made during the fourteenth and fifteenth centuries. The finial which, like the acorn knop, was generally fashioned in one piece with the spoon, comes to a faceted point like a diamond or a small pyramid.

Apostle spoon This is without doubt the best-known and most keenly collected of all early spoons, gaining its name from the figure of an apostle forming the finial. Apostle spoons, which were being made in the mid-fifteenth century and probably earlier, were no doubt made singly to be given as christening presents, but they were also made in sets of thirteen – the twelve apostles (St Matthias replacing Judas Iscariot) and Christ himself, the Master spoon. Each figure can be identified by the emblem he holds, frequently the symbol of his martyrdom.

The Master always carries an orb and cross in the left hand, with the right hand upheld in blessing. St Peter holds a key. St John, who is the only apostle not holding a book in one hand, raises his right hand in blessing and holds the cup of sorrow in his left. Sometimes the cup has been broken off and it is difficult to distinguish St John from Christ; however, St John is generally (there are some later exceptions) depicted clean-shaven, while all the other figures are bearded. St James the Great carries a pilgrim's staff and occasionally a shell on his back or hat: he is the patron saint of pilgrims and the shell was the sign of the pilgrim in the Middle Ages. St Andrew carries a saltire (X-shaped) cross; St Simon the Zealot a saw; St James the Less a fuller's bat, a slightly curved club-like object; St Thomas a spear. St Matthew sometimes carries a carpenter's square, symbolic of the church he is supposed to have built for the king of Ethiopia, but after about the mid-sixteenth century he is generally shown with the money bags of a tax collector. St Bartholomew carries a flaying knife; St Philip three loaves commemorating the feeding of the five thousand or, from about 1570, the short Latin cross; St Jude a long cross; and St Matthias a halberd or pole-axe.

Occasionally other saints appear. St Paul, for example, although not one of the twelve apostles, frequently crops up singly and is sometimes found in sets, usually taking the place of St Matthew; he is identifiable by the sword he carries. His appearance is largely due to the fact that he was (and is) the patron saint of London. All the figures generally, though not always, have a nimbus or halo, which in earlier examples is pierced but, towards the end of the sixteenth century, becomes solid, with the Holy Spirit as a dove impressed upon it. In London, Apostle spoons ceased to be made in the 1630s or early 1640s, but in the West Country, notably in Exeter and Taunton, they were still being made in the 1660s and 1670s, although by that date spoons with ornamental cast finials of any type were something of an anachronism.

130 A magnificent set of twelve silver-gilt Apostle spoons, the most keenly collected of all early English spoons.

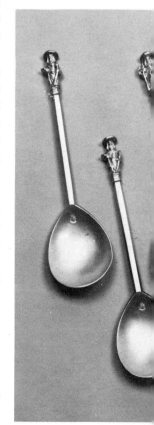

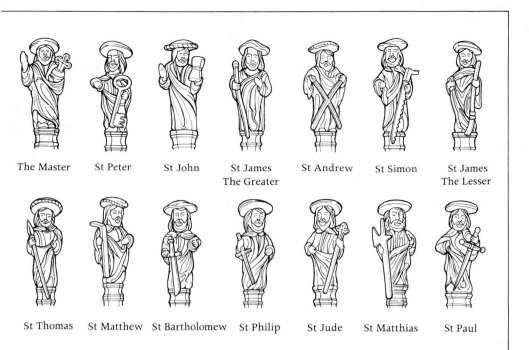

The Master | St Peter | St John | St James The Greater | St Andrew | St Simon | St James The Lesser

St Thomas | St Matthew | St Bartholomew | St Philip | St Jude | St Matthias | St Paul

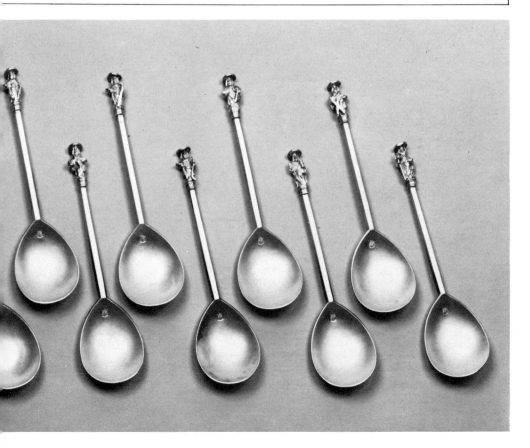

Wrythen knop An extremely attractive finial in the shape of a ball with spiralling lines, it was invariably cast as a separate piece. Surviving examples, which are rare, date mainly from the late fifteenth or early sixteenth centuries. The same form, incidentally, can sometimes be seen on casters made in about the third quarter of the eighteenth century.

Wrythen knop

Seal top A fairly common finial varying in form according to place and date of manufacture, the seal top is something like a shortened baluster top sliced off halfway up. Examples are known from the early fifteenth century up to about 1660; earlier seal tops are small, and the finial tends to grow larger and more elaborate with the passage of time.

Maidenhead finial It was once assumed that this finial of a female head and bust emerging from foliage or set on a plinth was intended to represent the Virgin Mary. However, there is no halo, as one would expect, and the woman's hair is done up, though maidens, or virgins, in the Middle Ages were accustomed to wear their hair hanging down. It is therefore unlikely that the figure is intended to represent a virgin, still less the Virgin Mary. There are some other spoons which do have the lady's hair down and, since she is holding the Sacred Heart, they can be taken as representing the Virgin. Maidenhead spoons were made in the fifteenth century and only disappeared about 1650.

Maidenhead

Lion sejant A finial in the form of a seated lion was certainly made in the fifteenth century and continued until the early seventeenth century. On early examples, the lion sometimes sits sideways (sejant guardant), but more commonly it faces forwards. It sometimes holds a shield before it, on which, presumably, the owner might have engraved his arms or initials.

Lion sejant

Baluster top This occurs in a variety of forms, often bearing some resemblance to the shape of a pawn in a traditional chess set. Examples are known from the late fifteenth century or earlier, but there are a greater number from the late sixteenth and early seventeenth centuries.

Baluster top

Slip top Slip-top spoons have no finial: the top of the stem is cut upwards from the front at a sharp angle. There are French spoons of this type from the fourteenth century, and though the earliest English example found so far is hall-marked 1487, they were almost certainly made earlier. The slip top was a very popular type: they were still being made in the reign of

Slip top

Puritan

Trefid

Scottish seal top

Scottish disc end

Charles I, and there were even a few made after the Restoration.

Stump top They are similar to the slip top, except that instead of the angled cut, the top is rounded off. They usually have heavy, octagonal stems and the rounded terminal, when new, would sometimes have been pyramidal in form.

'Puritan' spoon The name is rather unhelpful except that it provides an indication of date, which is from the mid-1630s to the Restoration, or to about 1670 in the provinces. A development of the slip and stump tops, with the end cut at a right angle, they were the first spoons to be made with flat rather than faceted stems, and although their period of popularity was short, they led the way to future developments.

Trefid spoon The 'Puritan' spoon was superceded by the trefid spoon: the end was flattened out and two small notches cut in it. In its pure form, the trefid spoon lasted from about 1660 to about 1700, although it was still being made in Exeter in about 1720 and in the Channel Islands thereafter. Later varieties are sometimes called 'dog-nose' and 'wavy-ended' finials: the notches were omitted and the finial was broadened and shaped. The 'rat tail' made its first appearance on the underside of the bowl of the trefid spoon, which is the true ancestor of the modern spoon.

The early spoons described above were made both in London and, to a greater or lesser extent, in the provinces too. There are, however, some types of spoon which appear to have been made in the provinces only and betray marked regional idiosyncrasies.

Scottish spoons, which are generally rare, have a definite character of their own. The Scottish seal top, for example, is markedly different from its English equivalent. The stem is thin and flat, unlike any English spoon of the late sixteenth century, and the finials are small and oblong.

Disc end The most familiar of early Scottish spoons is probably the disc-end spoon, which seems to have been the most widely used silver spoon in Scotland in the late sixteenth and seventeenth centuries, though few have survived nonetheless. The Scottish disc end appears to be the only spoon of its type made anywhere in the British Isles at that time, though there are somewhat similar ones from the North of England. The shape of the bowl is very nearly circular, the stem is flat and the finial consists of a disc at the top with a smaller, secondary disc below it. Initials are usually engraved on the top disc, with stylised acanthus leaves below.

A small number of Scottish 'Puritan' spoons exist. They have the same nearly circular bowl, a characteristic not found in southern England at that time, while the stem is broader and more splayed at the top. There is often some stylised acanthus decoration on the front of the stem, as in the disc-end spoon from which they evolved. Dating from the mid-seventeenth century, they form a link between the disc end and the trefid spoon.

South of the border, there are fewer exceptions to the general types of spoon being made in London. In York some *memento mori* spoons similar in type to the Scottish disc end were made in the reign of Charles II. The bowl is generally shaped like a trefid spoon of the period and at least one example has a standard trefid top instead of the Scottish disc. There is either a coat of arms or a death's head engraved on the top disc, and the stem is engraved with the words 'Die to live' on one side and 'Live to die' on the other. While normal spoon forms sometimes have birth dates engraved (e.g. 'Eliz: Nubery, born a Tuesday nite Sept^re 17th'), these memorial spoons appear to have been made exclusively in York and for a period of not more than about twenty years.

Scottish Puritan

To the observant and experienced spoon collector there are differences to be detected in the majority of spoons made in different parts of the country, but for the most part the variations are so small that to attempt to describe them would be more confusing than helpful, especially as there are always so many exceptions to every rule. However, there are two varieties of early spoons from the West Country which should be mentioned, as they appear to have no parallel with spoons made in London or any other part of England.

York death's head

Female-figure top Also called a mermaid spoon, this bears no relation to the maidenhead finial described earlier. The figure, or rather half-figure, is semi-nude, with hair worn long and arms akimbo below very prominent breasts and above an equally prominent belly. All known spoons with this finial are of good quality, some exceptionally good, and are often finely engraved with intertwining foliage as seen on the best London-made tankards and wine cups. So it is safe to assume that they were held in high regard. They were made towards the end of the sixteenth century and nearly all of them seem to have come from Barnstaple, though one or two may have been made in Plymouth. The caryatid form of the finial on these spoons can also be seen in the carved woodwork and plaster of the period and as part of the strapwork decoration on some London-made

Female figure

silver-mounted jugs. This makes it all the more surprising that spoons with this finial should apparently have been made exclusively in Devon.

Buddha knop

Buddha knop This also comes from Devon, chiefly Barnstaple, and dates from about 1630. No one really knows what the figure represents: it may be no more than a crude and debased version of the female-figure top, it may be an oriental deity (Krishna has also been suggested), and some authorities have even suggested an African origin. The one thing that can be said of these finials with complete conviction is that they are excessively ugly.

Knives and forks

Though knives are as old, or older than spoons, silver does not make a good cutting edge and blades were therefore usually made of steel. Silver-handled knives were made at an early date, though examples from before the mid-seventeenth century are so rare as to be virtually non-existent today. The earliest knives found in sets were made about 1690, with tapering, rounded or polygonal handles. A curved handle like a pistol grip prevailed in the early eighteenth century; a few specimens from the Rococo period are highly ornamented. The curve of the handle gradually shrank and in the Adam period became straight again, and sometimes reeded.

Although some heavy cast handles have survived reasonably well, after about 1760 the high price of silver encouraged the use of very thin stamped silver sheet on a resin core. With only a few exceptions these knives are in a sorry state today, full of holes and apparently on the point of disintegration. They are hardly worth the attention of the collector.

The history of the fork in England before 1700 is almost entirely conjectural. To the disgust of more sophisticated foreigners, the English in general continued to use the point of their knives to convey food from plate to mouth, though in the houses of the nobility forks were probably in common use at a date earlier than 1632, the year in which the oldest known example was made. Now in the Victoria and Albert Museum, this is a two-pronged fork in the 'Puritan' style, made in London. However, a set of twelve forks was recorded in the inventory of the royal jewels as early as 1550, and there is other documentary evidence of table forks not much later, though it appears from contemporary descriptions that forks were more often used by boisterous guests to poke their neighbours in the posterior than to eat their meat. Forks

followed the pattern of spoons, and trefid forks from the late seventeenth century can be found, though there is virtually no chance of acquiring more than single specimens.

Eighteenth- and nineteenth-century cutlery

At the beginning of the eighteenth century the prevailing pattern in flatware was the dog-nose pattern, a development of the trefid spoon and fork. The bowl of the spoon is long and oval with a 'rat tail' on the back, the stem is more rounded than the earlier trefid type and terminates in a scalloped or shield-shaped top. Fork stems conform in design and usually have three tines or prongs, rounded in section, though they are sometimes found with two tines.

The dog-nose pattern lasted from about 1690 to about 1710, when the plain and elegant Hanoverian pattern became dominant. On early spoons of this type, the 'rat tail' is still in evidence, but by about 1730 it tended to be replaced with a shorter tongue-shaped support. The rounded tops of spoon and fork turn up at the end, and for that reason they were always engraved on the back of the stem. Forks are still usually three-pronged, though examples with both two and four prongs exist.

About 1760, the spoon stem acquired a downward turn and the bowl became more egg-shaped; at the same time all forks were made with four tines. This is known as the Old English pattern, and it lasted with a number of minor variations until about 1820. During the 1770s the Old English pattern was sometimes feather-edged, and when that was done the spoons and forks were sometimes given a small shoulder just above the base of the stem. Since spoons now turned downwards, the engraving was done on the top of the stem. In the 1780s fashion dictated a still lighter and more delicate version of the Old English pattern, and that resulted in the hall marks being moved from their usual situation near the bowl to a point near the top of the stem. Bright-cut engraving became common at this time, and although it was quite short-lived in England, in Ireland it remained popular much longer. In Ireland, and in Scotland too, the spoon and fork in the Old English pattern tended to be slightly elongated by comparison with English-made equivalents, and normally had terminals which were slightly pointed.

A totally different pattern, standing apart from the general evolution of Hanoverian and Old English, appeared in about 1745. It is called the Onslow pattern, allegedly named after a well-known speaker of the House of Commons, and had deeply

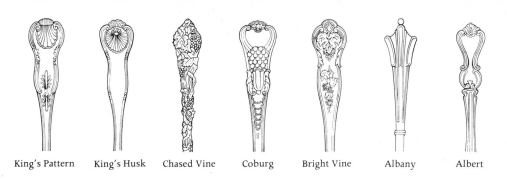

| King's Pattern | King's Husk | Chased Vine | Coburg | Bright Vine | Albany | Albert |

fluted stems and scrolled terminals. Though attractive, it was never very popular and disappeared again about 1770, the reason no doubt being that its visual appeal did not compensate for the fact that it was inconvenient in use; significantly, surviving examples are often gravy spoons or ladles rather than ordinary table cutlery.

About 1820 the Old English pattern gave way to the fiddle pattern, which had gained its name from the superficial resemblance of the outline of the stem to a fiddle or violin. The bowl of the spoon is egg-shaped – the standard form since the third quarter of the eighteenth century – while the shoulder above the bowl and the matching spatulate top of the stem create the impression of the 'fiddle'. There are three main variants of this pattern: (1) fiddle thread, in which a single line is deeply incised around the stem about one-sixteenth of an inch from the edge; (2) fiddle shell, in which a shell, made by sinking into a die, appears in relief at the top of the stem; (3) fiddle thread and shell, combining the two former elements.

After about 1820 there was an insatiable demand for more and more elaborate die-struck patterns, such as King's Pattern, King's Husk, Queen's, Chased Vine, Coburg, Albert and many others. Most of them, like the fiddle pattern, are still being made today and a visit to a large cutlery shop is the simplest way to become acquainted with them.

Victorian flatware is not, perhaps, of very great interest to most serious collectors, but it does have the advantage of being much more readily available than earlier cutlery. There is little point in a collector seeking sets of spoons and forks of even the Hanoverian period: they exist certainly, but not only are they expensive and hard to find, they almost invariably consist of 'made-up' sets – individual matching pieces collected from different sources. One tip worth remembering, for anyone who is considering collecting a set, is that, whatever pattern strikes his or her fancy, it is advisable to look for dessert forks first. They are invariably the most difficult pieces to locate.

Chapter 5

Collecting silver

Collecting things seems to be a common human preoccupation; but not everyone starts a collection, whether of antique silver or postage stamps or even football programmes, for the same reason. Someone who is contemplating a collection of silver, and therefore preparing to spend quite large sums of money, should consider carefully his or her reasons for doing so before making a start. Some collectors are not really interested in art objects as such but feel that in an age when the value of money is declining so swiftly their capital would be more profitably invested in English watercolours or Chinese jade than it would be in banks or building societies. This is not a good reason for becoming a collector. People who are governed by purely commercial motives seldom accumulate a collection of silver or anything else that is really valuable. Because they tend to think only in terms of relative values, graphs and statistics, they are wary of high prices and unwilling to spend what seems to be above the norm. Therefore they never acquire the finest examples in whatever field they happen to be operating. They may well end up, sadder if not wiser, as financial losers. Objects of any aesthetic merit cannot and should not be treated as mere commodities. In the words of John Culme and J. G. Strang, 'Anyone . . . who collects silver for its investment value alone misses much. To feel a piece of Queen Anne silver, for example, with its cool blue lustre, to study the proportions thoughtfully and to consider its details and artistry elevates us above the mischief of finance and the snobbery of taste. In its finest forms silver almost lives. Like velvet, or polished wood, it invites touch, sight and thought' (*Antique Silver and Silver Collecting*, Hamlyn, 1973). In any case, and on a more mundane level, the price or value of silver is affected by other factors besides the money supply or the state of the capital market. They are affected, for example, by changing taste: what seems particularly attractive and desirable now may have lost its popularity in a few years' time and its real value in cash terms will decline accordingly. Not since the seventeenth century have people generally put their money into plate. They found

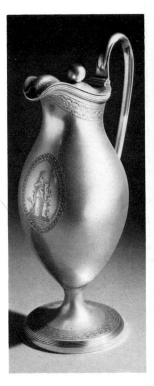

131 Water jug in the Adam style, made in London by John Schofield, 1781. An attractive and useful piece, it would be a fine addition to late eighteenth-century dining-room furniture. Height about 12 in.

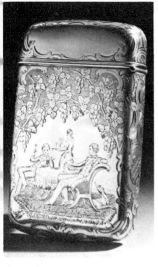

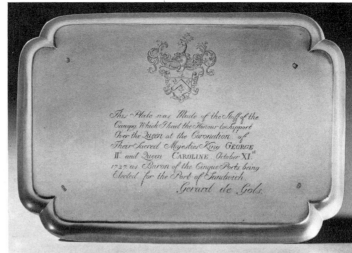

132 *Above:* A typical Victorian piece, a cigar case of 1846. Virtually useless, though charming, its main attraction lies in the vignette of two gentlemen drinking.

133 *Far right:* An extremely interesting commemorative salver of 1727. The wardens of the Cinque Ports used to hold a canopy over the king and queen at the coronation. The staffs which supported the canopy were silver-mounted and topped with a silver bell. After the coronation, each warden was given his staff and bell, and in this case Gerard de Gols had the silver re-fashioned into a salver. Historical inscriptions like this can add enormously to the interest of an object; such pieces are eagerly sought by collectors.

134 *Right:* Small silver-gilt bowl, made by John Angell for William Beckford (builder of Fonthill Abbey), 1812. Victoria and Albert Museum, London.

better methods of investment, and it is strange to think of modern collectors reverting to such primitive behaviour.

Of course, it is unlikely that a collection of silver will decline in actual cash value over a period of time. Inflation alone will prevent that, and a collection purchased with reasonable care and common sense will most likely appreciate. Even so, the rate of inflation in recent years has outstripped the rise in price of many art objects, and this, plus the unforseeable vagaries of fashion, makes collecting silver for commercial reasons alone a very doubtful activity.

Although silver has been made for many centuries, the collecting of old silver is comparatively recent. Art collecting on a large scale – pictures, sculpture, porcelain and other

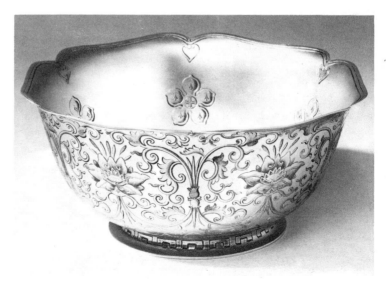

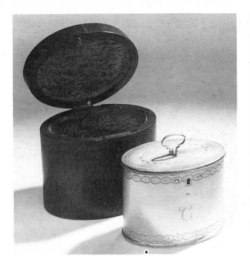

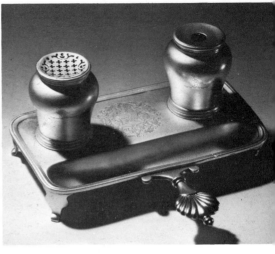

objects—was well established in the eighteenth century, but silver, except for the odd old and spectacular piece, was not generally collected until Victorian times. Silver objects were made for use or display, or both. At the same time they represented, especially in the days before banks, a convenient and attractive way of storing cash. Large or sudden expenditure was met by melting down the family plate; similarly, a surplus of cash was invested in silver. But it would be wrong to suppose that this was ever the sole reason for owning silver; otherwise, it would have been better to invest in silver ingots rather than hand-wrought vessels. No doubt the delight that

135 *Far left:* Tea caddy with wooden box, 1776. Not very useful today, but a pretty thing to place on a table nevertheless. It is unusual to find single caddies in a box; more often they were boxed in pairs or sets of three.

136 *Above:* Small inkstand, made in London by Edward Feline, 1749. A perfect piece for an early eighteenth-century desk or bachelor's chest. Length about 6 in.

137 An unusual pair of old Sheffield-plate tea caddies, about 1785.

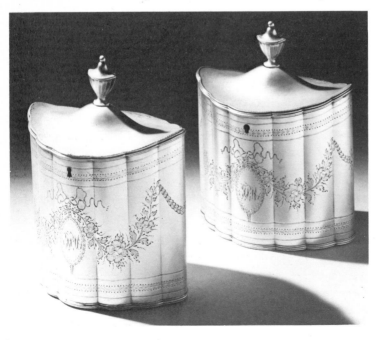

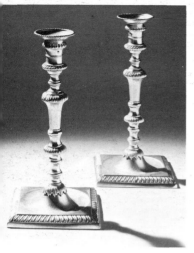

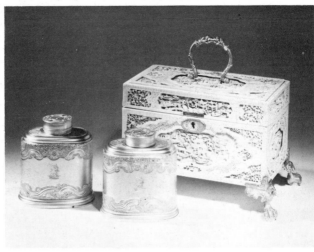

138 *Above:* A pair of George II candlesticks, made by John Alleine, 1757. Height 10 in.

139 *Far right:* A pair of caddies in somewhat restrained Rococo style, made in London, 1744. They fit into a carved ivory, silver-mounted casket. Such ornamental pieces need careful placing on the right piece of furniture, where they will not be overpowering.

people take in displaying their wealth to impress their neighbours encouraged the conversion of cash into the visually striking form of cups and goblets rather than dull chunks of metal, but silver, nevertheless, was always meant to be useful and decorative besides.

Collections of silver today may take many different forms, according to the interests (not to mention the wealth) of the individual collector. Broadly speaking, there are two types of collector. There is the specialist, who manages to accumulate an astonishing collection of – for example – early spoons or snuff-boxes or vinaigrettes. These may be called study collections; they do not necessarily have any connection with the collector's general style of living (everyone has read of people living in the humblest conditions who nevertheless own a priceless collection of this kind), but merely express the meticulous character of someone who has made a certain aspect of the goldsmith's art his lifelong interest. A larger proportion may be called general collectors, those who accumulate certain objects which for one reason or another have a special appeal for them. They probably collect other kinds of antiques also, maybe concentrating on a particular period – for a neo-classical, Adam-style gilt race cup is not ideally situated on top of a Jacobean oak cupboard!

Most collectors do concentrate on a certain period in silver, and the period they choose naturally depends on individual taste – the type of furniture they like generally. Someone whose house is furnished with plain and simple country furniture is unlikely to choose Rococo candlesticks for the mantelpiece, while someone who regards a Louis XV commode, all boullework and ormolu, as the finest expression of the

cabinetmakers's art will presumably not be afflicted by an overwhelming passion for Queen Anne coffee pots. However, it is not easy for the tyro to be certain of what exactly he does like, and before embarking on any purchases he should make himself thoroughly acquainted with the whole range of English antique silver. That is something that cannot be done from books alone. The beautiful lustre that old silver acquires, or the lovely pale lemon colour of old gilt, are not easily conveyed by photographs, however good, nor can a flat page adequately illustrate a three-dimensional object. Therefore, the new collector should visit one or more of the good public collections in museums. This may not always be easy (by far the best collection of English Elizabethan silver is in Moscow), but most people in the British Isles will find that there is a good display to be seen not very far away. A guide to the main collections of English silver open to the public will be found on page 149.

Some people think of silver primarily in terms of what is placed on the dining-room table before dinner and returned afterwards to the shelter of the sideboard. Having acquired their service of cutlery, a couple of salt cellars and pepper casters, a mustard pot, a pair of entrée dishes and perhaps two or four candlesticks, they feel their silver collection is complete. This is a rather dull and unimaginative approach. Silver is surely better used to enhance the whole house: not too much of it, since all excess is vulgar, but the odd piece here and there in the way that, rather more frequently, porcelain is displayed. If one is lucky enough to own a few fine pieces of porcelain, or fine old furniture, they may be splendidly enhanced by the thoughtful and imaginative addition of silver pieces.

140 An elegant silver-mounted glass claret jug in late eighteenth-century style but made in Sheffield, 1879.

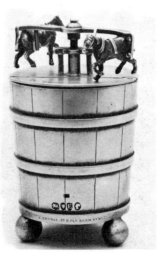

141 *Far left:* Pepper pot, London, 1881. Anyone who still feels that Victorian silver is beneath contempt would surely change his mind on seeing this marvellously made pepper pot with its strikingly lifelike detail.

142 *Left:* Pepper mill, made by Louis Dee, London, 1880. This enchanting mill might go with the canine caster (Plate 141). To my mind, it could be placed on a table of almost any period without creating a jarring note.

128

Silver and glass are also mutually enhancing, and a mixture of the two in the dining room can be most effective – wine glasses with silver cutlery, glass salt cellars and silver pepper pots, glass candlesticks and a silver centrepiece, with perhaps a pair of Chinese blue-and-white porcelain sauceboats instead of silver ones. Tastes vary, but on the whole such an assembly looks more attractively balanced than a table groaning under a mighty accumulation of glittering plate.

Antique silver can be bought either from a dealer or at an auction. By and large, the inexperienced collector will find that silver dealers, or indeed dealers in any other kind of antiques, are ready and willing to discuss his particular interests. Dealers, of course, make a living from selling, but a good dealer should never attempt to persuade a customer to buy anything until a mutual rapport has been established and the customer's interest and knowledge of the subject are well understood. There is a saying in the jewellery business, 'If you do not know about jewellery, at least know your jeweller', and it is a good

43 Silver-gilt bowl, by Andrew Fogelberg and Stephen Gilbert, 1789. This remarkable bowl, which looks fresh from the workshop, is one of my favourite pieces of pure Adam neo-classical silver. Diameter of bowl about 14 in. Victoria and Albert Museum, London.

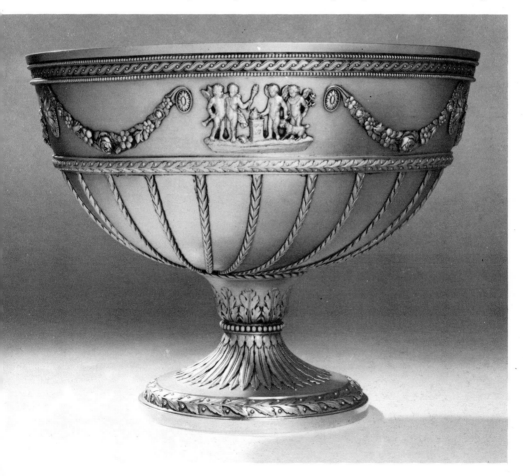

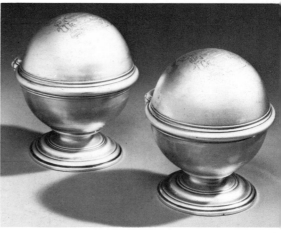

rule for silver also. Most dealers are enthusiasts, as are most collectors, and there should be no difficulty in establishing friendly communication and understanding. When I started to take an interest in silver as a schoolboy, two dealers in the neighbourhood showed me great kindness, giving me a large amount of their time, trouble and experience. Regardless of the fact that I was obviously not in a position to do business with them, I was always made welcome and allowed to look at and discuss at length anything I wanted. Not all dealers are so agreeable, but many are and all should be.

It is also possible to pick up a good deal of knowledge about silver in the sale rooms of auctioneers. Unfortunately, silver of good quality does not often appear these days in any great quantity outside London, but if London is too far away, the major auction rooms up and down the country which hold regular weekly or monthly sales of silver and other antiques—good, bad and indifferent—are well worth visiting. The rapid turnover of silver, pictures, furniture and so on can be highly informative.

At auctions, however, one must always be prepared to some extent to take pot luck, and on balance it is probably better to get to know one or two thoroughly reputable dealers and listen to their advice. The auctioneer, after all, is merely the agent for the seller; he does not take the same responsibility for what he sells as a good dealer should, and he has neither the time nor, possibly, the capacity, to discuss his wares fully with potential buyers.

The amazingly orderly history of English hall marks has been mentioned in Chapter 2, and it is not surprising that, for some people, the hall marks on silver have become a fascinating subject in themselves. However, this is an interest that can

144 *Far left:* Sugar box (probably) hall-marked 1734 It is often difficult to know the exact purpose of objects made 250 years ago, but, whatever its original function, this is a piece of fine quality.

145 *Above:* An unusual pair of soap boxes, made by Peter Archambo in London, about 1725-30 (they bear the maker's mark only). These boxes were made both in France and England; some are very prettily pierced on top. Height about 3 in.

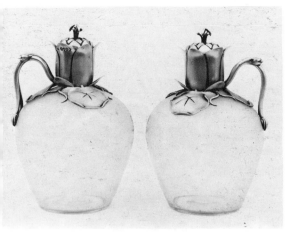

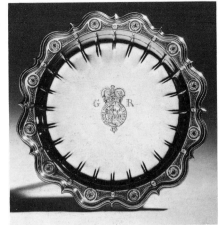

46 *Above:* A pair of Victorian silver-mounted glass wine jugs, the mounts very beautifully formed as lotus leaves, made in London by E.H. Stockwell, 1881. Each holds about one bottle of wine.

47 *Far right:* A beautiful, very small salver engraved with the royal coat of arms, made by Paul Crespin in London, 1723. This was probably ambassadorial plate – part of a large service given to an ambassador when he went abroad to take up his post. Diameter about 5 in.

perhaps be carried too far, and some collectors, especially young people who acquired their interest in silver in their magpie age, are so gripped by this aspect of the subject that they neglect the silver itself. Hand them some beautiful piece and they will immediately turn it over, looking for the marks, like Beachcomber's character who never bothered to read his letters and kept only the envelopes bearing his favourite twopenny stamps. The fact that a piece of silver was made in Chester in 1763, or even in London in 1902, can–absurdly– assume greater interest than the article itself. The experienced collector, however, will look at the piece as a whole, observing its condition and calculating its date from the general style, form of decoration, heraldic engraving if any, and so on. Only then will he look at the hall marks to see if there is a date on the piece which verifies his conclusions.

In fact, some of the most attractive pieces of silver bear no hall marks at all, and the collector should never be put off by their absence. It does not mean that the article is a fake, or that it is in some way inferior, or, as some people assume, that it was not made in England at all. A fine piece of silver with no marks at all is, or ought to be, far preferable to a second-rate piece with full hall marks. It is the silver that matters, not the marks.

There are a number of reasons why a piece of silver should have no hall marks, or a maker's mark only. It may have been made in the sixteenth or seventeenth century in some fairly remote town which was far from the assay office and had no marks of its own. However, London-made pieces may also occur without marks. In theory, of course, they should always be present, but some people will try to circumvent the law whenever possible, especially if compliance involves them in extra expense, and it cost money to have a piece of silver

assayed. It might be held up at the assay office for a week or two, and during that time the goldsmith naturally could not sell it. To send it to Goldsmiths' Hall and to get it back again meant losing the services of an apprentice for several hours. All these may have been minor irritations, but when a goldsmith felt confident that he could sell the piece safely without hall marks, he probably did so.

The law stated that goods made for sale to the public had to be hall-marked, but goldsmiths, clearly infringing the spirit of the law if not its letter, interpreted this as applying only to articles made speculatively and offered for general sale. In a private transaction between a goldsmith and a patron for whom he executed a specifically commissioned article, they reasoned, the law did not apply, as the article was never offered for public sale. When the goldsmith had completed it, he simply stamped it with his own maker's mark—perhaps not even that—and delivered it to the customer. Of course the customer himself may have had something to say about such a procedure. Many people obviously preferred their commissioned silver articles hall-marked, to prove that they conformed to the sterling standard. Others, however, enjoyed a sufficiently trustful relationship with their goldsmith to make such precautions unnecessary.

In general, then, it is unwise for collectors to allow themselves to become obsessed by hall marks. No one would deny that the study of them can be fascinating, and for someone who wishes to make a serious collection of provincial English, or Scottish or Irish silver, then the marks indicating the place of manufacture are vital. But whatever the interest and importance of hall marks, they cannot compare with the fierce, atavistic excitement that the collector feels when he comes, perhaps unexpectedly, upon a piece of silver which by the sheer beauty of its fashioning stands out from its run-of-the-mill counterparts like a beautiful woman in a crowd. When that happens the hall marks, present or absent, are of definitely secondary importance.

Hall marks were introduced to protect the public from fraud, but their very existence has tempted dishonest people to forge them. On the whole, forgeries and fakes are not very common in English silver, although a few turn up every year, but really skilfully executed forgeries are fortunately quite rare. Forged hall marks usually assume one of two possible forms. Either the punches themselves, which make the marks, are forged, or genuine old hall marks are introduced to the piece—it would be worth removing the hall marks from something small like a

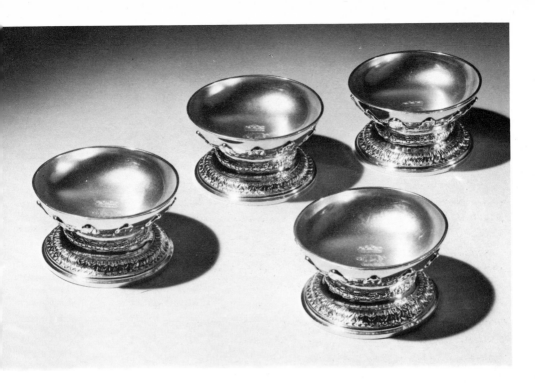

148 A set of salt cellars, made in London by David Tanqueray, about 1725 (maker's mark only). These spool-shaped examples are among the most pleasing of small salt cellars.

spoon, for example, in order to use them in a much larger and accordingly more costly piece. Very often the forgery is so poorly executed that even the novice, perhaps without quite knowing why, senses something wrong. Sometimes, however, it is done very expertly, and the collector would do well to consult a reputable dealer whenever he feels an element of doubt.

Forged marks may be more easily spotted by a dealer, who is accustomed to looking at silver hall marks every day and is therefore familiar with all their characteristics. He will know not only what the marks should look like but also whereabouts on the article they should appear, knowledge that can only come from long observation. Besides the placing of the marks, there is usually some slight difference between a modern, forged punch and a genuine old one. The tiny details that give the game away are not easy to describe, but are learned slowly from constant observation.

The transposing of hall marks from one piece to another was sometimes done in the past, especially between 1719 and 1758, to avoid the duty payable on silver. Such pieces are known as 'duty dodgers'. In more recent times it was done to convince the unsuspecting buyer that the piece—possibly made the week before—was an antique. A suspicious eye, however, should be able to detect this type of forgery with a good

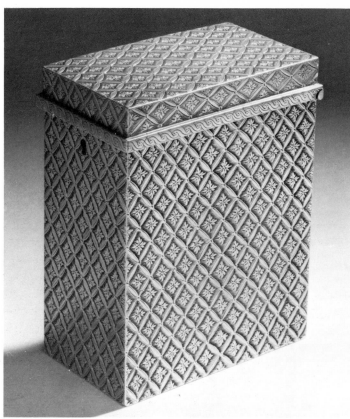

149 *Left:* Tea caddy, with a very attractive type of latticework engraving that is found on a number of caddies dating from the 1760s and 1770s. The severity of outline indicates that not everybody wanted all his silver in the current Rococo style.

150 *Below:* Shaving bowl, 1712. The recess in the rim was made to fit around the neck of a customer being shaved by the barber. These are rare objects, seldom found after the middle of the eighteenth century, and usually pleasantly simple in design. Diameter about 14 in.

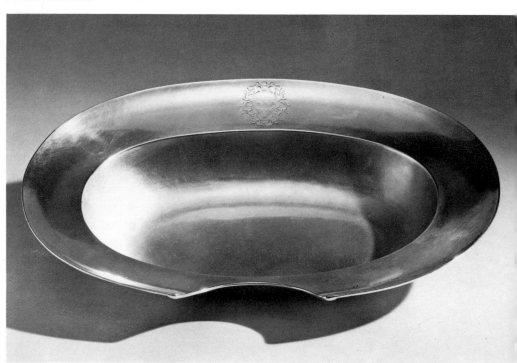

magnifying glass: the little oblong piece bearing the genuine hall marks has to be let into the bogus article, and close examination will usually reveal the thin tell-tale line of solder around it.

Another type of forgery, most often found in spoons, is to make a cast of a genuine old piece. This is not, as a rule, hard to detect. The marks usually appear rather fuzzy, and the stem of the spoon is softer than in a genuine hammered article. Moreover, if a set of spoons is in question, the hall marks will appear in precisely the same place on each one – impossible if they had been individually stamped by hand.

It is always difficult to draw a line between honest restoration or 'improvement' and intent to deceive. Engraved and chased decoration can be sharpened up, and if done well the evidence is not obvious. However, under a powerful lens, the line of the engraving tool can be detected *inside* the line of the original engraving. A good engraver can put an elaborate and stylistically accurate coat of arms on a plain and otherwise not particularly interesting article in order to enhance its appeal to a collector. This too may be very hard to detect, but frequently the general condition of the piece reveals the fraud. Old silver inevitably becomes somewhat worn by time and usage. If the engraved coat of arms is brilliantly sharp while other parts, notably the hall marks, show signs of wear, then it would be wise to regard the piece with a certain scepticism.

As we have seen in Chapter 3, it was the occasional, rather deplorable custom in the nineteenth century to have old silver chased or embossed with decorative details that appealed to its owners more than its original plain appearance. This was not done with intent to deceive anyone, and it was not illegal. In fact, decoration more recent than the original article is in most cases quite obvious.

Collecting silver can be in every way a rewarding pursuit, and the silver dealer, who is, of course, normally a collector also, usually feels that he is making a living in the most exciting and delightful way imaginable. He is often asked how he can bear to sell pieces of silver which clearly arouse his warmest enthusiasm. His answer is, 'Ah, wait until you see what I might find next week!'

Chapter 6

Provincial goldsmiths

From the time of the Norman Conquest, and no doubt earlier, down to quite recent times, hundreds of goldsmiths were at work in large towns and small throughout the British Isles. They made new articles in silver and occasionally perhaps in gold also, though it is important to remember that many references to 'gold' articles in old records actually refer to silver-gilt. They also made jewellery, for the jeweller's trade, as distinct from that of the goldsmith and enameller, did not become established in its own right until the Renaissance, and no doubt a good part of their time was spent in repairing and renovating worn or broken wares. Many of the goldsmiths active in provincial centres – large places like Dublin, Edinburgh, Norwich and York, as well as smaller ones like Barnstaple, Carlisle, Limerick and Wick – are recorded in the monumental work of Sir Charles James Jackson, *English Goldsmiths and their Marks* (2nd ed. 1921), which despite its title also includes Scotland and Ireland. Many new discoveries have been made since the publication of Jackson, but a great deal of work still remains to be done. The keen amateur collector, no less than the academic researcher, can be of great help in tracking down makers who have not yet been identified and deciphering town marks that have not yet been located. Detective work is needed especially for the period before 1697, the year of the reform of the hall-marking laws and the introduction of the Britannia standard.

Part of the interest of provincial silver lies in its variations from contemporary styles in London. Some examples, like the engraved pomegranate tankards made by John Plummer in York in the 1650s and 1660s, or the disc-end spoons of Scotland, have already been mentioned in Chapters 3 and 4. From Scotland also came that notable vessel, the quaich, which was never made anywhere else. A shallow, two-handled bowl, it derived its form from a wooden prototype, and early examples (from the late seventeenth and early eighteenth centuries) are engraved in a manner resembling the staves and bindings of the wooden originals. Tumblers made in the north-

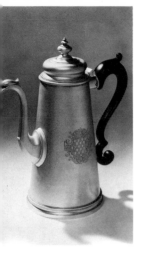

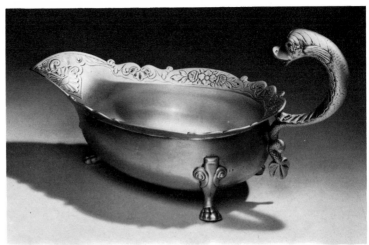

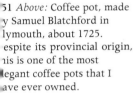

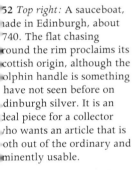

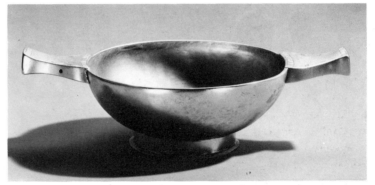

51 *Above:* Coffee pot, made by Samuel Blatchford in Plymouth, about 1725. Despite its provincial origin, this is one of the most elegant coffee pots that I have ever owned.

52 *Top right:* A sauceboat, made in Edinburgh, about 1740. The flat chasing round the rim proclaims its Scottish origin, although the dolphin handle is something I have not seen before on Edinburgh silver. It is an ideal piece for a collector who wants an article that is both out of the ordinary and eminently usable.

53 *Bottom right:* Quaich, a typically Scottish object, made by James Anderson in Edinburgh, 1729. Width (including handles) 9 in.

east and in Chester display marked differences from London tumblers, those from York, Hull, Leeds and Newcastle having a lower profile and a more flattened base, while the typical Chester tumbler is closer to the London type, taller and more rounded at the base. Then there is a very pleasing form of cream jug which we owe to the goldsmiths of Plymouth around the 1730s. It is really a shallow bowl with a slightly everted rim, small lip, and scroll handle at right angles to the lip-handle line. There are three examples, two of them forming a matching pair, which were made in London, but in this instance it seems certain that the London ones are copies and, for a change, the London makers imitated a Plymouth design.

Some articles were never made at all in the provinces, or at least only in certain places. If one were to amass a collection of one hundred vinaigrettes, for example, one would probably find that ninety of them were made in Birmingham and ten in London, with not one from any other place.

The medieval goldsmiths in the provinces were regulated, in theory at any rate, by the Company of Goldsmiths in London,

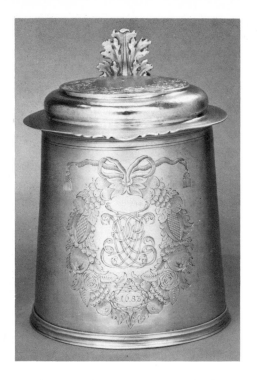

until 1423 when seven provincial centres—York, Newcastle upon Tyne, Lincoln, Norwich, Bristol, Salisbury and Coventry —were permitted by statute to adopt their own 'touches' or town marks and to regulate their own affairs. Elsewhere, the London Company retained responsibility. From time to time the wardens of the Goldsmiths' Company would make searches throughout the kingdom, calling on every goldsmith in a

154 *Far left:* A beautiful tankard made by Gabriel Felling in Bruton, Somerset, dated 1683. Felling was a most accomplished goldsmith who was probably apprenticed in London.

155 *Above:* Card case, made in Birmingham by Nathaniel Mills, 1845. It is typical of the work done in Birmingham during the nineteenth century, and cases like this are eagerly collected today.

156 *Left:* Gold box, made by Edward Smith in Birmingham, 1850-60. It was probably bought for stock and the scene inside the lid engraved specially for a customer. Length about 3½ ir

57 *Above:* Beaker, made in Newcastle, about 1660, though the style suggests it might be earlier. Its main interest lies in the contemporary inscription, which proclaims that it was a gift from King Charles II.

58 *Far right:* Tumbler cup, about 1715. It shows all the signs of a North Countryman, with a flatter base and slightly lower sides than London counterparts.

certain area and assaying all the pieces in his shop on the spot. If any were found to fall below the sterling standard, they were broken up; the goldsmith was fined and made to swear not to commit the offence again.

Very little is known of activities in the seven towns named in the act of 1423 in the fifteenth century. York began an annual date letter cycle in 1559 which continued, with a long gap from 1713 to 1778, until the final closure of the York assay office in 1856. Norwich maintained a date-letter system sporadically from 1565 until 1697, when the licence of the assay office was not renewed. Newcastle used a variety of town marks, usually in the form of a castle, in the seventeenth century, but the punches seem to have been made by individual makers, not by the official assay office.

The act of 1697, reactionary in many ways, once more removed the privilege of marking plate from the seven provincial centres and confined it to London alone. Obviously this caused great hardship to goldsmiths a long way from the capital, who now had to send their work to London for assay, and the chorus of complaint led to a new act in 1700 permitting the establishment of assay offices in Bristol, Chester, Exeter, Norwich and York. Newcastle was particularly incensed at being left out. However, two years later it succeeded in regaining permission to operate its own assay office.

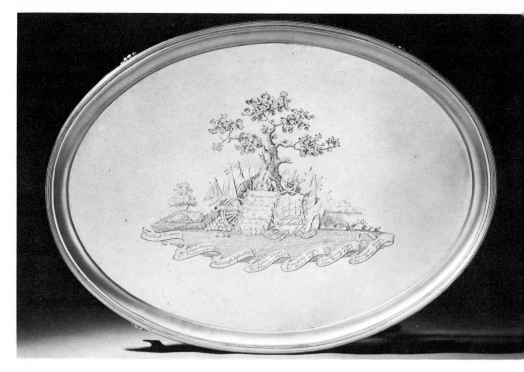

This was the situation for most of the eighteenth century. As things turned out, neither Bristol nor Norwich ever became major centres of silver, and for practical purposes the centres of the trade outside London were York, Newcastle, Chester and Exeter, as well as Edinburgh, Glasgow and Dublin.

In 1773 Sheffield and Birmingham petitioned the House of Commons for assay offices to be established there because of the vast amount of silver they produced, which at that time had to be taken to London or Chester for assay and marking, a very troublesome and expensive business. The London assay office was understandably unwilling to lose the lucrative rewards it gained from marking the silver articles being turned out in such numbers by the new industrial giants, and cross-petitioned vigorously against independence for Birmingham and Sheffield. Common sense prevailed, however, and both cities received their assay offices later in the same year. Today, the only British assay offices outside London are Birmingham, with its mark of an anchor, Sheffield, a crown (the lobbyists from Sheffield and Birmingham in 1773 are said to have held meetings at an inn called the Crown and Anchor), and Edinburgh, a castle.

Provincial silver offers an endless field of fascinating study for the local historian. There are large piles of manuscript, as well as printed sources, to be gleaned for information on

159 Irish tray, engraved by Thomas Bewick of Newcastle, 1806. The tray is not particularly Irish in character, but the superbly executed engraving is unmistakably Bewick.

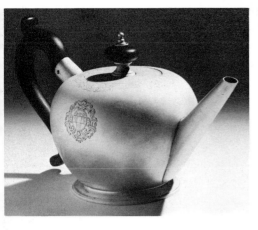

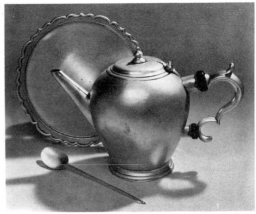

160 *Above:* Teapot of the so-called 'bullet' type, London-made, 1730.

161 *Above right:* Scottish teapot and stand, made in Aberdeen by George Cooper, about 1725.

162 *Below:* An Edinburgh 'bullet' teapot, 1724.

163 *Below right:* A small sweetmeat basket, made by George Hodder, one of Cork's leading goldsmiths, about 1745, a very rare piece. Length 4 in.

provincial goldsmiths over the centuries. The Public Record Office in London of course contains a vast, in a way rather too vast, repository of information for the painstaking researcher. Then there are the county archive offices, which can frequently provide such source material as rate books, church wardens' accounts and so forth. From such material one can gradually compile a list, albeit an incomplete one, of the goldsmiths resident in a particular town, and having discovered their names, try to find out the marks they used.

Hitherto unidentified provincial marks are found in the greatest number on two types of silver. There are hundreds, if not thousands of spoons which were made before the end of the seventeenth century by local goldsmiths. On some, the marks can be identified without doubt, and others have been tentatively attributed to a particular maker. But there are still many different marks that remain more or less a mystery, though it is reasonable to hope that the majority will one day be identified, providing the present level of interest in provincial silver is maintained. Spoons, however, are easily portable,

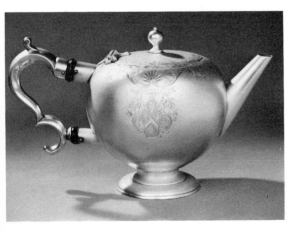

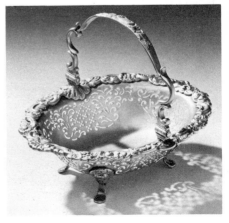

141

and when they are discovered in a particular place it is only rarely that there is any sound reason for assuming that they have been there ever since they were made, and that they were therefore probably made in the vicinity. For this reason, spoons are rather less useful as a primary source for the investigation of provincial goldsmiths than the other main category, church plate.

Church plate was often fashioned locally because it was less expensive than having it done in London or one of the grander provincial centres. Communion plate of local make is a fruitful source of information, particularly for the post-Reformation period, when there was a massive changeover from the old chalice of the mass to the new, simpler form of communion cup.

Communion plate was sometimes presented as a gift, but if not, its purchase is almost invariably recorded in the church wardens' accounts. Providing these accounts are still available, as they are in a surprisingly large number of parishes, it is nearly always possible to find the record of the purchase. Unfortunately, however, the relevant entry probably says only 'Payed ye goldsmythe for new makinge ye cuppe', or some such phrase. Only very seldom does it mention the actual name of the goldsmith. When his name does appear, the diligent researcher feels a sense of profound satisfaction, but he (or she) should not congratulate himself just yet. He has the name of the goldsmith, and he has only to compare it with the cup mentioned in the accounts to discover the goldsmith's mark. But what does he find? Only too often the original communion cup has gone, and he is confronted by a Victorian replacement. It can be very frustrating work.

Nevertheless much can be accomplished by searching local records, and as an appendix to this chapter I reprint some of the results of my work undertaken a few years ago in an effort to classify local goldsmiths' work in King's Lynn, an important town and port in the Middle Ages.

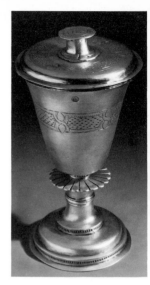

164 Communion cup, made in Coventry, about 1570. The maker, whose mark is IF, is so far unidentified, but there seems to be no doubt where it was made as all cups with this maker's mark are to be found in churches within a 25-mile radius of the city.

The King's Lynn goldsmiths

The following account is a shortened version of a paper which appeared in the *Journal of the Society of Silver Collectors* and is reprinted here by kind permission of the editor.

Towards the end of the eleventh century the town of Lynn was founded by the bishop of Norwich, Herbert de Losinga, at the request of a group of traders who were perhaps already established on the western shores of the Manor of Gaywood. The bishop founded the church of St Margaret and a priory in fulfilment of a promise to Pope Pashal II, as penance for the various acts of simony which had marked

his ascent of the ecclesiastical ladder, and he laid the foundations of an economic and commercial community by establishing a grant of a market and a fair.

The town was in a good position to develop trade both by road into the hinterland and also by sea to places farther afield, and these advantages were successfully exploited by the townspeople: until the advent of the Black Death the population was constantly expanding, and in the early fourteenth century reached an estimated 5,700 inhabitants. An interesting book called *The Making of King's Lynn* by Vanessa Parker includes a table of the various occupations of the freemen of Lynn which she has culled from the freemen's register. She lists the occupations under the following headings: merchants; food and drink; clothing; local industries; building; miscellaneous and unspecified. Goldsmiths appear under 'miscellaneous', which comprises freemen of the following occupations: apothecary, barber, clerk, customer, chapman, goldsmith, jeweller, mariner, organ-maker, musician, shipmaster, surgeon, tobacco seller, waterman, and gentleman. If one adds up the freemen in each period into which the table is divided, it is interesting to compare that total with the goldsmiths who were present and working in Lynn according to my own researches.

Time	Total freemen	Miscellaneous	Goldsmiths
1300-05	94	2	2
1342-70	266	1	10 (sic)
1371-1400	255	8	1
1401-30	206	3	3
1431-60	455	7	3
1461-90	274	22	2
1491-1520	388	21	0
1521-50	364	10	1
1551-80	504	20	6
1581-1610	438	26	6
1611-40	452	21	3
1641-70	605	150	1
1671-1710	635	220	4

We see here a fairly typical picture, at least when compared with other places where I have investigated local goldsmiths: first a steady number during the Middle Ages, with usually a downward turn around the late fourteenth and early fifteenth centuries owing to successive and economically disastrous outbreaks of plague; a rise into the mid-sixteenth century, and then a steady lessening of numbers throughout the seventeenth century. This is, of course, a general picture, but it does hold true in a surprisingly large number of cases.

It is really impossible to decide how much work the medieval goldsmiths did, as there is virtually no work left now for us to estimate the quantity—or quality—of their output, but it seems

reasonable to suppose that they fulfilled a need similar to the goldsmiths of the second half of the sixteenth century, as suppliers of fair-to-mediocre plate for the churches and monasteries in their area and as repairers and small-workers.

In Norfolk particularly there are large numbers of pre-Reformation patens still in existence, mostly unmarked, which seem almost certain to have been made in one or other of the various towns in that county which supported goldsmiths. Take for instance the list of plate of St Nicholas in Lynn, which was sold in 1543:

1 little Crosse of silver	xvi [ounces]
1 little Crosslet of silver	
1 little cruett of silver gilt	x
1 cruett of silver gilt	viii
1 Pair Censors Gilt	xxxvii
1 Crucifix of silver gilt	xv
1 Scrip of silver	x
1 Pyxe of silver gilt	xxx
1 Broken Cross of silver pt gilt	xxiii
1 picture of Christ crucified	iii
2 knoppes of silver gilt	xvi
1 pyxe gilt	xxi
4 pyxes gilt	xvi
1 Chalice cover gilt	x
4 pattens silver gilt } 4 chalices of silver gilt }	LXXViii
1 Scepter part plate	ii
1 Chalice silver Patten gilt	xiii
1 Holy water stoop with a sprinkler	LXXXX
1 Chalice silver with Paten gilt	XLiii

It seems unreasonable to suppose that this large amount of plate was all made in London. There can be no proof, but assuming the plate was accumulated over many years, it is significant that between 1415 and the date of the sale, 1543, no less than eight goldsmiths were working in Lynn. Surely there would not have been so many as this if they had not relied on getting a fair proportion of local church work. So little survives from the period that conclusions are impossible.

The period of religious disruption in the 1540s and 1550s must have been very bad for the local goldsmith, who relied to a large extent upon church patronage not only for new commissions but for a constant stream of the repairs that are so frequently noted in church wardens' accounts in almost any period. In the period of the Dissolution of the Monasteries and, later on, the commissioners' reports on church goods, nervous churchmen were clearly unlikely to give large orders to the smiths. This is born out by the list of Lynn freemen, which in the sixty years from 1491 to 1550 contains only one goldsmith. It seems clear that in King's Lynn changing economic and ecclesiastical conditions had an important effect on the number of working goldsmiths.

New cups for old

The accession of Elizabeth I marked the beginning of a long period of full employment for the local goldsmiths, and there is no doubt that the Lynn men were there in force to take what they could of the new orders forthcoming after the Queen's proclamation restoring the cup to the laity, on 22 March 1559. It has been shown by Charles Oman that there must have been some staging system for implementing Archbishop Parker's order to change mass chalices into communion cups, as it would have caused endless confusion if every church in the realm had been compelled to make the change in the same year. The plan that appears to have been adopted was that each year one or two dioceses were instructed to start their conversion. In 1564 the London Company of Goldsmiths had warned their colleagues of the Norwich Goldsmiths' Company that their turn was imminent and that they should regularise their system of hall marking, as the sudden influx of orders could lead to a number of abuses. Presumably, the goldsmiths in outlying areas of Norfolk and Suffolk were similarly informed, and in consequence were ready for the rush of work that must have followed this order. It would appear that the turn of the Norwich diocese came in 1566-67, and in that year Lynn had four goldsmiths available to take as many orders as they could from their Norwich and London competitors. I have so far found seven cups by one maker, some of which bear engraved dates corresponding to the year of the great changeover, but unfortunately I have been unable to trace which of the four goldsmiths it could have been.

The cups bearing this mark, which looks like a leaf over a circle enclosing the letter I, are not very beautiful nor particularly well executed, but they are fairly representative of Elizabethan communion cups as a whole. Their real interest lies in the inscriptions to be found encircling the bowls, all of which are similar but not identical. On the seven cups by this maker there are five different inscriptions:

> *All glory be vnto the O Lord*
> *All honor and glory be vnto the O Lord*
> *O Lord all glory be vnto the *Amen**
> *All honor *and glory = be — vnto B God Amen*
> *All honor and glory be vnto God*

The source is probably the last prayer in the communion service, which reads 'all honour and glory be unto thee O Father Almighty, world without end'. This small group of Elizabethan communion cups seems to be the only one of that period bearing such inscriptions. In fact the presence of the inscriptions originally led me to ascribe them to about 1640 when they would not have been unusual, but I now feel that there is no doubt of their sixteenth-century date; they represent, therefore, an extremely rare and interesting item in the history of church plate. The inscription must have been the goldsmith's own idea, not what the parish wanted, as it exists on all his cups, made for several different churches.

A second group of pieces, also Elizabethan but slightly later in date, bears a single mark which I have taken to be TC conjoined and fairly confidently ascribe to Thomas Cooke. Cooke gained his freedom by purchase in 1579 but was sworn in by a visiting party from the Goldsmiths' Company in 1578. Perhaps they felt he was practically ready to become a goldsmith in 1578 and the purchasing of his freedom was simply a matter of time. Although I have been unable to find any document linking the TC conjoined with Thomas Cooke, I believe it can belong to no other person. There was, however, another possible candidate: some years ago I found a note in the goldsmiths' minute book of one Thomas Christian of Cambridge. Against his name is drawn a copy of his mark which does look rather like the one that I ascribe to Thomas Cooke. The date of 1566 against Thomas Christian's name would also roughly correspond with the mark in question, but I have found no mention of Thomas Christian ever having lived or worked in Lynn, nor does it seem likely that a man from Cambridge, nearly 50 miles away, managed to secure so many orders from churches all within fifteen miles of King's Lynn.

The communion cup at Fring, about twelve miles north-east of Lynn, is obviously Elizabethan though altered later. It has a rather strange mark which I take to be a battle-axe. Since no other piece has come to my notice bearing this mark, the suggestion that it was made in Lynn can only be speculative, but there was a man working in Lynn called Thomas Bolden who seems a possible candidate. Could this mark be a rebus or a pun on his last name?

Another sixteenth-century goldsmith to whom I have been able to ascribe a mark with more certainty is James Wilcocke. He was made a freeman in 1593 and was still working in 1635. Wilcocke may have been a prolific goldsmith, but so far only two cups and one large gilt paten cover that were without question made by him have come to light. He was the first to use the town mark of Lynn (three dragons' heads erect, each piered with a cross crosslet) along with his own maker's mark, IW, mullet above and below. The communion cup and cover at Congham, although it does not bear Wilcocke's personal mark, is struck with the Lynn mark that he used and I believe is almost certainly made by him. There is also a small paten and three spoons that can possibly be ascribed to him. His work shows him as a sensitive, even sophisticated maker, and one who was well aware of contemporary London styles. It is a great pity that no more of his work has been identified.

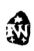 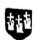

It must be assumed that some of the church wardens in the Lynn area had been rather dilatory in the process of converting their old chalices into communion cups in 1567 because there are a fair number of cups made by William Howlett in the 1630s, following Bishop White's visitation of 1629. Howlett was a competent craftsman, as the diversity of his work shows, but what is puzzling is the even greater diversity of quality, which runs from excellent to rubbishy. Another slightly puzzling feature of his work is that he appears to have 'cannibalised' older pieces of silver in making some of his works. A

few pieces made by William Howlett have been recorded bearing the full London hall-marks of 1638 but what made him suddenly decide to take or send his silver to London to be marked remains a mystery. It is possible that owing to some misdeed discovered by the Goldsmiths' Company, he was ordered to bring one parcel of silver to London for trial. Howlett gained his freedom by purchase in 1629. He was certainly the most prolific of all the Lynn makers judging by the amount of his work still extant. He used as a maker's mark H over W, and a Lynn mark similar to that used by James Wilcocke. On certain pieces he used a third mark formed of the letters ST in monogram, the S being reversed. This mark has been the subject of much controversy, but the almost certain explanation is that ST stands for sterling and affirms the standard of the silver. The fourth mark Howlett occasionally used is in fact a unicorn's head incuse.

Robert Howlett, who was possibly the grandson of William Howlett, was made free as a goldsmith in 1661. The only pieces of silver which might be by his hand are unfortunately unmarked. Superbly made and now belonging to the Corporation of King's Lynn, they are a pair of heavy plain beakers, both pricked just below the rim, 'Lenne Reges', the larger one also pricked '1664'. They are engraved with a scratch weight of $38\frac{1}{2}$ ounces, and as they weigh 7 ounces each it is possible that they were originally a set of six. In September 1663 it was ordered that three silver cups, each weighing over 13 ounces, should be 'taken out of ye treasury and delivered to Mr Thomas Robinson, one of ye Chamberlains to be sold and three cups to be bought instead thereof at the discretion of Mr Howlett and the said Chamberlain'. The scratch weight coincides with the amount of silver to be used for the three beakers mentioned, and it seems likely that Robert Howlett persuaded Mr Robinson, the chamberlain, to let him make these six attractive little cups instead of the three originally ordered. If the missing beakers could be found, perhaps just one might be marked. In their absence, a definite attribution is impossible, but they are obviously not London-made and since Robert Howlett was the only goldsmith known to be working in Lynn in 1664 it seems a reasonable supposition that they represent the only examples from his workshop known so far.

A final mark which I have tentatively identified appears on three silver alms dishes, all in churches within five miles of Lynn. They bear the mark RM and were probably made in the workshop of a goldsmith known to us simply as Mr Marsh, who was active around the end of the seventeenth and beginning of the eighteenth century. They are all rather crude in execution and were surely not made in London. When the first name of Mr Marsh is finally discovered, it seems likely that it will begin with an R. One rather remote possibility is that this is the same man as a Richard Marsh who was working in Ipswich in 1683.

The total surviving output of the Lynn goldsmiths over a period of about 140 years that I have so far discovered is fewer than fifty pieces.

Cleaning silver

In the days when people who owned large quantities of silver also employed large numbers of servants, cleaning silver was no problem. Nowadays, some people feel that the need to keep silver polished is a slight deterrent to its display on their shelves and sideboards. But in fact silver takes very little polishing, and many people tend to polish it too much rather than too little.

Silver that is corroded or completely blackened as a result of generations of neglect is perhaps best cleaned by a silversmith. Otherwise, jeweller's rouge—a pink powder worked into a paste with a few drops of water—will do the job adequately. Cutlery or other silver in fairly frequent use will seldom need polishing if it is washed in soap (or washing-up detergent) and water, carefully dried (silver should never be left wet), and stored in acid-free tissue paper or baize, or in a plastic bag. Proprietary brands of silver cleaner, such as Goddard's Silver Foam, may be used, or alternatively a soft, sludgy paste made up of powdered chalk and equal quantities of ammonia and methylated spirits.

The cleaner should be rubbed on with a damp sponge; an old, soft, natural-bristle toothbrush may be used to get into awkward corners. All traces of polish should be washed off in hot soapy water, again using the sponge and, if necessary, the toothbrush. The silver should then be rinsed, dried with a linen cloth, and polished gently with chamois leather. At no time should great pressure be exerted: continual hard buffing of silver does not polish it so much as wear it out. Extra care should be taken with silver gilt; in particular, brushes and any abrasive material should be avoided.

Collections of British silver

Museums and galleries in Britain and Eire

London *Apsley House*, 149 Piccadilly.
Marvellous collection of massive Regency silver-gilt belonging to the 1st Duke of Wellington.

British Museum, Great Russell Street.
Not a large collection, but the Waddesdon Bequest has some fine sixteenth-century German and English pieces and there is a good collection of Huguenot silver.

Victoria and Albert Museum, South Kensington.
Wonderful study collection on the first floor from all periods and on the ground floor in the period rooms.

Abingdon *Abingdon County Hall Museum*, Market Place.
Good small collection of seventeenth- and eighteenth-century plate given by different aldermen to the borough.

Belfast *Ulster Museum*, The Botanic Gardens.
Good general collection but particularly strong on Irish silver.

Birmingham *Birmingham City Art Gallery*, Chamberlain Square.
A well-displayed and carefully balanced general collection of English silver covering most periods.

Brighton *The Royal Pavilion.*
Examples of George IV's exotic taste in silver.

Cambridge *Fitzwilliam Museum*, Trumpington Street.
Not very much English silver but a fair collection of early continental work.

Cardiff *National Museum of Wales*, Cathay Park.
This houses the Jackson Collection, a good general collection for the student.

Dublin *National Museum of Ireland*, Kildare Street.
Fine collection of Irish silver. A must for any collector of Dublin or Irish provincial silver.

Edinburgh *National Museum of Antiquities of Scotland*, Queen Street.
A small but very interesting collection, notable are the Scottish standing mazers, highland jewellery, and quaiches.

Royal Scottish Museum, Chambers Street.
A larger, less specialised collection of Scottish silver, possibly more useful to the collector, with a wider range of Scottish pieces and also some English silver.

Exeter *Royal Albert Memorial Museum and Art Gallery*, Queen Street.
A truly remarkable collection of Devonshire-made silver – thoroughly worthwhile.

Leeds *Temple Newsam House.*
Superb collection of mainly eighteenth-century silver.

Manchester *Manchester City Art Gallery*, Mosley Street.
The Assheton–Bennett Collection of silver, ranging from Elizabethan to the mid-eighteenth century. An excellent and well-formed collection including good examples of early spoons.

Newcastle *The Laing Art Gallery*, Higham Place.
Small collection of mostly Newcastle-made silver, including the city church plate.

Norwich *Castle Museum*
Beautifully displayed collection of mostly Norwich-made silver, ranging from early Elizabethan to about 1700; also some London pieces. Well worthwhile.

Oxford *Ashmolean Museum*, Beaumont Street.
Arguably the most important silver collection outside the Victoria and Albert Museum. Particularly strong on Elizabethan silver and mounted wares; also highly important collection of Paul de Lamerie silver. A must for any serious collector or student.

Town Hall, St Algate's.
The city plate and regalia.

Southampton *Southampton Art Gallery*, Civic Centre.
Good, small general collection.

Houses, etc, open to the public

Bury St Edmunds *Ickworth* (National Trust)
Fine collection of silver by Paul de Lamerie and other Huguenots made for the Marquess of Bristol.

Cambridge *Anglesey Abbey* (National Trust)
Good silver and gold boxes.

Dorking	*Polesden Lacey* (National Trust) Mostly late seventeenth-century silver in the chinoiserie style.
Manchester	*Dunham Massey* (National Trust) Fine silver made for George Booth, 2nd Earl of Warrington, mostly from the first half of the eighteenth century.
Sevenoaks	*Knole House* (National Trust) A remarkable small collection of late seventeenth-century silver, notably in the State Bedroom, with silver furniture, wall sconces, mirrors and so on.
Woburn	*Woburn Abbey* Fine collection of silver including a pair of baskets by Paul de Lamerie of outstanding quality.
Woodstock	*Blenheim Palace* Silver made for the 1st Duke of Marlborough.

Church treasuries

Certain English cathedrals hold interesting collections of church plate from the surrounding diocese. Particularly worthy of note are the cathedrals at Canterbury, Chichester, Durham, Gloucester, Lincoln, Norwich, Ripon, and Winchester. Other recommended sites: Bristol's St Nicholas Church Museum, the Minster at York, and Oxford's Christ Church Cathedral.

Museums in the United States of America and Canada

Boston	*Boston Museum of Fine Arts*, 465 Huntingdon Avenue. Highly important museum containing a really fine collection of English silver from the sixteenth to the nineteenth centuries. Also one of the great collections of American silver.
Chicago	*Art Institute of Chicago*, Michigan Avenue at Adams Street. Smallish general collection including some important Art Nouveau pieces.
Cleveland	*Cleveland Museum of Art*, 1150 East Boulevard. Some important pieces of silver and an excellent general study collection.
Hartford, Conn.	*Wadsworth Atheneum* A fine collection of sixteenth-, seventeenth- and eighteenth-century silver, collected by Mrs Eugene Miles and presented by her to the museum. Good catalogue.

Los Angeles　*Los Angeles County Museum*, Exposition Park.
Some remarkable pieces, including part of the William Randolph Hearst Collection; mostly early silver.

New York　*Metropolitan Museum of Art*, Fifth Avenue and 82nd Street.
The famous Untermeyer Collection of English silver was recently left to the museum. This is a highly important collection, and there is an excellent book devoted to it (see Bibliography).

San Marino　*Huntingdon Art Gallery*
The Munro Collection is housed here, including a fine set of Apostle spoons of 1524 and some startling sixteenth- and seventeenth-century silver.

Portland, Oregon　*Portland Art Museum*, S.W. Park and Madison Street.
Small collection devoted mostly to London makers of the early eighteenth century.

San Francisco　*M. H. de Young Memorial Museum*, Golden Gate Park.
A small general collection.

Toledo　*Toledo Museum of Art*, Monroe Street at Scottwood Avenue.
A startling collection of great quality though smallish quantity, it should not be missed, being beautifully organised and displayed.

Toronto　*Royal Ontario Museum*, 100 Queen's Park.
The Lord Lee of Fareham collection. A remarkable collection of silver and silver-mounted pieces, mostly of the fifteenth and sixteenth centuries, both English and continental.

Williamsburg　*Colonial Williamsburg Foundation*, Goodwin Building.
An altogether remarkable place, this restored town was once the capital of British Virginia. It has a wonderful collection of silver of the seventeenth and eighteenth centuries. Unfortunately not all of it is on view but there is an excellent catalogue devoted to the silver collection.

Glossary of articles

This list excludes techniques and types of decoration (described in Chapter 1) and patterns in flatware (Chapter 4).

Andirons or **firedogs** Metal brackets for supporting logs in an open hearth. They are uncommon in English silver, but were made occasionally from the late seventeenth century, sometimes cast, sometimes on an iron core.

Argyll or **Argyle** A gravy warmer, resembling a coffee pot but incorporating a heating element, sometimes a central tube or surrounding jacket containing hot water. First made about the third quarter of the eighteenth century, they gained their name from one of the dukes of Argyll who is alleged to have invented the idea.

Asparagus tongs Early examples, from the eighteenth century, are scissor-like, with claws instead of blades. In the nineteenth century they were made in bow form, like sugar tongs, often to match a table service.

Basket For cakes, etc., some of the prettiest products of the silversmith, made in various forms but typically oval in plan with pierced sides and a swing handle.

Beaker A cup with no stem, handle or cover, usually cylindrical in form. They were made in every period but became less common in silver in the eighteenth century.

Bell Silver hand bells for summoning a servant were made at least as early as the sixteenth century. They are sometimes found as an adjunct to an inkstand.

Biggin A small coffee pot, probably named after a type of child's night cap.

Billet In silver, either a metal ingot or a thumbpiece.

Bleeding bowl A shallow circular bowl with a single flat pierced handle. In the United States it is called a porringer, and that – not a bowl used by barber-surgeons – is probably what it is.

Butter dish Made in silver with a glass lining since the eighteenth century. Early examples are oval and pierced, later ones are circular or oblong.

Can or **cann** A mug. The term is more common in the United States.

Candelabrum A standing candlestick with several branches. In style candelabra generally follow contemporary candlesticks.

Caudle cup A porringer.

Candlestick Normally a single candleholder on a stem of columnar or baluster form, with numberless variations. Almost none has survived from before the late seventeenth century, but thereafter they become steadily more common. Chamber candlesticks – candleholders on a wide base with a handle and no stem – were also made in silver.

Canister A box-like container for tea, made in a great variety of forms, often in pairs for two varieties of tea.

Canteen A travelling set of knife, fork and spoon and perhaps beaker and small box, made in the late seventeenth and eighteenth centuries.

Caster A shaker or sprinkler for sugar, pepper, etc., usually in vase or similar form and often made in sets of three.

Centrepiece A very large and elaborate ornament for the centre of the dining table. Rococo and Regency goldsmiths really let themselves go when making these non-functional objects, often incorporating spectacular decoration.

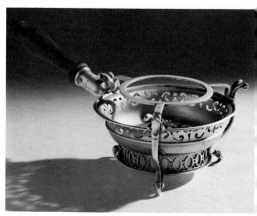

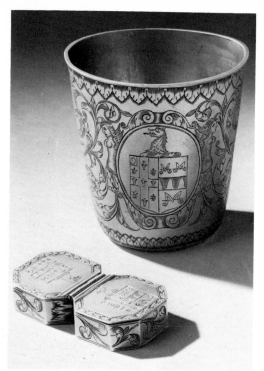

Items from a canteen

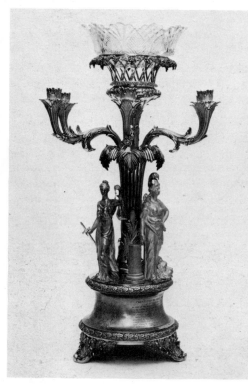

Centrepiece

Chafing dish Any dish which is provided with some means for keeping the food warm, such as a bowl for burning charcoal or a small lamp.

Chalice The large standing cup for the wine in the Roman Catholic mass, usually silver gilt if not gold. English examples are of course mainly medieval and rare. Protestants, denying the doctrine of transubstantiation, preferred a more modest vessel usually called a communion cup.

Chandelier A multi-branched candleholder suspended from the ceiling, as distinct from a candelabrum which stands on a surface.

Charger A large plate, circular or shield-shaped, which stood on the sideboard. The decoration of some chargers makes it obvious that they were intended for display only, and they were sometimes presentation pieces.

Cheese scoop Silver scoops with ivory or wooden handles were sometimes made in the Regency period and later to match a table service.

Chocolate pot Similar to coffee pots but with a little lid in the cover for stirring the chocolate.

Coaster A small circular stand with silver sides, often pierced, and a silver or wooden base, on which a bottle stood. It is frequently found in old Sheffield plate.

Coffee pot A tall covered jug, made from the late seventeenth century onwards. See page 78.

Cream jug A small jug made in many forms in the eighteenth and nineteenth centuries, when cream was drunk with tea and coffee.

Cruet The original cruets were the vessels used in the mass, but the name was later applied to sets of casters, etc., which were often made accompanied by a frame or stand.

Dish cross An eighteenth-century device for keeping dishes warm, consisting of a central lamp with adjustable arms capable of holding dishes of various sizes.

Dish ring A low circular ring, or bowl with flat base and, often, concave sides, on which dishes were placed. They come from Ireland and date from the mid-eighteenth century.

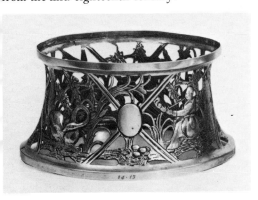

Douter A rare scissor-like device with flat blades for extinguishing candles.

Dredger A pierced box or caster for pepper or other spice.

Egg frame Egg cups were sometimes made in pairs in a frame in the late eighteenth and early nineteenth centuries, with a spoon and sometimes a salt cellar.

Entrée dish A dish, circular, oval, rectangular, etc., with a cover, sometimes made with a stand for a lamp.

Épergne A centrepiece, usually highly ornamental, with a central bowl and little dishes for sweetmeats, often hanging from branches, as well as candleholders, casters, and all manner of decorative conceits.

Étui A small slim case containing articles like scissors and needles, for ladies.

Ewer A type of jug standing on a foot, usually accompanied by a basin, used for carrying water at the dinner table.

Flagon A tall type of tankard, uncommon after the mid-eighteenth century, for beer or other liquor. They usually follow contemporary tankards in style.

Goblet A large wine cup.

Inkstand They are often elaborate pieces, including pots for ink and sand, a bell, taperstick, etc., on some kind of tray, usually rectangular. Some were given as presentation pieces, suitably engraved, and some were made in wood and/or glass with silver mounts.

Kettle They usually conform to contemporary teapots in style but were often made with a stand containing a lamp.

Ladle Made for various purposes—cream, soup, sauce, etc. They often matched table services.

Mace The instrument of civic authority, deriving from the type of club used by medieval knights, usually with a crown finial. Some towns proudly own a mace as old as the fifteenth century.

Mazarine A flat pierced plate for straining food. The name no doubt derives from Cardinal Mazarin, who is dubiously credited with so many innovations in the decorative arts.

Mazer A silver-mounted wooden bowl on a foot. They were used for drink in the Middle Ages.

Monteith Similar to a punch bowl in appearance but characterised by a scalloped rim, in which wine glasses were slotted to cool in iced water. The rim is often detachable. Tradition states that the monteith, which first appeared in the late seventeenth century, is named after a Scotsman whose cloak had a serrated edge.

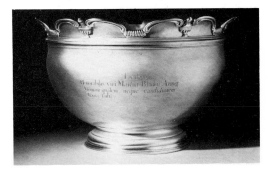

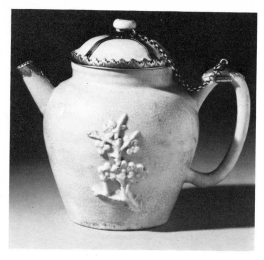

Mounts At every period vessels and objects of disparate materials were fitted with rims, lids, spouts, handles, feet, decorative bands, etc. of silver or silver gilt. A well-known example is the coconut cup, in which a coconut makes the bowl of the cup while the rim, stem and foot are of silver.

Muffineer Another name for a caster, usually a small one.

Mug A drinking vessel with a handle, normally smaller than a tankard and without a lid.

Mustard pot Until the mid-eighteenth century mustard was served dry in a caster with an unpierced top. The more familiar pot for ready-mixed mustard appeared about 1760, usually with a blue glass liner.

Nef A medieval vessel in the form, beautifully worked, of a ship, carrying a napkin, knife, spoon, etc. The masterpieces of the south German goldsmiths, they were not made in England until the form was revived in the eighteenth and nineteenth centuries as a container for bottles or decanters.

Pap boat The eighteenth-century alternative to a baby's bottle—a small oval bowl with a narrow lip. They are sometimes found converted to cream jugs or sauceboats.

Paten The plate used for the bread at the communion service.

Peg tankard Though rare in England, some tankards are found with little pegs or markers at regular intervals inside. The tankard was passed from hand to hand, and the pegs marked how much each person was supposed to drink.

Pipkin A small saucepan with a spout and a wooden handle for warming brandy.

Plateau A large mirrored base, sometimes over twelve feet long, on which candlesticks and a centrepiece were placed, usually of basically oval form and with a low silver-gilt gallery. They were popular in the early nineteenth century.

Pomander A small pierced spherical box for sweet-smelling herbs, etc. A useful object in less hygienic days, it became obsolete in the seventeenth century.

Porringer A small two-handled bowl or cup, with or without cover. See Plate 67.

Pouncebox Often part of an inkstand, for sprinkling a fine powder called pounce on writing paper. Pounce is usually thought of as the equivalent of blotting paper, but it was probably more often sprinkled on the paper to prepare the surface before writing.

Punch bowl A large circular bowl, often with two drop-ring handles. They were an important part of the goldsmiths' production from the late seventeenth century, and continued to be made as presentation pieces after drinking punch had fallen out of fashion.

Quaich A drinking cup with two handles, unique to Scotland. See Plate 153.

Salt A large ceremonial container for salt which took pride of place on the dining table before the centrepiece or épergne. It was gradually replaced in the seventeenth century by smaller, more convenient trencher salts or salt cellars.

Salver A flat, usually circular plate, placed underneath another plate or bowl. Salvers became, and still are, largely ornamental presentation pieces.

Sandbox Indistinguishable from a pouncebox.

Sauceboat A container for sauce. As Judith Banister remarks, although Voltaire may have complained that the English had only one sauce,

they had many types of sauceboat. Early, eighteenth-century examples have a lip at each end, later ones are more like a low, elongated jug.

Sconce A wall-mounted candle holder, typically in the form of a cartouche with two or more projecting branches. The name was sometimes applied to ordinary candlesticks or candelabra.

Skillet A saucepan, in particular a pan on three feet with a flat cover, made in the seventeenth century and later.

Snuffer For trimming candles. They look like scissors with a little box mounted on the blade for the trimmed wick, and were often made with a tray or frame.

Spice box There are a number of smallish silver boxes, frequently in the form of a shell, made in the seventeenth century, some of which were no doubt intended for spices. The name is applied generally to any box or casket with no very obvious purpose.

Standish An old name for an inkstand.

Strawberry dish The arguments over these pretty little saucer-like dishes are summarised on page 48.

Tankard A vessel for drinking beer, with a capacity of over half a pint and usually one pint or more. Tankards normally have a single handle and a hinged cover. They were made in large numbers from the Middle Ages, but became less popular in the late eighteenth century. They were mostly made with hard use rather than decorative effect in mind and, with some notable exceptions, they tend to be comparatively plain in style.

Taperstick A small candlestick.

Tazza A wide shallow bowl on a central foot.

Teapot Common from the eighteenth century, deviating early from the cylindrical form adopted by the coffee pot. See page 68.

Tea urn A large vase-shaped alternative to the kettle. They had some popularity in the late eighteenth and nineteenth centuries.

Toast rack The earliest silver toast racks date from the second half of the eighteenth century. They were generally formed of wire on an oval base. Later ones went through the whole gamut of Victorian styles.

Trencher salt A small salt cellar, usually made in sets, one for each place setting, from the seventeenth century onwards.

Tumbler Similar to a beaker but usually with a rounded base.

Tureen A large bowl for soup, usually with cover. Some early eighteenth-century examples exist with matching ladles.

Vinaigrette A smallish box with pierced lid, made in a great many decorative forms from the seventeenth century. A sponge with scented vinegar was kept inside for the use of ladies feeling faint.

Warming pan These pleasant devices, looking like a vast frying pan with a hinged lid (burning charcoal therein), were very occasionally made in silver for sybaritic customers.

Whistles Silver whistles or rattles were made for babies in the eighteenth and nineteenth centuries. They had bells and corals (for teething) attached.

Wine cooler or **ice pail** A bucket for a single bottle, common since the late eighteenth century. Larger vessels, often urn-shaped, were made for several bottles as early as the second half of the seventeenth century. Similar pieces were later incorporated in sideboards.

Wine label Small silver plaques, engraved with the name of a drink and suspended on a chain, to be hung on a bottle or decanter. They have been made since the early eighteenth century.

Wine taster A small flattish bowl or cup, usually with a raised dome in the base. See page 48.

Bibliography

These are the books I have found most useful in the course of my work and in the writing of this book.

Ash, Douglas, *How to Identify English Silver Drinking Vessels, 600-1830*, G. Bell and Sons, London, 1964.

Bailey, C. T. P., *Knives and Forks*, Medici Society, London, 1927.

Banister, Judith, *Introduction to Old English Silver*, Evans Brothers, London, 1965.

Banister, Judith, *English Silver*, Hamlyn, London, 1969.

Bennett, Douglas, *Irish Georgian Silver*, Cassell, London, 1972.

Bradbury, Frederick, *History of Old Sheffield Plate* (reprint), J. W. Northend, Sheffield, 1968.

Burns, Thomas, *Old Scottish Communion Plate*, R. and R. Clark, Edinburgh, 1892.

Carrington and Hughes, *Plate of the Worshipful Company of Goldsmiths*, Oxford University Press, Oxford, 1926.

Clayton, Michael (editor), *Collector's Dictionary of the Silver and Gold of Great Britain and North America*, Country Life, London, 1971.

Collins, A. J., *Inventory of Jewels and Plate of Queen Elizabeth I*, British Museum, London, 1955.

Cripps, Wilfred J., *Old English Plate: Ecclesiastical, Decorative and Domestic–Its Makers and Marks*, E. P. Publishing, East Ardsley, West Yorkshire, 1977.

Dauterman, C. C., *English Silver Coffee Pots–The Folger Coffee Company Collection*, Portland Art Museum, Portland, Oregon, USA, 1961.

Davis, John D., *English Silver at Williamsburg*, Colonial Williamsburg Foundation, USA, 1979.

Ellis, H. D., *Silver Belonging to the Worshipful Company of Armourers and Brasiers* (2 vols), Waterlow and Sons, London, 1892 and 1910.

Ellis, H. D., *Silver Plate, Worshipful Company of Cloth Workers*, privately printed, London, 1891.

Ellis, H. D., *Collection of Sixteenth and Seventeenth Century Provincial Spoons*, Sotheby, London, 1935.

Evans, Joan, *Huguenot Goldsmiths of London*, Proceedings of the Huguenot Society, 1936.

Finlay, Ian, *Scottish Gold and Silver Work*, Chatto and Windus, London, 1956.

Gardner, J. S., *Exhibition of Silversmiths' Work of European Origin*, Burlington Fine Arts Club, 1901.

Gardner, J. S., *Old Silver Work, Chiefly English*, Burlington Fine Arts Club, 1903.

Gilchrist, James, *Anglican Church Plate*, Michael Joseph, London, 1967.

Grimwade, Arthur, G., *Rococo Silver*, Faber and Faber, London, 1974.

Grimwade, Arthur G., *London Goldsmiths, 1697-1837: Their Marks and Lives from the Original Registers at Goldsmith's Hall and Other Sources*, Faber and Faber, London, 1976.

Hackenbroch, Yvonne, *English and Other Silver in the Irwin Untermeyer Collection*, Metropolitan Museum of Art, New York, 1974.

Hayward, John F., *Virtuoso Goldsmiths and the Triumph of Mannerism, 1540-1620*, Sotheby Parke Bernet Publications, London, 1976.

Hayward, John F., *Huguenot Silver in England, 1688-1727*, Faber and Faber, London, 1959.

Heal, Ambrose, *The London Goldsmiths, 1200-1800: A Record of the Names and Addresses of the Craftsmen, Their Shop Signs and Trade Cards*, David and Charles, Newton Abbot, 1972.

Holland, Margaret, *The Phaidon Guide to Silver*, Phaidon, London, 1978.

How, George Evelyn Paget and How, J. P., *English and Scottish Silver Spoons: Medieval to Late Stuart and Pre Elizabethan Hall-marks on English Plate* (3 vols), How (of Edinburgh), London, 1952.

Jackson, Sir Charles J., *English Goldsmiths and Their Marks* (reprint), Dover Publications, New York, 1965

Jackson, Sir Charles J., *An Illustrated History of English Plate* (reprint, 2 vols), Dover Publications, New York 1977.

Jewitt and Hope, *Corporation Plate of England and Wale* (2 vols), Bemrose and Sons, London, 1895.

Jones, E. Alfred, *Old Plate of the Cambridge Colleges*, Cambridge University Press, Cambridge, 1910.

Jones, E. Alfred, *Old English Gold Plate*, Bemrose and Sons, London, 1907.

Jones, E. Alfred, *The Old Royal Plate in the Tower of London*, Fox Jones, Oxford, 1908.

Jones, E. Alfred, *Catalogue of the William Francis Farrer Collection*, St Catherine Press, London, 1924.

Jones, E. Alfred, *The Gold and Silver of Windsor Castle*, Arden Press, Letchworth, 1911.

Jones, E. Alfred, *Old English Plate of the Emperor of Russia*, privately printed, 1909.

Lee, Georgina E. and Lee, Ronald A., *British Silver Monteith Bowls: Including American and European Examples*, Manor House Press, Byfleet, Surrey, 1978.

Mahaffy, J. P., *The Plate in Trinity College, Dublin*, Macmillan, London, 1918.

Mayne, Richard, *Old Channel Islands Silver: Its Makers and Marks*, Société Jersiaise, St Helier, 1969.

Mercers Company, *Plate of the Worshipful Company of Mercers*, privately printed, London, 1940.

Milbourne, Thomas, *Plate of the Worshipful Company of Vintners*, privately printed, London, 1888.

Moffatt, H. C., *Old Oxford Plate*, Archibald Constable, London, 1906.

Oman, Charles C., *English Silver in the Kremlin, 1557-1663*, Methuen, London, 1961.

Oman, Charles C., *English Engraved Silver, 1150-1900*, Faber and Faber, London, 1978.

Oman, Charles C., *English Church Plate, 597-1830*, Oxford University Press, Oxford, 1957.

Oman, Charles C., *Caroline Silver*, Faber and Faber, London, 1971.

Oman, Charles C., *English Domestic Silver*, A. & C. Black, London, 1968.

Oman, Charles C., *The Winchester College Plate* (reprinted from *The Connoisseur*), London, 1962.

Parrish and Bowen, *Antique English Silver in the Lipton Collection*, Dayton Art Institute in collaboration with Thomas J. Lipton Inc., Dayton, Ohio, 1958.

Phillips, P. A. S., *Paul de Lamerie, His Life and Works*, privately printed, London, 1935.

Preston, Arthur and Baker, A.C., *The Abingdon Corporation Plate*, Abbey Press, Abingdon, Berkshire.

Reddaway & Walker, *Early History of the Goldsmiths' Company 1327-1509*, Arnold, London, 1975.

Ridgeway, Maurice H., *Chester Goldsmiths: From Early Times to 1726*, John Sherratt & Son, Timperley, Cheshire, 1968.

Rowe, Robert, *Adam Silver*, Faber and Faber, London, 1965.

Taylor, Gerald, *Silver*, Penguin, London, 1956.

Ticher, Kurt, *Irish Silver in the Rococo Period*, Irish University Press, 1972.

Watts, W. W., *Old English Silver*, Ernest Benn, London, 1924.

Index